IN RESPONSE TO PLACE

PHOTOGRAPHS FROM THE NATURE CONSERVANCY'S

LAST GREAT PLACES

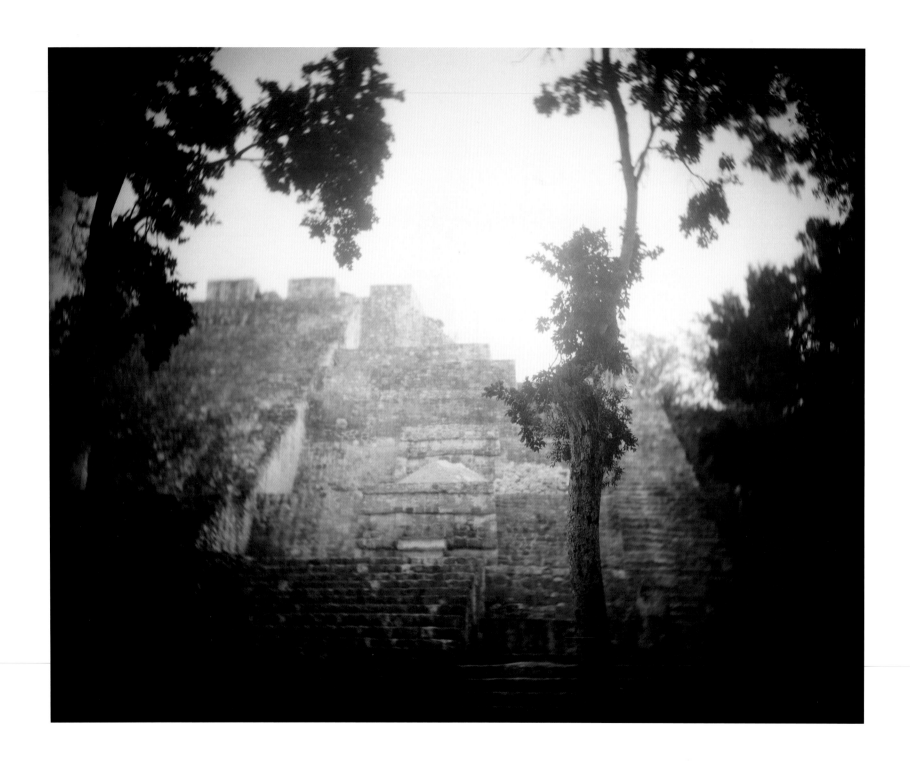

SALLY MANN, CALAKMUL

IN RESPONSE TO PLACE

WILLIAM CHRISTENBERRY • LYNN DAVIS • TERRY EVANS

LEE FRIEDLANDER • KAREN HALVERSON • ANNIE LEIBOVITZ

SALLY MANN • MARY ELLEN MARK • RICHARD MISRACH

HOPE SANDROW • FAZAL SHEIKH • WILLIAM WEGMAN

FOREWORD BY TERRY TEMPEST WILLIAMS • ESSAY BY ANDY GRUNDBERG

PHOTOGRAPHS FROM

THE NATURE CONSERVANCY'S

LAST GREAT PLACES

BULFINCH PRESS • LITTLE, BROWN AND COMPANY
BOSTON NEW YORK LONDON

First published on the occasion of the exhibition "In Response to Place: Photographs from The Nature Conservancy's Last Great Places."

The Corcoran Gallery of Art, Washington, D.C.
September–December 2001

Houston Museum of Natural Science, Houston
February–April 2002

Ansel Adams Center for Photography, San Francisco
May–July 2002

High Museum of Art, Atlanta
August–December 2002

Field Museum, Chicago
January–April 2003

Indianapolis Museum of Art, Indianapolis
May–August 2003

Museum Center, Cincinnati
March–June 2004

Renaissance Center, Detroit
July–September 2004

Major funding for the exhibition of "In Response to Place: Photographs from The Nature Conservancy's Last Great Places" has been provided by **Merrill Lynch**. Merrill Lynch, one of the world's leading financial management and advisory companies, supports a wide range of cultural initiatives around the world.

The exhibition has also been supported by generous gifts from Cadillac, Georgia-Pacific Corporation, MBNA America, Millstone Coffee, and 3M.

Duotone separations by Robert Hennessey, Middletown, Connecticut.
Printed and bound in Germany by Cantz.
Book and jacket design by Katy Homans.

Library of Congress Cataloging-in-Publication Data
In resonse to place: photographs from The Nature Conservancy's last great places / The Nature Conservancy / foreword by Terry Tempest Williams; essay by Andy Grundberg.
 p. c.
ISBN 0-8212-2740-8(hc) / ISBN 0-8212-2741-6(pb)
 1. Nature photography. 2. Landscape photography. 3. Natural areas—Pictorial works. I. Nature Conservancy (U.S.)

TR721.I525 2001
779'.3'0922—dc21 2001018079

Bulfinch Press is an imprint and trademark of Little, Brown and Company (Inc.)

CONTENTS

KAREN HALVERSON, CALIFORNIA BUCKEYE TREE, HOWARD RANCH, COSUMNES RIVER PRESERVE

THE NATURE CONSERVANCY AND THE LAST GREAT PLACES

THE LAST GREAT PLACES ARE RIVERS, DESERTS, FORESTS, CORAL REEFS. They encompass mountains and plains, bays and beaches. They are the life under water and above it. They echo with the calls of birds and with the voices of people. The Last Great Places are landscapes where the natural world still bears hope and promise for all its inhabitants.

Across the country and around the world, we all have seen landscapes lost. It might be where a strip mall has overtaken a marsh, or where hotels now rise from sand dunes, or where wilderness has been broken and tamed up to the brink of a beloved national park. With this loss, the web of life is severed, habitat for bear and salmon and dragonfly degraded and constricted. The irony, and the tragedy, of such loss is that often we don't appreciate these open, living landscapes until they're gone.

The Nature Conservancy is dedicated to saving the landscapes that are the Last Great Places. We have protected millions of acres of habitat in these and other landscapes, bolstered by the convictions, generosity, and unflagging support of our one million members. But lasting conservation is much more complicated than buying land outright—the Conservancy's hallmark strategy. Part of our approach, for instance, involves raising awareness about the ways in which these landscapes sustain us, all of us, near and far.

In this spirit, and to commemorate our fiftieth anniversary, The Nature Conservancy has sponsored the exhibition called "In Response to Place," commissioning twelve of the most talented photographers of our time to take pictures at some of the Last Great Places. This book documents their responses in pictures that are as beautiful and complex as the places themselves.

Because our capacity to buy land alone isn't enough to stem the tide of ecological loss, we are developing a blueprint for conservation across the Western Hemisphere and beyond, guided by the best available science. Our vision is the preservation, and sometimes the restoration, of ecologically functioning landscapes. By looking across ecological regions such as the Sonoran Desert and the Canadian Rockies, we are mapping out priority conservation areas and finding innovative strategies to ensure their lasting protection.

Our approach to conservation also hinges on partnerships. With landowners, from timber companies to families, we develop conservation easements—voluntary, legally binding agreements to protect land that will remain in private ownership. With government agencies, we work to rejuvenate public lands, such as returning fire to landscapes that once burned—and thrived—under the regular sweep of flame. With water managers and dam operators, we work to restore sufficient water flows to rivers, allowing fish to spawn and giving oysters the fresh water they need to survive—and the oysterman the catch that allows him and his way of life to survive.

At the heart of all we do, The Nature Conservancy works with local communities to protect *their* great places while helping them find the means to live productively, sustainably, and harmoniously with the natural environment. We have developed incentives for farmers to keep cattle out of streams and erosion in check, and incentives for ranchers to keep cattle on the land—and suburban sprawl at bay. As the photographers explore in this exhibition and book, people are just as much a product of landscape as wildflowers and jaguars. The key to the survival of the Last Great Places rests ultimately with the people who live and work there.

We believe the best way to achieve our conservation mission is to work cooperatively and non-confrontationally. This basic operating principle has gotten us far along the path because we welcome a range of partners in the effort to protect the Last Great Places and the diversity of life. We're proud of our record of support from corporations, such as those making possible "In Response to Place." Merrill Lynch is the presenting sponsor of the exhibition, joined by Cadillac, Georgia-Pacific, MBNA America, Millstone Coffee, and 3M. Theirs is the type of support that grows our actions and leads to conservation change.

So much is at stake. Vibrant, living ecosystems. Landscapes that are home to some of us, destinations to others, all essential to our spirit and our future. Together, The Nature Conservancy and the myriad people who find common ground in the name of conservation will continue to protect the Last Great Places. Ours will be an incalculable legacy that endures for generations to come.

STEVEN J. McCORMICK
President, The Nature Conservancy

FOREWORD

TERRY TEMPEST WILLIAMS

Through my binoculars, all I see is green. I bring them down, look with my naked eyes into the depth of the cloud forest, then bring the field glasses up again. I still can't see anything that resembles a bird.

"*Mira—*" my guide says. He steps behind me, puts his hands on my shoulder and lines up my body with the bird he is seeing and I am not. "There, on the right, beyond the vine. . . ."

The bird moves. I quickly bring my binocs into focus—I see it, flashes of yellow and blue.

"*¿Que es eso?*" I ask.

"A slate-colored redstart," he responds.

This is a new bird for me, as most of them are in Costa Rica. I am a long way from home, the sandstone canyons of southern Utah. I needed a new perspective from the aridity of the desert to the lushness of the rain forest. I wanted to breathe in the forest, breathe with the forest and receive an infusion of oxygen.

Call it my pilgrimage from red to green.

My guide in the Monteverde Cloudforest Reserve is Pedro Bosques, a Tico who is one of the finest naturalists I have ever encountered. I am here in hopes of seeing the resplendent quetzal, *Pharomachrus moccino*, the emerald jewel-bird of the trogon family. But for now, it is enough to be walking with Pedro in the rain, in this forest, enshrouded in clouds.

More than enough.

I tell Pedro he has "*ojos de magica*," that he is teaching me how to see.

In the red-rock desert of Utah, the vista is long and wide, the eroding crust of the Earth is splayed open like a great wound. I know what to anticipate. My eyes look for turkey vulture, a black chevron against blue sky, unsteady in flight, a locator of blood and bones. Red-tailed hawks coast on thermals. And the songs of meadowlarks rise from the sage flats, yellow flashes of joy. In open country, you see birds easily. One squints against the sun.

In the cloud forest of Costa Rica, the view is vertical, one's neck is cocked, eyes are raised, and pupils dilate. You have the feeling, certainly the stance, that you are looking for God. It is hard to tell the difference between rain and tears, the depth of green is so intense. Everything bends and sways, moans and sighs, nothing is rigid. Even palms walk.

Pedro walks slowly ahead. It is dark, even in morning. He crouches and makes a low, melancholy cry.

"Calling quetzal—" he whispers.

Something moves in the foliage. I lift my binoculars. There—I have it.

Before I can even speak, Pedro says, "Wood thrush."

"*Si, tenemos es pajaro en estados unidos.*"

I try to speak Spanish, tell him we have this bird in the States, that it is one of my favorites. He obliges with English and speaks of the miracle of migration, evident each winter as thousands upon thousands of neotropical birds wing their way from North America south and back again.

The wood thrush is puffed up because of the cold. I share with Pedro how much I cherish this bird's song, the bell-like clarity of its voice. He says he has never heard it sing, that the wood thrush remains silent in its southern residence, that Costa Rica is its resting place. I am delighted by this knowledge. In the United States, specifically in eastern forests, the wood thrush sings the most sublime trills to attract a mate.

We, too, can have a different response to place.

¿Que es eso yo ver? What is it I see?

In the highest reaches of the canopy is a silhouette of a large bird. I cannot make out any particular color because of the light. Pedro walks me to another vantage point.

"Quetzal," Pedro whispers. "Female."

My heart is racing. Resplendent she is, turquoise and emerald feathers glistening in the gently falling mist, her barred tail, black and white, creates a dizzying effect as though this bird is more ghostly than real. A wind is blowing, rocking the branch where she is perched. She turns. Her large dark eyes startle and awaken something deep inside me. She seems to be looking from the past into the future and back again to this time, fully present. The scarlet triangle of feathers beneath her tail becomes an arrow, a bloodstained reminder of the quetzal's mythical lineage.

Quetzal. Quetzalcoatl. The great god of the Aztec. Half bird. Half serpent. He was the sun during another incarnation of the Earth, the god who visited Mictlán, the underworld, where he brought back the bones of the dead and sprinkled his own blood over them, transforming them into human beings.

No wonder whole civilizations created religions around these birds. No wonder the word *quetzal* is derived from the Aztec word *quetzalli,* meaning "precious" or "beautiful."

We have always been drawn toward beauty. It both arms and disarms the human psyche. We are undone, rearranged, transformed, and disturbed, thrown off balance from the equilibrium that was once ours. Beauty reminds us there is a power and force beyond ourselves. In that moment of reverie, we confront both desire and humility.

But beauty comes with a price. It opens our hearts. We become vulnerable. We seek it, protect it, want to preserve it for all to enjoy. Trouble arises when we want to keep it only for ourselves. Greed destroys and corrupts beauty. So does ignorance.

A quetzal in the cloud forest of Monteverde. A bird in place. Place matters. Why?

Pedro Bosques tells a story.

He came to Monteverde more than a decade ago, simply to watch birds. He fell in love with the quetzals and three-wattled bellbirds, a strange, wondrous species whose call can be heard almost a half-mile away. He learned that both birds were endangered due to a loss of habitat, specifically the demise of wild avocado trees, members of the family *Lauraceae.*

Pedro was introduced to biologists Debra Hamilton DeRosier and Dr. George V. N. Powell, the coordinator and founder, respectively, of the Bellbird Conservation Project. They told him about their migration studies, how they were central to developing a conservation strategy that could save these imperiled birds.

What they found was that the Pacific slope of both Costa Rica and Panama had been deforested to such critical levels that many species had been driven to near extinction, the quetzal and bellbird among them. They learned the quetzals and bellbirds migrate seasonally from the cloud forests of Monteverde, where they nest from March through July, down to the Cordillera Tilarán. They follow the ripening avocado trees from the highlands to the lowlands. Both birds play a crucial role in the perpetuation of these tropical forests, as they are primary seed dispersers of the wild avocado.

To protect the birds, conservationists realize they must protect the avocado trees (which account for eighty percent of the quetzal diet) along the birds' altitudinal, or vertical, migration path. Many of the trees are found on privately owned farms on the periphery of the Monteverde Cloudforest Reserve. In the last census, twenty-one quetzals were found outside the reserve, eighteen of them foraging in three avocado trees, all on private land. It was the same situation with the bellbirds. In their latest bellbird census of 2000, they found eighty individuals, down from almost one hundred forty in 1997. Unprotected birds dependent on unprotected trees.

As a result of these findings, the Bellbird Conservation Project and the Alliance for the Monteverde Institute have helped initiate several local reforestation projects to aid the quetzals and bellbirds.

Pedro tells me they have planted more than five thousand trees from fifteen different families, wild avocados among them, all with the help of local nurseries.

"We call this corridor conservation, creating bridges of trees that connect forests to forests," Pedro explains. "And children from around the world have been helping us."

He is referring to the Children's Rainforest Project. In 1989, a group of Swedish children became concerned about the destruction of the rain forest and took action. They solicited help from children in more than twenty nations to establish "an international children's crusade to save rain forests." The first forest they decided to buy and protect was adjacent to the Monteverde Cloudforest Reserve. At the time, it was not known that this was quetzal habitat. Now with this discovery, they are strengthening their efforts, continuing to purchase thousands of acres to secure the seasonal home of the quetzal.

Pedro and his colleagues are working tirelessly to raise money to purchase contiguous land from farmers and developers. Much of it has already fallen prey to deforestation.

But Pedro is hopeful. We continue walking on the trail. He stops and points inside the dense cloud forest. "There, see that large tree in the center?"

I nod.

"Wild avocado." He describes the enormous arching tree before us, its delicate leaves, its branches splayed like the fingers of an open hand. "One day our seedlings will be just as large."

The Nature Conservancy has a green hand in Costa Rica, as well, that is joining with *los manos de la gente*. From the twelve-thousand-foot summits of the Talamanca Cordillera, the Conservancy's "ridges to reefs" protection efforts extend downslope to the Osa Peninsula on the Pacific coast, and eastward to the coral reefs of the Caribbean.

In my own community of Castle Valley, Utah, The Nature Conservancy is helping us to help ourselves as we create a sustainable vision of what it means to live in the desert. Pace Hill, a magnificent sandstone formation, is home to the endangered plants Jones cycladenia (*Cycladenia humilis; V. Jonesii*) and Schultz stickleaf (*Mentzelia schultzii*). We are in negotiations with the State Institutional Trust Lands Administration to purchase this land, among other sites along the Colorado River Corridor.

The preservation of beauty and wildness is the mission not only of The Nature Conservancy but of people in communities all over the world, be it Pedro Bosques in the cloud forest of Monteverde or schoolchildren in Sweden who have adopted the challenge of saving the rain forest as if it were in their own backyard.

Call it home work in response to place, creating habitats of hope.

Late in the afternoon, Pedro and I see another quetzal, this time male. The trailing tail feathers, two feet long, are waving in the wind, turquoise blue. The beauty of this bird, its power and presence, is almost too much to bear.

"*Que suerte,*" I say under my breath.

"*Claro,*" responds Pedro, smiling.

Quietly, with our heads down, we walk past the crowned quetzal. With a respectful distance between us, we turn and look up. The quetzal's red breast, bloodred, is glowing in the last rays of light.

The image of bloodshed by Hernando Cortés and the long chain of seduction and brutality delivered by Spanish conquistadors in the Americas must be held in the memory of quetzals, passed on generation to generation.

Recall the headdress made of quetzal feathers presented to Cortés by the Aztecs, who believed him to be the returning Quetzalcoatl. His presence according to the Aztec calendar was anticipated in the year *Ce Acatl*, 1519, the very year Cortés arrived. After receiving this most sacred of gifts, Cortés proceeded to massacre the Indians and plunder their temples for gold, virtually destroying the Aztec Empire. The betrayed headdress now resides in the British Museum in London, out of context and out of place.

"Imagine a world without native beauty?" Pedro says as we walk back to my cottage. "In Costa Rica we say, '*La paz de la gente es la paz del madre tierra.*'"

I repeat his words out loud to make certain I understand, as white-fronted parrots careen in front of us, seeking their night roosts.

"The peace of the people is the peace of Mother Earth."

"*Exactamente,*" Pedro says. "*Pero—*" he pauses and finishes

his sentence in English. "But it is possible only with constant vision and vigilance."

The volume you hold in your hands gives us both vision and vigilance. The "*ojos de magica*" of the photographers before you remind us of native beauty, how much it means to the survival of our own souls to intermingle with wildness. They, too, are teaching us how to see, how to expand our notion of community to include plants, animals, rocks, rivers, and human beings.

We are no more and no less than the life that surrounds us.

A different point of view is evolving. Perhaps this is what we need most at the beginning of the twenty-first century—a change of perspective, another way of seeing, another way of being in the world.

We can learn to live more deeply, more fully in place, our eyes wide open to the wild. We don't have to develop every acre in sight or drill for oil simply because it's there. Restraint is a virtue we have yet to cultivate.

We can change our lives to accommodate the health of resplendent quetzals and three-wattled bellbirds, and cycladenia quietly blooming in the desert. We can stand our ground in the places we love, not because it is the right thing to do, but because the future of life on this planet depends on such acts of compassion and courage.

The preservation of the wild is the restoration of our humanity. No longer do we need to conquer nature: Our task now is to nurture the land as it nurtures us.

With the vision and support of The Nature Conservancy, we can protect and preserve these Last Great Places, understanding that beauty is not optional but essential in determining how each of us will choose to live *in response to place*.

Monteverde, Costa Rica
January 21, 2001

PLACE MATTERS

ANDY GRUNDBERG

PLACE MATTERS. I am writing this essay on a farm in the shadow of the Blue Ridge Mountains of Virginia, not far from Shenandoah National Park. The park, like the countryside out my window, is a creation of human culture. Whatever "wilderness" visitors find there is a fiction; the land was cleared and used for subsistence farming for hundreds of years before a decision was made to return it to nature. The fields I look out on are in a more reluctant process of reforestation, but they too are relics of a colonial, agrarian past. As the farmer across the road mows his first hay of the year, so that the smell of grass fills the house, I am aware of how resilient and transforming nature can be. Nothing here is natural in the sense of being original, but it is beautiful.

I cannot pretend, like Ralph Waldo Emerson in the nineteenth century, to have a "transparent eyeball" that takes in the messages of nature much in the way a satellite dish today passively takes in television signals.[1] What I write, how I feel, indeed, what I see, is governed by where I am now and where I have been before. But if my relationship with nature does not transcend culture, as most philosophers and theorists of recent vintage would argue, it is equally true that my relationship with culture does not transcend nature.[2] I am stuck in it, in the sense that I am embedded in air and light and that my feet touch the ground. The notion that I am alienated from, or alien to, nature does not ring true. Even in the city, I wake up sooner if the window is open.

Feeling a part of nature makes one responsible to it, and ultimately for it. Our responsibilities are in large part a matter of who we are. For visual artists, they might involve symbolic representations of natural beauty or natural order, or working directly with natural materials. Environmentalists often talk about the ethical basis of caring for the land and water, but there is an aesthetic of well-cared-for places that artists recognize and sometimes seek to emulate. Indeed, one might argue that in our tangled relationships with nature, ethics and aesthetics are equal partners.

In Response to Place is, first of all, a collection of photographs taken in places that are both beautiful and worth saving, lands and waters called Last Great Places by The Nature Conservancy. Some of these places are exotic and remote, while others lurk in our midst virtually unnoticed; some are threatened by human encroachment, while others seem to have been bypassed by civilization entirely, so that the natural world remains remarkably intact. All deserve our care and attention, since they, together with thousands of other places great and small, hold the key to the future of the world's biological diversity.

In Response to Place is also a collection of photographs taken by twelve artists of established reputation who were asked to respond, as artists, to their experience of a particular place. Several chose destinations close enough to home to promise at least a hint of familiarity, while others ventured far from what might have been predicted based on their previous work. The result is an affiliation of twelve points of view, twelve interpretations of what the idea of place might mean at the threshold of the twenty-first century.

Third, In Response to Place is a collection of photographs that raises important questions about our current relationship to the natural world, and about how this relationship might be represented in pictures. As artists know intuitively, the most universal meanings often emerge from the most personal of subjects. It was my hope as the project's organizing curator, as well as the hope of The Nature Conservancy, the project's sponsor, that by matching specific places with individual sensibilities, a set of coherent, useful visual propositions would emerge. The pictures gathered here are evidence that this hope was well founded.

Photography seemed the ideal medium for such a venture because camera images mediate between the visible, describable world and the intentions of the human observer. Photographs are documents, that is to say, of both the material thing in front of the lens and the metaphysical eye behind it. Photographs are also reservoirs of memory and keepers of the past; they can function to illuminate the particulars of the natural world even at a distance of time and place. And by depicting rare natural beauty and diversity, they allow us to savor what otherwise would be accessible only to a few, and then only briefly.

Photography, unlike its sister visual arts of painting, sculpture, and drawing, has always been engaged in depicting the ways in which the natural world is perceived by human beings. This is largely because when it was invented in the nineteenth century, the relations between nature and human endeavor were changing. The Western world was being mechanized, industrialized, and urbanized, and increasingly art and aesthetics came to be located in the pastoral countryside, and in the direct comprehension of its prelapsarian beauty. In the United States, this Romantic appreciation of unspoiled (and often tempestuous) nature coincided with the vision of Manifest Destiny, which concluded, by century's end, with the cementing of a contiguous nation from coast to coast and the colonizing of most of what had been the American frontier.

When photography was announced to the world in 1839, it was hailed for its apparent ability to hold a mirror up to nature (then spelled with a capital *N*), whereas painting and drawing depended on the intervention of the hand. One would think that the "mirror of Nature" notion would have been especially apt for the daguerreotype, with its precisely etched details embedded in a metal plate, but that process was used primarily for portraiture. Artistic practitioners of the day favored a second process, the paper-based Calotype, because it produced a fuzzier and more general "effect" better suited to pastoral idylls. William Henry Fox Talbot, the Calotype's inventor, referred to his process as "The Pencil of Nature," paradoxically referencing photography to drawing, and thus the human hand. Whether the image was soft or sharp, however, the belief that nature was synonymous with beauty and truth led to a profusion of landscape photography in the nineteenth century.

The tradition of the landscape genre—in painting as well as photography—has since become so rich and commanding that today we are inclined to assume that if we want to picture a place, or visually to describe our relationship to the natural world, we need to make landscapes. This is an assumption that bears rethinking. For one, the pictorial conventions of the landscape in Western art are the creation of a particular cultural moment that is now three centuries old—not a particularly long time in the span of the history of art.[3] For another, the landscape tradition positions the natural world and the human world in opposition to each other, when more and more we are recognizing that they are inextricably linked.

We need only consider the well-known photographs of Yosemite and the Sierra Nevada taken by Ansel Adams in the 1930s and 1940s to see how the landscape tradition has posited humanity as the antithesis of the natural world. Although Adams did much of his best work in the Yosemite Valley, which even early in the century was a popular tourist site, we see no sign in his pictures of visitors, automobiles, roads, or telephone poles. To Adams, and to most photographers of his generation, such evidence of human presence would have constituted an intrusion and spoiled the beauty of the scene. It would also, at least by implication, symbolize the ruin of nature itself. Adams, like John Muir before him and many others after him, believed that wilderness was the essential condition of nature and essential to its persistence. The title of a 1962 Sierra Club photography book by one of Adams's contemporaries, Eliot Porter, put this notion succinctly: *In Wildness Is the Preservation of the World*.

Adams's exclusions of human presence are not atypical; they merely reflect what arguably is an enduring American mindset about nature, beauty, and the land. As Michael Lewis has written:

The park and the highway strip can be thought of as the twin poles of the American attitude to the landscape. In the first

instance land is understood as a coherent organism, whose aesthetic properties are inseparable from its spiritual, in the second, as a physical commodity, to be used without reference to what came before, or to what stands nearby; in the one, land is landscape, in the other, real estate.[4]

The notion of nature as landscape, no less than the notion of nature as real estate, does not do justice to the way we should account for its importance in our lives and in the lives of all species.

In the 1970s a new generation of photographers sought to correct the exclusionary stance of Ansel Adams and his peers. The style they created, named for a 1975 exhibition called "New Topographics: Photographs of a Man-Altered Landscape,"[5] emphasized the human occupation of the land by including industrial and domestic buildings and other signs of construction and use. The New Topographics style seemed radically new at the time, although it was influenced both by nineteenth-century survey photography of the American West and by Walker Evans's work of the 1930s. Overlooked, however, was the fact that the photographers' assumptions about the relationship between the human and natural worlds were virtually identical to those of Ansel Adams: Nature was itself only in the absence of human beings; signs of human presence signified despoilment and impurity. Thus, one could argue that the "Man-Altered Landscape" photography of the past quarter century was simply the flip side of the same coin that Ansel Adams and his peers had used for the previous fifty years. One group of photographers excluded human presence while the other emphasized it, but both were convinced that the natural world was fundamentally discrete from human beings.

Another explanation for this human/nature duality is that, in the twentieth century, the objective component of a photograph—in this case, a natural scene—and its subjective component—the picture maker—were conventionally viewed as either/or propositions. Either the picture was objective (that is, a mirror of what was before the lens, thus a document), or it was subjective (that is, an expression of the feelings and thoughts of its maker, thus a work of art). Much recent criticism and art history have been devoted to demonstrating that this distinction is spurious. All pictures owe something to their subject, just as all pictures are a reflection of the intentions of their makers and the cultural and historical circumstances of their making. Since this objective/subjective polarity has been successfully challenged, why not the human/nature duality as well? There is a cultural and historical need to find new ways to describe our place in the natural world, and this need is a matter of importance not only for photography or for art as a whole, but also for our lives.

This is the motivating idea underlying *In Response to Place*.

The story behind the photographs gathered here is a straightforward one. Beginning in 1999 and continuing into the year 2000, twelve artists for whom photography is a medium of expression were asked to contribute their talents to a prospective exhibition and book called *In Response to Place*. The occasion was the celebration, in 2001, of the fiftieth anniversary of The Nature Conservancy. The artists would select a site from The Nature Conservancy's Last Great Places, visit in the company of the Conservancy's on-site project manager, and then take whatever kind of pictures they wished, based on their responses to the place. It was, in one sense, a dream commission. The twelve were asked only to record their own experience of the place, not to produce any particular kind of picture. They were not limited to making landscapes or any other genre of photography. Some produced all their pictures on one trip; others chose to revisit their site several times and over several seasons.

The potential downside to this offer was that the project was designed as an experiment. As curator, I selected artists who were successfully identified with particular approaches and styles but who also seemed ready to explore new artistic territory. I wanted to be surprised by what they did, and I hoped that they would be surprised as well. This posed the risk that some of the artists would try something new that would later turn out to be unsuccessful. At minimum, the results would be impossible to anticipate.

In retrospect, the impossible happened: Without exception, the participants returned with pictures that excited them and challenged our understandings of their work. To say that each artist arrived at a career breakthrough would be too much to claim and too much to ask, but all of them can attest that the opportunity led them to think about new subject matter, new projects, and new ways of working. In this sense, the collection you see here is as much a testimony to the reservoir of untapped possibilities of expression that every artist harbors as it is a celebration of the ways in which nature continues to inspire us.

Given the open-ended conception of the commission and the range of work produced, certain questions are inevitable. For example, all of the artists have distinctive and recognizable styles; if their work is really about an encounter with new and sometimes strange territory, why is it instantly identifiable by its style? Put another way, what is it about style that perseveres here, and why? I would argue that for an artist, his or her style, developed over the course of a career, represents a known and familiar quantity. Thrust into a new situation, or confronted by material that demands a new interpretation, the artist brings along his or her style in the same way a backpacker carries a map and compass. With the bearings provided by style, the artist is free to explore the notion of place more fully and to forget, if only provisionally, the need to capture that notion on film.

Thus we can say that Lee Friedlander's pictures of the San Pedro River, to some extent, resemble his earlier pictures of cacti in the Sonoran Desert, or that Lynn Davis's striking views of the monumental land forms of the Colorado Plateau in Utah continue the vector of her earlier pictures of icebergs and pyramids. There are always exceptions to the rule, of course, and it seems fair to guess that Annie Leibovitz's images of the Shawangunk Mountains in New York might not be immediately identified by someone acquainted with her celebrated portraits of celebrities. Leibovitz often works in black and white, but only rarely has she attempted to photograph the natural world. Still, a sophisticated observer can see in her pictures the kind of restless experimen-

tation and complex sense of spatial organization that are characteristic of her work.

Another question worth asking is why the pictures are not exclusively landscapes. Mary Ellen Mark and Fazal Sheikh, in particular, eschewed the landscape genre in favor of portraiture—practiced by both in the regular course of their art. As I have already indicated, the presumption that only landscapes can describe a "response to place," or any human relationship to the natural world, seems to me a shortcut that verges on being a short circuit. True, landscapes have been the territory in which we in Western culture traditionally have attempted to depict our feelings about the natural world, but in today's world, human presence and nature overlap more frequently than not. The Nature Conservancy has recognized this in taking up community-based conservation, in which sustainable human uses of land and water are supported to help foster an interdependent ecosystem that people have a stake in preserving. This is not the wilderness idea, which views human settlement as an intrusion, but a more capacious, and complicated, idea about how to assure the planet's survival.

Mark's portraits from two isolated coastal settlements on opposite ends of the United States, and Sheikh's portraits of the faces and hands of landless people living within a national park in Brazil, are apt reminders of the human face of conservation. It is rare that an effort to protect natural places does not have an impact on the people who live and work in these places. The people in these pictures, as much as public-spirited citizens, environmental leaders, and government officials, will determine the success of any effort to bring into balance the needs of nature and of humanity. A landscape may show us what is worth saving, but it does not always reveal what the stakes are in human terms.

A similar question has a similar answer: Why do so many of the landscape photographs here include fences, roads, houses, and other signs of human habitation? In one of Karen Halverson's pictures from the Cosumnes River in California, for example, a garden hose dominates the foreground. In Terry Evans's two-image panorama of the tallgrass prairie in

Oklahoma, a blacktop highway arcs into and out of the left-hand corner. In one of Lynn Davis's photographs the central subject is an abandoned, wing-roofed building that once was the office of a motel. Clearly, these artists point out, the Last Great Places are not isolated from the rest of the world or from our daily lives.

These reminders of human activity do not read as critical commentary, however, as they might have a quarter of a century ago. Instead, we can view them as acknowledgments of the cheek-to-jowl relationships of the realms of nature and humans in today's world. The surroundings of the Cosumnes River site, Halverson reports, have given way to small-scale suburban development. The surroundings of Grande Sertão Veredas, where Fazal Sheikh worked, are freshly plowed plains where soon, with the aid of chemical fertilizer, soybeans will grow.

Whether beauty can still adhere to such places in such surroundings is a question that the pictures themselves answer, and answer affirmatively. But the beauty that they offer is not the majestic, apparently limitless version of Ansel Adams's landscapes, or the reductive, compromised version of the generation that rebelled against Adams's example. Instead, it is a rich and complex beauty, one that acknowledges a more intricate understanding of how human beings can both preserve and decimate the natural world. And it acknowledges that we are ourselves a part of nature and not outside of it.

Depicting nature in a new way does not necessarily mean we have to dispense with the landscape genre. Indeed, roughly half of the project artists chose to photograph in a manner recognizable as traditional landscape photography. Even within this mode, however, they sought out new territory in terms of their previous work. William Christenberry, for example, for the first time made "pure" landscapes in which no sign of an earlier human presence appears.

Christenberry is an artist whose photography coexists with his activities in painting and sculpture. For this project he took views of the Bibb County Glades and the Cahaba River, in which space and color appear almost as givens. Like Walker Evans,

the photographer whom he most admires, Christenberry uses a "documentary style" that lulls the viewer into thinking that his images were inevitable and therefore without conscious intention, like a commonplace snapshot. In reality, though, the commonplace of Christenberry's photographs is highly evolved and sophisticated. What might seem simply happenstance, like the drops of rain striking the surface of the river's brown water, turns out to be precisely calibrated to seize our attention.

Christenberry has long photographed in Tuscaloosa and Hale counties of Alabama, near where he was raised and where his family still lives. His career as a photographer began in the 1960s, when he started to use a Brownie camera to document old, abandoned buildings and fading signs in the region. Many of these same buildings and signs, he later learned, had been subjects for Walker Evans during the Great Depression, when Evans made the photographs for the book *Let Us Now Praise Famous Men*. Christenberry later switched to a view camera to record these melancholy relics more precisely, as well as scenes in which plants (including the infamous kudzu vine) seem to be overtaking the evidence of prior human occupation.

For all his years photographing in this region of Alabama, however, Christenberry had never visited the Bibb County Glades until he chose to photograph it for The Nature Conservancy. This oversight is understandable, since the compact dome of biodiversity of the glades was not discovered until 1992. Long without human attention, the glades has none of the cultural markings that usually are the center of attention in a Christenberry photograph. So the artist, having watched the natural world gain ascendancy over his favorite buildings in the course of many years of photographing them, found himself taking the first unacculturated landscapes of his career. In these pictures, rock, soil, sky, and water are celebrated as themselves survivors of time. Ultimately, the cultural world represented in

Christenberry's earlier pictures of buildings and signs is little different from the natural world of the Bibb County Glades: Both are subject to being defined by the passage of time, which contains the seeds of their seasonal appearance and geological transformation.

Like Christenberry, Lee Friedlander chose to focus on exclusively "natural" scenes. Friedlander is highly regarded as

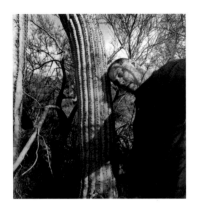

an artist whose task has been to expand what art can be and, consequently, to demythologize art making. Known more as a "street photographer" than as a landscapist, Friedlander has in fact surveyed a broad terrain of possible photographic genres: portraits, still lifes, nudes, and landscapes. Still, based on his work of the 1960s and 1970s, one thinks of the photographer as a social landscapist, one whose interest has long been with the ways in which man-made structures configure both the landscape and the pictures he makes of it. Books like *American Monument* (1976) and *Factory Valleys* (1982) concentrated on the remnants of an industrialized society intent on honoring its own (fairly short) history.

The pictures from the San Pedro River and other parts of southeastern Arizona are like his more recent landscapes, which forsake history and the social world in favor of a nearly chaotic regime of the natural world. Nominally these photographs are in black and white, but their meanings, and their visual pleasures, lie in the enormous spectrum of tones between these poles. Burrowing into plants growing in the vicinity of underground water, Friedlander's vision seems at times to lose itself to rapture. The many crossings and excursions of mesquite and cottonwood seem like a palm reader's nightmare, resisting any clue to an overall organizing principle. Yet these complex images are not inchoate; instead, they test the limits of pictorial coherence and the preference of our own eyes for a simpler order.

There is, as always, a simpler order lurking in Friedlander's

photographs. Beyond the tree branches and limbs that function like a rood screen in the indeterminate foreground, the eyes can discover their source: a large and most often grizzled survivor of this demanding ecosystem. Like the trees themselves, the pictures seem to take root in the visual solidity of these trunks. The trees might be read as metaphors for the picture maker's mind and as homage to a tradition of photography that has its source in the work of Eugène Atget, whose own pictures of trees, taken in the parks of Paris in the first quarter of the twentieth century, also reflect the vision of a mature artist.

Richard Misrach has been photographing in the arid American West for more than twenty years, and for much of that time he has worked in and around Nevada, creating what he calls "cantos," or poetic series, which focus on particular aspects of our relationship to the land we call a desert. In his 1990 series called "Bravo 20" he focused on a military bombing range, where the ground had

been marked by shell craters and hulks of makeshift targets; in "Violent Legacies" (1992) he photographed pages of a *Playboy* magazine that had been used for target practice. At the same time that he has cast a critical eye on human endeavors, however, he has also been supremely attentive to the desert's potential for beauty. His pictures evoke a tradition of the sublime that dominated American landscape painting in the late nineteenth century and, it almost goes without saying, greatly influenced American photography as well.

In Misrach's pictures of the area around Pyramid Lake in northwestern Nevada, his propensity for reproducing the splendor of unalloyed natural beauty is allowed free rein. This may be a matter of circumstance: The photographer's trip coincided with an unusual period of rain, so that sand dunes that for most of the year are surrounded by yet more sand were briefly marooned by an inland sea of rainwater. Seizing on the way in

which the water reflected the sand hills and the intense sky, Misrach has produced some of the most evocative images of his career. But to say that these are timeless pictures is to miss their real meanings: Like the seasons themselves, the photographs are bound by the passage of time, being the consequence of a meterological event that happens on average less than once a decade.

Lynn Davis's toned black-and-white landscape pictures, taken in Utah, also consider the relationship between time's passage and eternity. The massive rock forms, arches, and buttes she depicts are reminders of a geologic history that predates our own species, but they are contextualized by the roads, fences, and buildings that appear in similarly composed pictures. Interestingly, the kind of remote ranch life these images imply seems an echo of the past as well, since the region is increasingly a destination for adventure travelers and ecotourists, some of whom have built vacation homes nearby.

The tension between stasis and change has been a long-standing theme of Davis's career. In a series of photographs of icebergs, taken in Greenland in 1988, the looming, solid forms of ice belie their transitory existence. A more recent series of pictures of temples, statues, and ruins, taken in Asia, Africa, and Europe, suggests that the marks of human enterprise, while temporal on an epochal scale, have a longer shelf life than we might expect. Like photographs, these remains of earlier civilizations can be read as a palimpsest of human aspirations, in the same way that the photographer's pictures of pure nature speak to an all-pervasive, awe-inspiring spiritual presence. By choosing to center her subjects within a square frame, Davis gives them an iconic quality that makes them as powerful and mythic as totems.

Terry Evans has photographed the tallgrass prairie in her native Kansas for more than twenty years, beginning with close-up images in black and white and moving on to aerial views taken in color. For the past several years she has journeyed as far south as Texas and as far north as Canada to survey what once was an ocean-sized area of native grasslands marked by their dense and interdependent aggregation of plant species. Surprisingly, she had never visited the Tallgrass Prairie Preserve in Oklahoma until this project, but with an eye trained to observe every nuance of prairie, she was well prepared to respond to its complexity.

Evans brings a wide repertory of pictorial approaches to the subject of prairie, ranging from multi-image panoramas taken on the ground to topographic aerial views to still lifes of botanical specimens collected on the site. The variety of her picture taking is a sign of her appreciation of the variety of the prairie itself, but more important, it reflects the almost scientific zeal she brings to the task of depicting the essence of place. More than many photographers, she is willing to de-emphasize her own style to accommodate the demands of her subject. In the case of the specimen pictures, she has honored not only the scientific procedures of the botanists who collected and dried the original plants but also the site itself, by briefly returning the specimens to the locations from which they were collected.

Evans also is interested in the dividing line between the natural, atavistic landscape and its functional, current uses—a division that prairie lands often exhibit. Take the matter of grazing: The Tallgrass Prairie Preserve includes areas reserved for reintroduced bison, which once were the numerically dominant mammal on the plains, bordering on areas fenced for cattle, which supply the economic lifeblood of the region's ranches. Bison range over a much wider area than cattle and graze selectively, so they are favored by biologists who hope to restore the prairie's health and diversity. However, the once free-ranging animals now have to be fenced like cattle. It is this sort of irony that Evans seeks to foreground in her work, including evidence

of human occupation without causing us to jump to hasty judgments.

In similar fashion, Karen Halverson's photographs survey both apparently undisturbed natural scenes and the altered terrain of human habitation. Her subjects sometimes seem sublime, as she pays homage to nineteenth-century landscape painters like John Constable, and at other times self-deprecatingly humorous, as when a tree stump provides a counterpoint for an incongruous pressure tank. By balancing the Cosumnes River's natural beauty with signs that humans live nearby, the pictures suggest a neighborly cohabitation agreement, or at least a provisional accommodation of needs.

Halverson's landscape work has long focused on the ways in which human presence is felt in the natural world, emphasizing that the act of looking is itself a form of intrusion that denaturalizes what is observed. And, as a Californian, she is all too aware of frontier myths that portray the observer—invariably configured as a male—as the master of all that he beholds. In a series of panoramic landscapes she made in the American West, she frequently included her sport-utility vehicle in the foreground (often at dusk, often with its lights on) as a reminder of and surrogate for her own presence as an observer. More recently, in another series of panoramic pictures, she traced Mulholland Drive in Los Angeles from its downtown beginnings to the sea. These pictures are the flip side of her western views, showing manicured, manufactured foliage planted to mask the parade of houses set back from the highway. As in the work she did at the Cosumnes River, Halverson's task was to find an equilibrium between natural beauty and the kind of crafted beauty that results when we displace nature with our own version of it.

Sally Mann's recent transition from photographer of children and family to photographer of unpeopled landscapes is evident in her pictures from the forest of Calakmul, on Mexico's Yucatán Peninsula. What unites these pictures with her landscapes of the American South—and with her earlier and perhaps better-known pictures of young children, including her own son and two daughters—is her interest in capturing a sense of Edenic experience. In Mann's work as a whole, this experience of innocence is tempered by something like the knowledge of original sin. Her children seem possessed of an adult self-consciousness, while her landscapes often contain evidence of civilization's impact on the Earth.

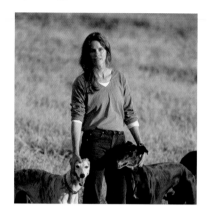

The Yucatán pictures, which are Mann's first color landscapes, show the remains of a Mayan culture that cleared land and built incredible stone temples and monuments, for reasons that are only partially understood. Today the natural world has to a great extent reclaimed these structures, but they provide evidence of a history and culture that predates the arrival of European explorers. In this sense they are "before the fall," and Mann's technique helps magnify the sense that we are in the presence of a pre-rational, pantheistic realm of the spirit. The washed-out colors and streaming spills of light that characterize the pictures are a consequence of Mann's decision to use an antique lens, the glass elements of which have become de-cemented and displaced over time. In some cases the color image seems on the verge of reverting to black and white, an impression that implies its own return to a more innocent time. (Since taking these pictures, Mann has returned both to photographing her family—her husband is now her main subject—and to black-and-white film.)

William Wegman's pictures are ostensibly less serious depictions of the hazy distinctions we make between human and natural worlds. His weimaraner dogs, which appear to have arranged themselves as an integral, organic part of the coastal Maine landscape, are a hybrid of nature and culture, being among the domesticated animals that now function primarily as pets. They are, metaphorically speaking, stand-ins for ourselves.

On the shores of Cobscook Bay the dogs seem to yearn to return to a more natural state—perhaps inspired, on our behalf, by the sublime beauty of the place. Yet as viewers we remind ourselves that the dogs are in large part doing the bidding of their master, who is also the photographer. By posing them in the landscape in ways that mimic or parody the natural setting, Wegman makes the dogs seem both human and natural, self-conscious and relaxed, much like neophyte nudists out sunbathing for the first time.

Wegman is popularly known for his humorous and sometimes poignant images of these weimaraners, which have been published in a series of picture books for children and shown on the *Sesame Street* television program. But although he may be part entertainer, he is also a serious artist who, beginning in the early 1970s, launched an all-out assault on the pretensions and high seriousness of the art world.

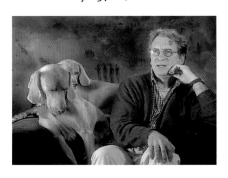

His career began with short video pieces in which he appeared as a hapless, offbeat protagonist. (In one, bare to the waist, he pretended to hum through his navel.) But he was soon upstaged and replaced by his first dog, Man Ray, who happily performed whatever stunts his owner could imagine. Man Ray also appeared in the photographs that Wegman began taking at the same time, which were allied with a movement called Conceptual Art. After Man Ray and his female counterpart, Fay Ray, the weimaraner cast has expanded to include a new generation of puppies.

For the past several summers the artist, his family, and a changing troupe of these dogs have lived on a lake in central Maine, where he has worked on a variety of projects including a Hollywood-style film that parodies the Hardy Boys adventure books. Maine's picturesque natural settings are only partly subsumed by Wegman's interest in playing with the conventions that constitute our idea of beauty; in his pictures, beauty is both interrogated and reaffirmed through the encounter of pets and place.

Wegman's ties to a conceptual approach to photography born in the art world of the 1970s are echoed in the work of a number of younger camera artists, including Hope Sandrow. Sandrow chose to photograph in Indonesia's Komodo National Park because of her recent interest in underwater photography, as well as her more longstanding interest in the ways in which nature, geometry, mathematics, and chance influence our understanding of the world of the spirit. Previously, she had conceived of and exhibited an installation that consisted of photographs taken underwater and of boxes filled with the empty shells of tiny Long Island mollusks. Like nautilus shells, these spiral calcium dwellings follow the mathematical sequence of the Fibonacci series, in which each new number in a sequence is the sum of the proceeding two. To Sandrow, this coincidence of natural construction and mathematical representation also signifies a conjunction between nature and art.

In the waters off Komodo, where conservation work focuses on preserving the threatened marine environments of its coral reefs, Sandrow produced a series of panoramas constructed from pictures taken with the lens of her camera halfway under water. The technique allows us to see the marine and terrestrial "landscape" simultaneously, although at different magnifications. Since each camera image is a single exposure, the composite panorama embeds time as well; the variations of color, horizon line, and point of view indicate that chance also plays a large role in the artist's activity. In addition to the photographs, Sandrow has produced a video that describes her experiences on the trip and a Web site that functions as a public, day-by-day journal. The installation of this work also includes a series of boxes that contain powdered white chalk. The boxes are in the proportion of the Golden Rectangle, a form based in nature and revered by classical civilizations, and the chalk they hold is the ground remains of coral, the essential component of the reefs now being devastated by fishing techniques using dynamite and cyanide.

And then there are the portraits. As a photographer who travels the globe on magazine assignments or for her own work, Mary Ellen Mark has learned to adjust rapidly to new people and places and to employ her unique style in service of the particulars of a given situation. Primarily she tells her stories of place

through the people she meets; most of the pictures she has taken in the past thirty years have been portraits in which individual faces describe suffering, hardship, innocence, and a certain kind of nobility. She is perhaps best known for her pictures of Mother Teresa's mission in India and of Seattle teenage runaways. For this project, the New York–based photographer chose to go to the remote Pribilof Islands and, later, to the geographically closer but no less insular Virginia Coast Reserve on the Delmarva Peninsula.

Both places are ecologically important but economically distressed. Mark's central subject was the people who live in the midst of this contradiction, and her main challenge was to portray them as something other than specimens of an exotic "other." The people of the Pribilofs once lived a strenuous but self-sustaining existence of seals and the sea; today they not only have been cut off from many of their traditions, including seal hunting, but they also face ecological decline in the sea around them. The Pribilof children, on whom Mark concentrated, are a generation in transition. Conservation efforts now focus on reconnecting them with the traditional way of life of their ancestors as a means of helping them restore the ecological balance of their islands.

In the communities of the Virginia Coast Reserve, Mark found a close-knit people facing equally difficult socioeconomic realities. Fisheries there have declined, and some family farms have been supplanted by large-scale agriculture. Job opportunities are few. Many residents live in substandard housing, much of which lacks indoor plumbing. Despite these hardships, the consolations of faith and family life, which Mark found com-

pelling subjects, help sustain a sense of community. Characteristically, Mark manages to suggest these social realities with remarkable economy in her pictures, while also providing us with a sense of particular individuals and their day-to-day realities.

Similarly, Fazal Sheikh has focused on a distressed community living in a national park deep in the interior of Brazil, and has produced pictures that both focus on individual lives and create a context for understanding their social and political realities. Sheikh relies on more than style to contextualize the people there: His photographs are designed to be seen in specific groups and series, and some are accompanied by texts, called "simpatias," which come from legends and folk tales.

What Sheikh found in Brazil fits seamlessly into his previous work, which has centered on African and Afghan refugees living in camps away from their homelands. In essence, he tries to come to grips with what it means to have a sense of place and then, through external forces, to lose it. In the African and

Afghan work, the external force was war, which forced his portrait subjects across borders and into new countries. In this new work, the external force is the spread of industrialized agriculture and the displacement is within the same country.

Sheikh's subjects are subsistence farm families who are landless despite having worked the land for years; they have been made economic refugees by encroaching agribusiness, which is degrading their water quality. Worse, it is now illegal for them to live where they do, for it was made a national park some years ago. Sheikh at first suspected that their lives would be further marginalized with their relocation—another exile. But, because of conservationists' efforts, the people of Grande Sertão Veredas will receive clear title to tillable land outside the park.

Annie Leibovitz, having decided to photograph the Conservancy site closest to her weekend home in upstate New York,

has taken perhaps the most unexpected images of the project. Best known as the essential portraitist of today's cultural pantheon of the talented, powerful, fashionable, and beautiful, she chose to forgo both the usual style of her portraiture and any human subjects. Instead, her pictures of the Shawangunk Mountains are remarkably like the landscapes of nineteenth-century Hudson River School painting, even though they are in black and white. They show us a sublime, powerful, and accessible natural world, whether the point of view is level with the hulking form of a boulder lying deep inside the forest, or a bird's-eye perspective provided by a helicopter.

In choosing black-and-white film, Leibovitz avoided the easy criticism that color is too beguiling. Yet her monochromatic landscapes are not without visual values, bathed as they are in silvery shades of light grays and velvet blacks. For precedents in her own work, one can look to her series on the White Oak Dance Project, a collaboration of Mark Morris and Mikhail Baryshnikov, which she took on Cumberland Island, Georgia. There the allure of the natural world was present but primarily in the background; in her pictures of the Shawangunk Mountains it takes center stage and mounts its own performance.

Taken together, the work done by the twelve photographers of *In Response to Place* demonstrates the remarkable resourcefulness of these contemporary artists. All ventured into the project without any guarantees that they could create coherent responses on demand, but all responded with pictures that illuminate and challenge our ideas about how best to depict our relationship to natural places. Notably missing from this collection are any pictures based on the conventional norms of nature photography, which is to say that these pictures have little in common with standard calendar pictures or with images from monthly magazines that seem content to make beautiful places look beautiful. There are no close-ups of butterfly wings, no liquid sunsets, no leaping jaguars. The stereotypes of nature photography are, by definition, already familiar and therefore powerless to move us. The pictures in *In Response to Place* aspire to something different; they try to locate beauty on their own terms, however personal and idiosyncratic.

Place matters. So does art, which is one product of human existence that exalts our connectedness to nature while doing little damage to it. The pictures here reveal, through the filter of individual style, the character of their places and the character of their makers. Like all works of art, they offer us a fresh, uncommon experience that provides us with a new way of looking at the world. But they also serve to confirm what we may already have had reason to believe: that human beings and the natural world are intertwined in art as well as in life.

1. "I become a transparent eyeball. I am nothing. I see all." Ralph Waldo Emerson, "Nature," in *Ralph Waldo Emerson: Selected Essays* (New York: Penguin, 1982), p. 39.

2. "Culture is usually understood to be what defines place and its meaning to people. But place equally defines culture," the cultural critic Lucy Lippard has written. Lippard, *The Lure of the Local* (New York: The New Press, 1997), p. 11.

3. Art critic Dave Hickey has written specifically of the landscape's rootedness in culture: "The practice of describing nature by picturing the noncultural wilderness within a frame, from the perspectival view of a human individual . . . is the specific, indigenous product of Northern Europe's Protestant diaspora after the dawn of the Enlightenment. . . . [W]e need to remember that the practice of picturing the landscape is rigorously bounded in time and space. . . ." In "Shooting the Land," *The Altered Landscape* (Reno: University of Nevada Press, 1999), pp. 25–26.

4. Michael Lewis, "The American Landscape," *The New Criterion*, vol. 18, no. 8 (April 2000), p. 5.

5. Artists included in "New Topographics" were Robert Adams, Lewis Baltz, Bernd and Hilla Becher, Joe Deal, Frank Gohlke, Nicholas Nixon, John Schott, Stephen Shore, and Henry Wessel, Jr. The exhibition was organized by William Jenkins at the International Museum of Photography, George Eastman House. See the catalogue *New Topographics: Photographs of a Man-Altered Landscape* (Rochester: George Eastman House, 1975).

WILLIAM WEGMAN

COBSCOOK BAY, MAINE

THIS WAS A NEW ADVENTURE FOR ME. I GO TO MAINE every summer, but usually to the western mountains. Cobscook Bay is in the east. I found it confusing at first. It is mountainous and flat, still and tumultuous. It has incredible rock formations, water patterns, kelp, grasses, and driftwood. Everywhere I turned I noticed something.

In the end, the dogs pointed the way. They love going to new places, and I knew they would be interesting photographically in a natural environment. They reflect light and change wherever they seem to be. I live vicariously through them. When they check out a place, I absorb it through them.

During our day, two of the dogs got stung by bees. They rolled around like they were having a fit. Later, another dog got quilled by a porcupine. But they had fun. I did too. I first went to Maine when I was fourteen years old. That was the most memorable trip of my life. I found out then that Maine is a dream place. —w.w.

HARD ALONG THE CANADIAN BORDER IN DOWNEAST MAINE, Cobscook Bay is a shallow estuary known for its twenty-foot tides, an echo of those in the famous Bay of Fundy nearby. The rhythms of life here, both marine and human, are long adapted to the pull of the tides and the strength of the currents.

Of all the estuaries on the Atlantic seaboard, Cobscook remains, by some biologists' estimates, the most ecologically intact. Beneath its clear, cold waters lies an intricate web of marine life, from common and commercially important species like green urchins and blue mussels, clams and scallops, to the fanciful—red anemone, the hydroid, and the ribbon worm. The range and diversity of the bay's life is extraordinarily rich for the north Atlantic coast.

Like other estuaries in the Gulf of Maine system, Cobscook has been fished for generations. Along its two hundred miles of convoluted coastline live some seven thousand people, their fishing economy and way of life tied directly to the bay. Few in number, they have used the place gently, and Cobscook has escaped the degradation that coastal and industrial development has brought to many other estuaries. Despite the bay's abundant marine life, however, it is a hard living, made even harder these days by the intense competition for the sea's dwindling harvests—a competition spawned by the rising demand for seafood around the globe. Cobscook's is still a productive fishery, but because it remains unmanaged, its wealth is in danger of being overharvested.

With an ambitious goal to conserve the biological diversity and productivity of Cobscook Bay, The Nature Conservancy has ventured into the uncharted waters of marine conservation. One of the biggest challenges at Cobscook, as with other coastal systems, is the lack of data on the complex interactions among species and the ecological processes that sustain them. Even basic numbers, like those estimating the populations of commercial species and the threshold for sustainable harvests, are not known. Understanding the system better and disseminating that knowledge to local fishermen are top priorities for conservation. Fishermen, in turn, are taking the initiative to change scallop management practices and are going all the way to Maine's legislature to do so.

Cobscook Bay is one of our treasured commons—places that cannot be owned as land can, places that we must share and protect for the benefit of both nature and people.

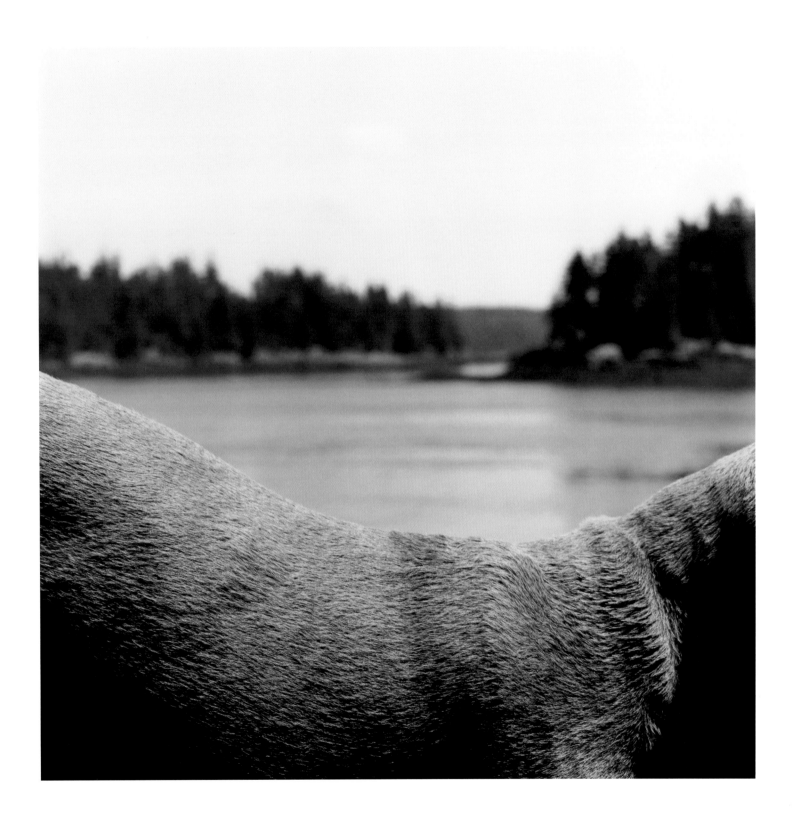

BAY

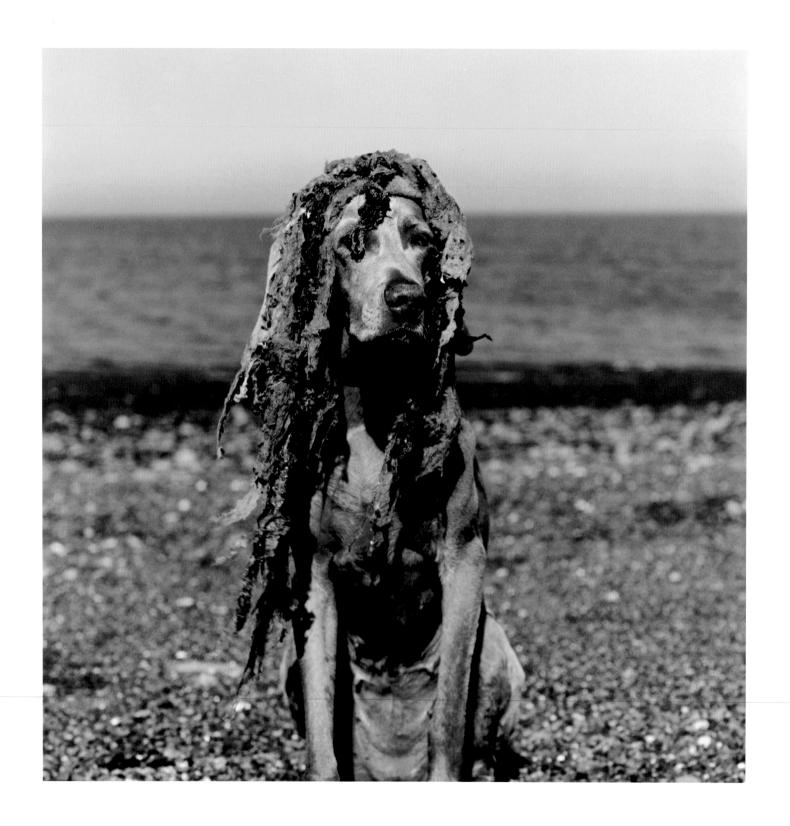

ANDROMEDA

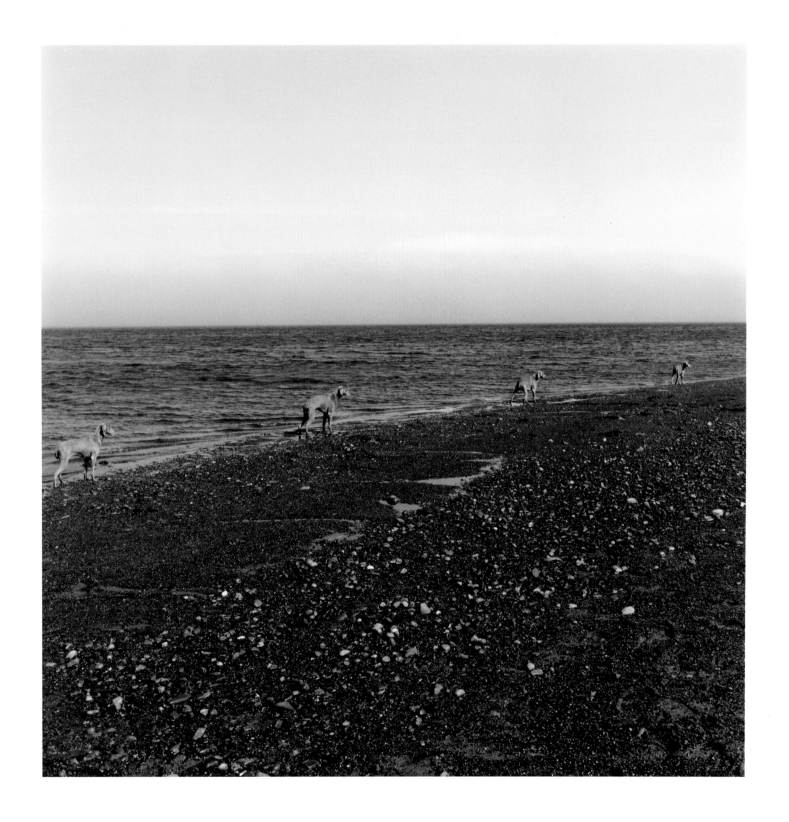

TIDAL

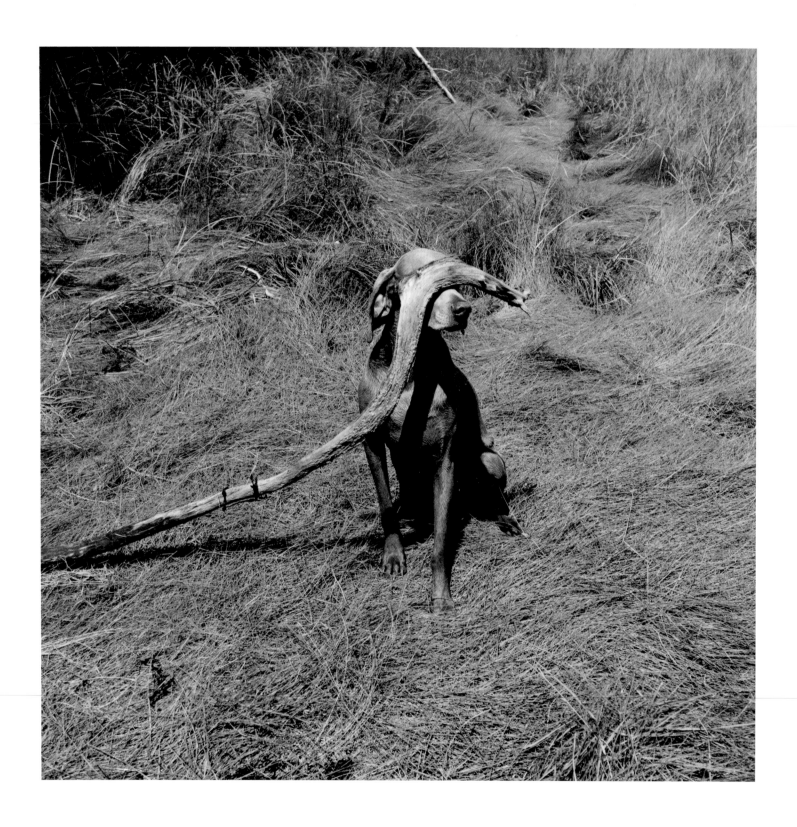

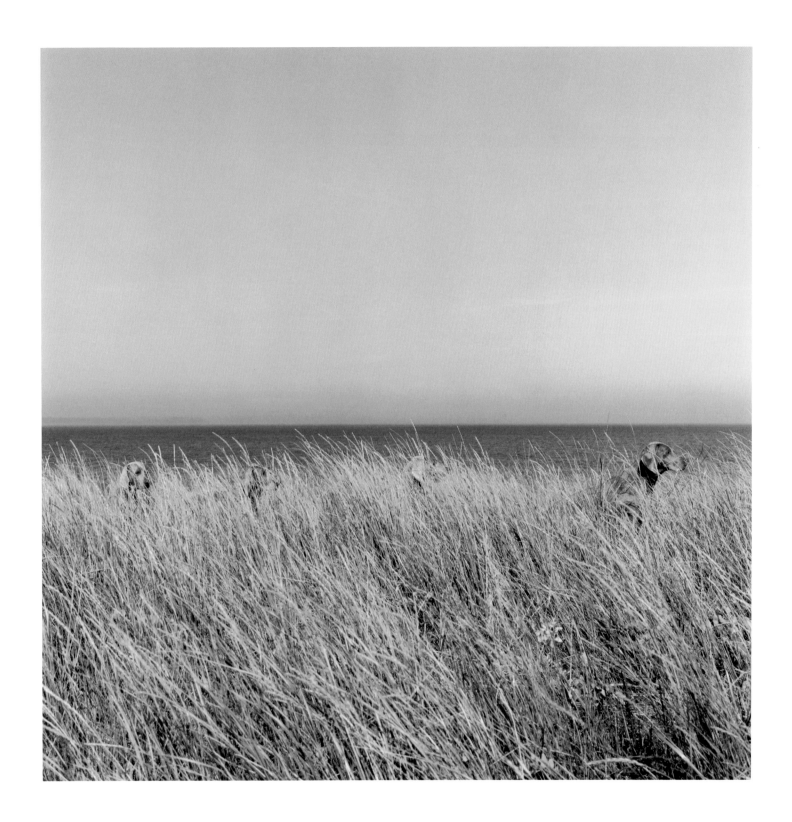

SHORELINE

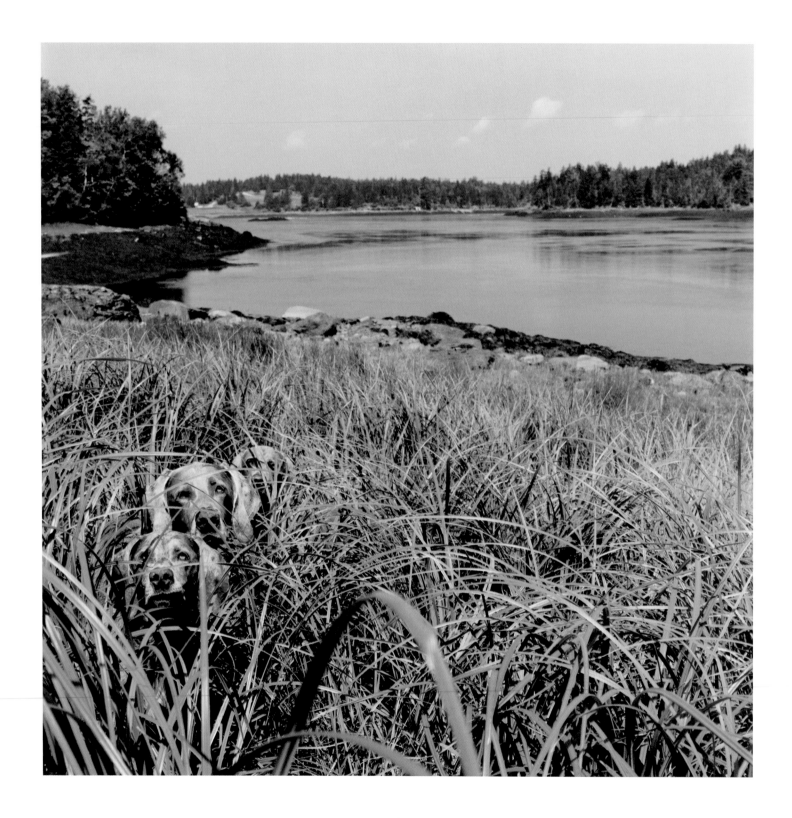

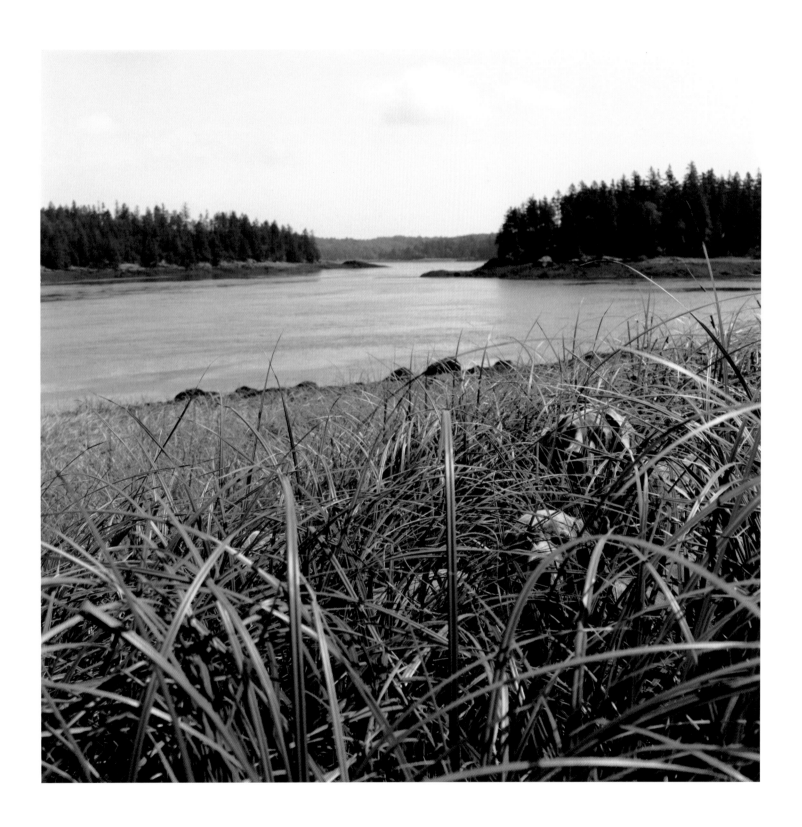

COBSCOOK (DIPTYCH)

31

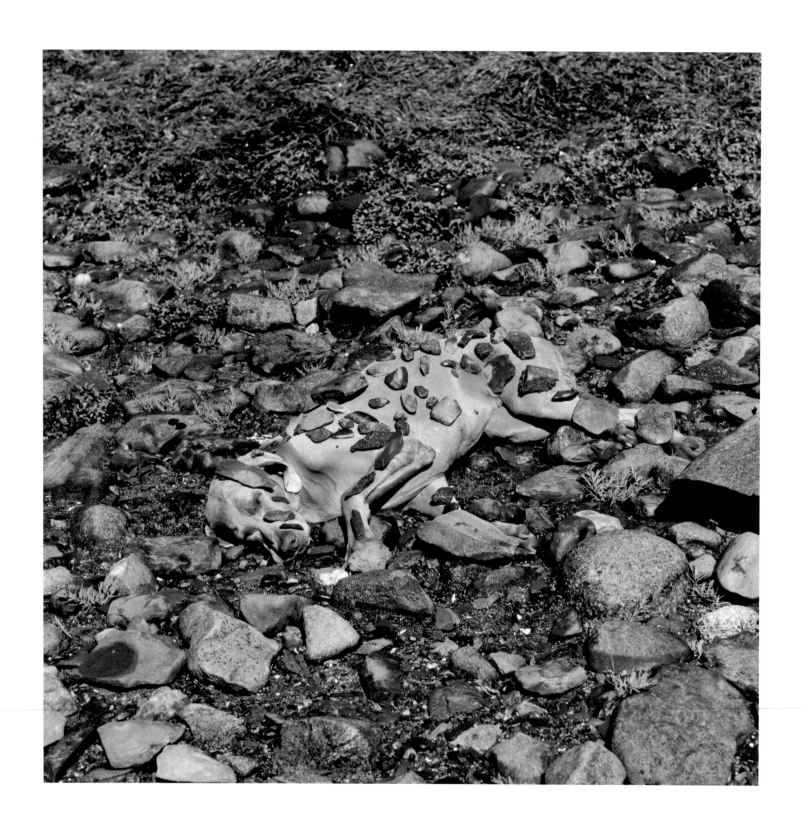

BED ROCK

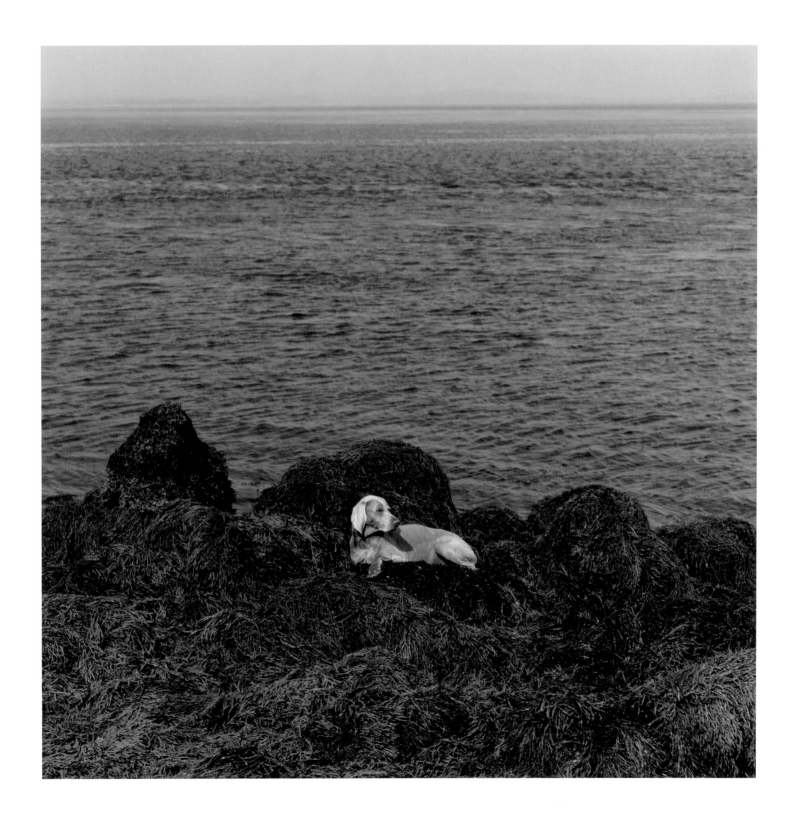

OF THE SEA

33

ANNIE LEIBOVITZ

SHAWANGUNK MOUNTAINS, NEW YORK

SECRETLY, I HAVE ALWAYS LOVED LANDSCAPE PHOTOGRAPHY. It comes out of doing location work for my portraits. I frequently go out into the world with my subjects and use land and horizon lines. I've often wished I didn't have to put people in the picture.

I like the emotion of the land itself. I have always been very drawn to images that express emotion but don't have people in them—for instance, Roger Fenton's photographs of the battlefields of the Crimean War, with their open vistas of rolling hills, their cannonballs on the ground, and no human bodies. They are so evocative of emptiness.

Since I own some property in upstate New York, I went to "the Gunks," as they are called, for this project. I felt obliged to try to better understand my own backyard. The Gunks are actually an extraordinary *hunk*—outcropping—of rock, and I wanted to show the raw bones of it. In some of the pictures it looks like the rocks just fell, when they actually fell thousands of years ago. It's a difficult environment, but nature is so determined that trees grow right through the rock.

It's not easy to take a good picture that can move you in landscape. You're at the mercy of the light, and your work becomes a dance with nature and the weather. But this was a great opportunity to use part of my brain I don't get to exercise enough. And it was different: Nobody was talking back at me.

—A.L.

BETWEEN THE CATSKILLS AND THE HUDSON RIVER, THE SHAWANGUNK Mountains are the northern manifestation of one of the Appalachians' age-old folds—a ridge system extending from New York through New Jersey to the Susquehanna River in Pennsylvania. Initially uplifted and folded about 450 million years ago, the ridge was later sculpted by glaciers—the scouring and tumbling of rocks that look to Annie Leibovitz as if it might have happened yesterday.

The northern Shawangunks are widely recognized as one of the most important sites for biodiversity conservation in the Northeast. Much of the ridge's higher elevations are blanketed with pine barrens communities found nowhere else in the world. Elusive creatures such as timber rattlesnakes and bobcats find haven in the upper reaches of the mountains.

The miles of unbroken forest, rock walls, boulder-strewn trails, and ridgeline views have made the Shawangunks a popular destination for hikers, rock climbers, mountain bikers, and others needing a break from the confines of New York City. More than 500,000 people visit the ridge annually, and such recreational use has become the leading threat to the fragile areas of the ridge. As with other special parts of America's remaining wildlands, the Shawangunk ridge is in danger of being loved to death.

Of all the protected natural areas on the ridge, the Sam's Point Dwarf Pine Ridge Preserve is perhaps the most intact and unfragmented, having only a few hiking trails and old carriage roads crossing it. Using a new framework developed by the National Park Service, The Nature Conservancy has designed a visitor management program aimed at protecting the preserve's biodiversity while allowing recreation to continue. It is also creating an education and outreach plan intended to engage the public in research and in taking care of the preserve, for the Conservancy, like the Park Service, knows that visitors are the strongest protectors of the natural areas they love.

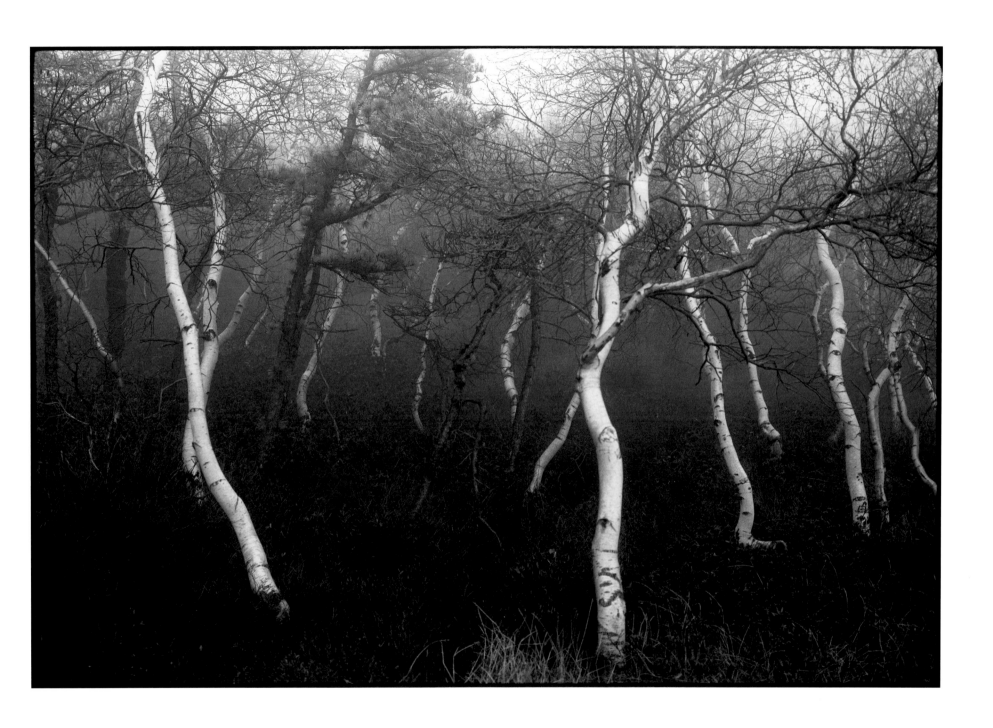

PITCH PINES AND GRAY BIRCH IN THE DWARF PINE RIDGES. SAM'S POINT DWARF PINE RIDGE PRESERVE, ELLENVILLE, NEW YORK

35

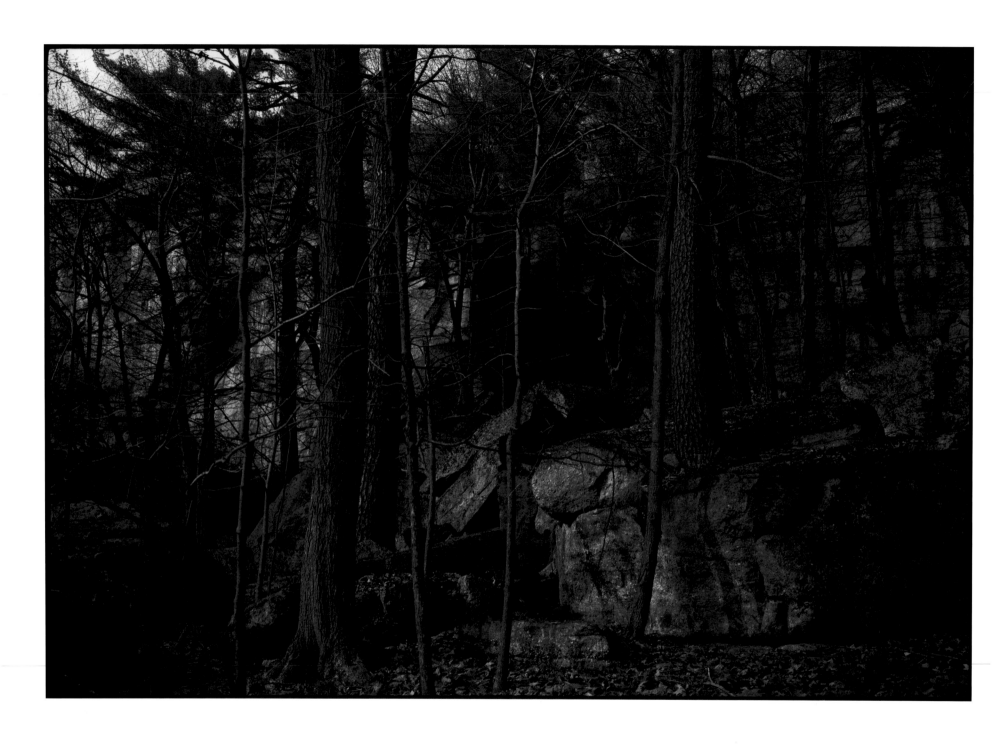

CHESTNUT OAK FOREST, TALUS SLOPE COMMUNITY. SAM'S POINT DWARF PINE RIDGE PRESERVE, ELLENVILLE, NEW YORK

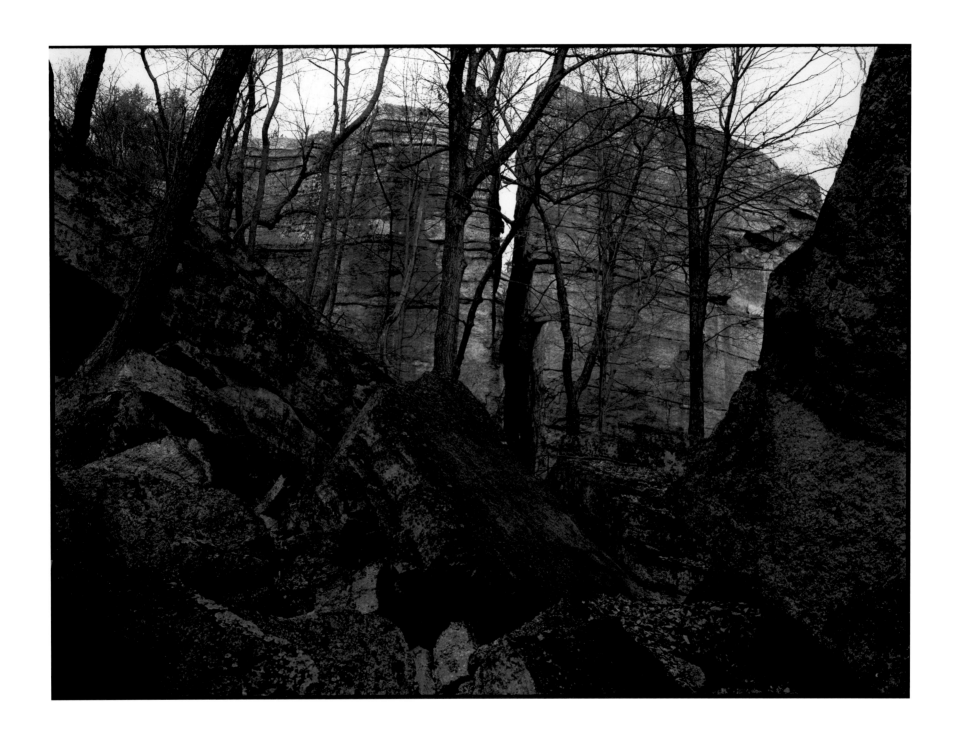

BEDROCK FRACTURING IN THE SHAWANGUNK CONGLOMERATE CLIFFS. SAM'S POINT DWARF PINE RIDGE PRESERVE, ELLENVILLE, NEW YORK

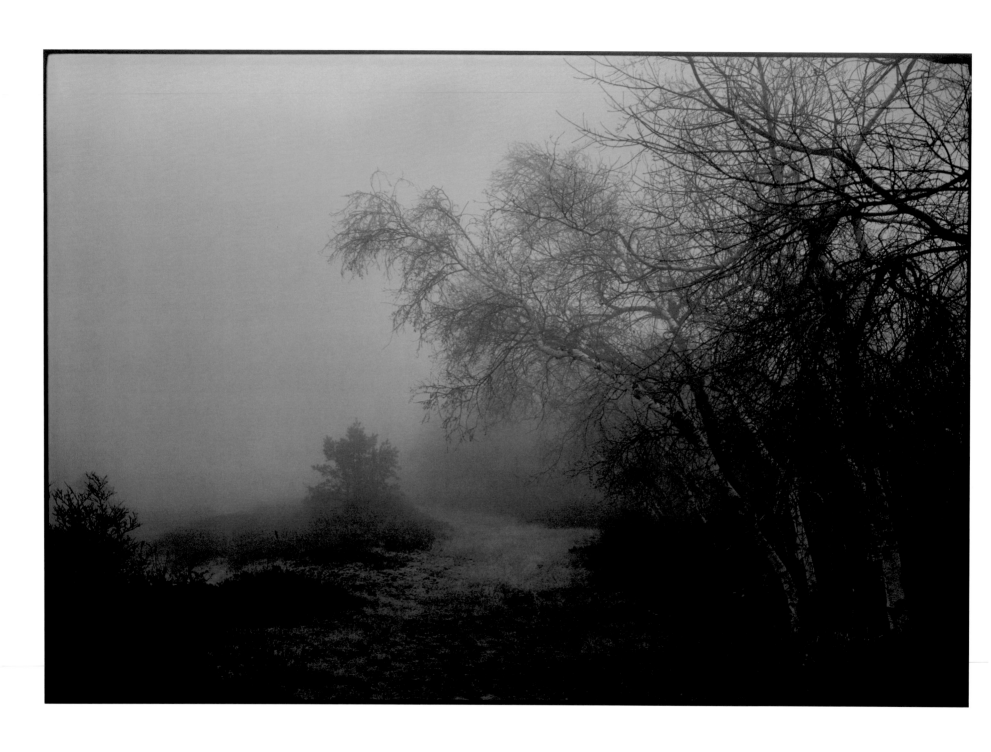

SPARSELY VEGETATED BEDROCK SLABS. LAKE MARATANZA, SAM'S POINT DWARF PINE RIDGE PRESERVE, ELLENVILLE, NEW YORK

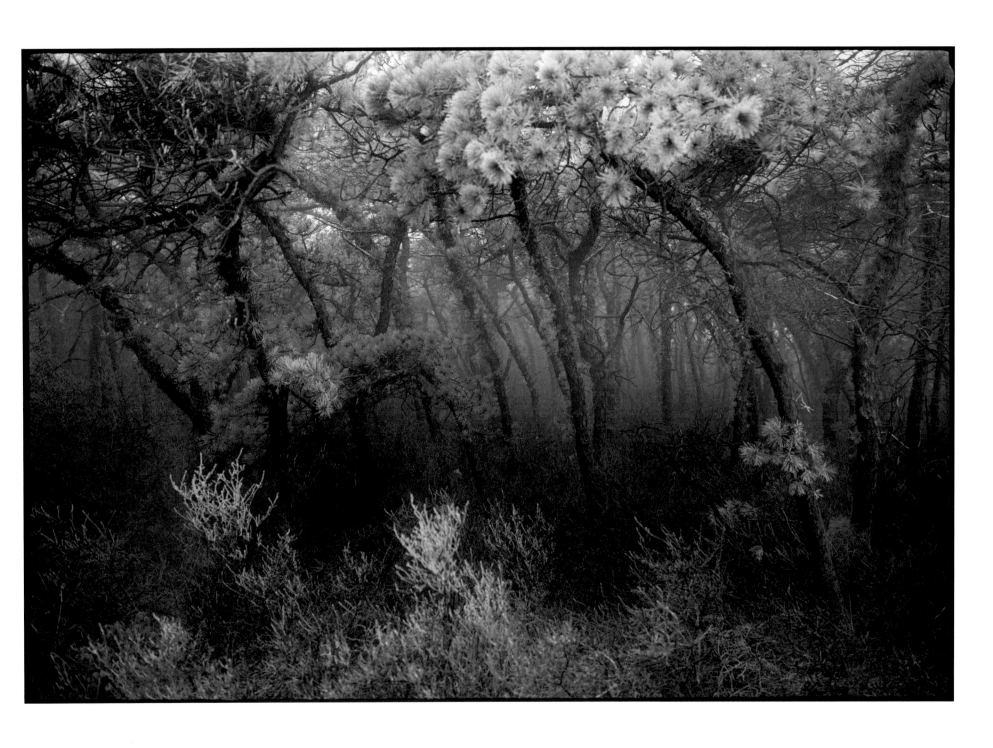

FROSTY, ICE-COATED PITCH PINES IN THE DWARF PINE RIDGE. SAM'S POINT DWARF PINE RIDGE PRESERVE, ELLENVILLE, NEW YORK

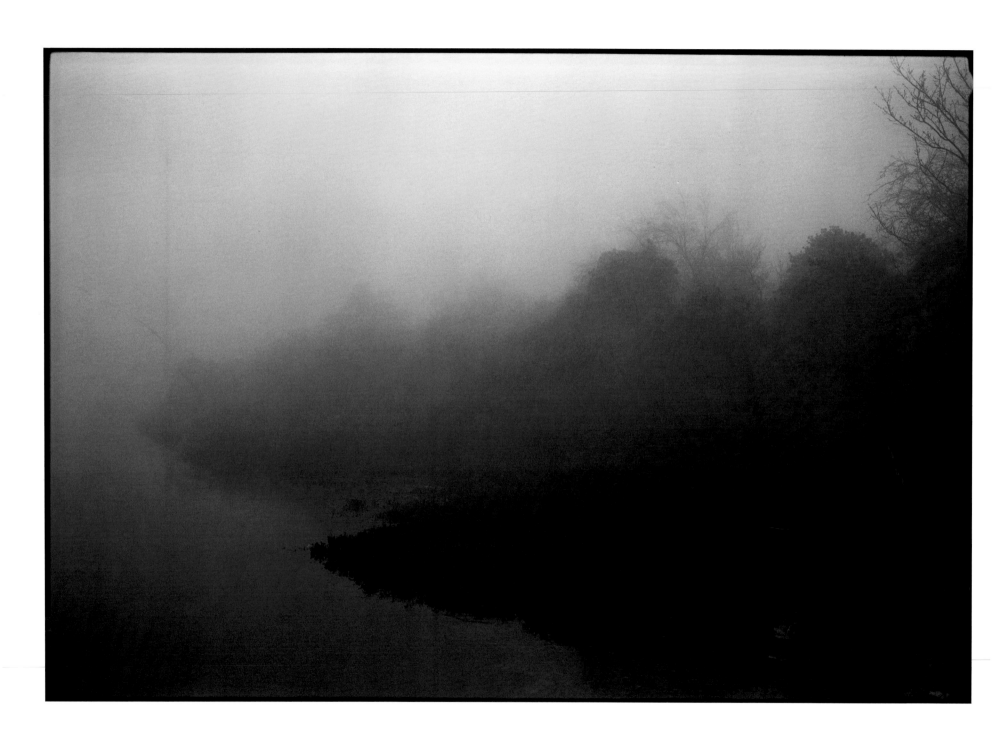

LAKE MARATANZA. SAM'S POINT DWARF PINE RIDGE PRESERVE, ELLENVILLE, NEW YORK

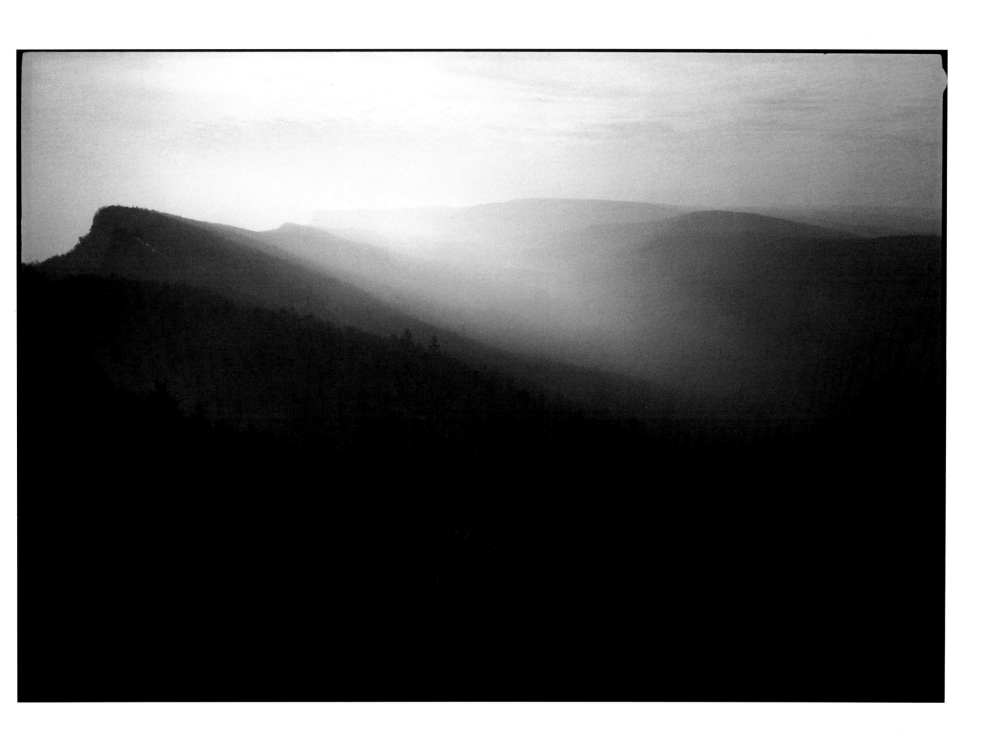

LOOKING SOUTH AT THE TRAPPS AND CLOVE VALLEY. MOHONK PRESERVE, SHAWANGUNK MOUNTAINS, NEW YORK

41

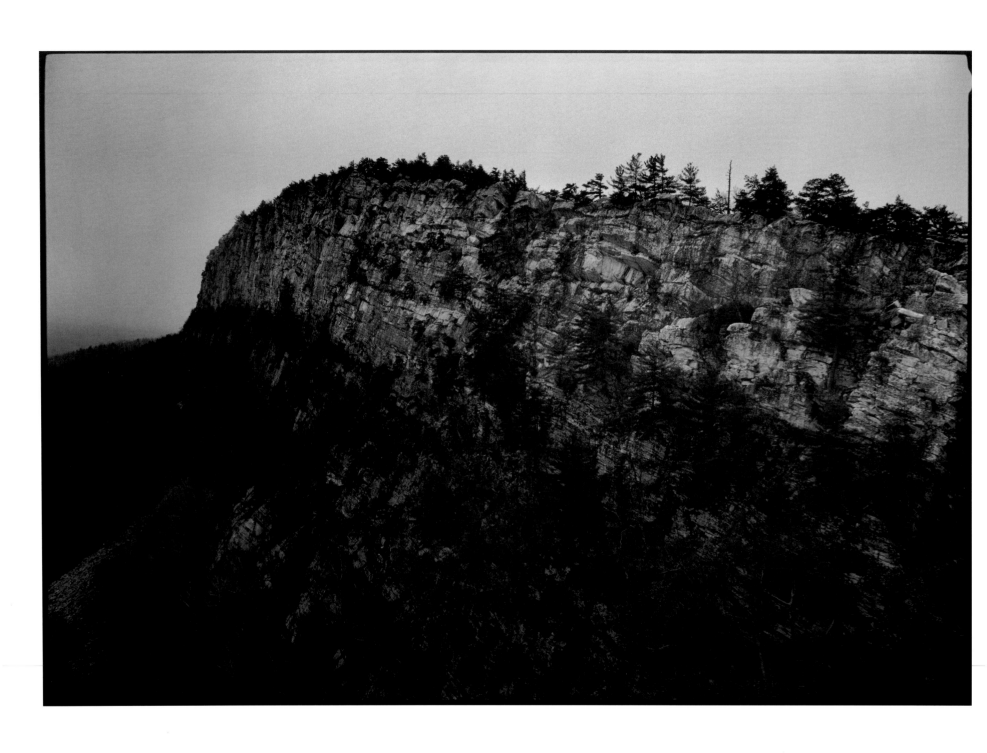

THE SHAWANGUNK CONGLOMERATE CLIFFS. MILLBROOK MOUNTAIN, GARDINER, NEW YORK

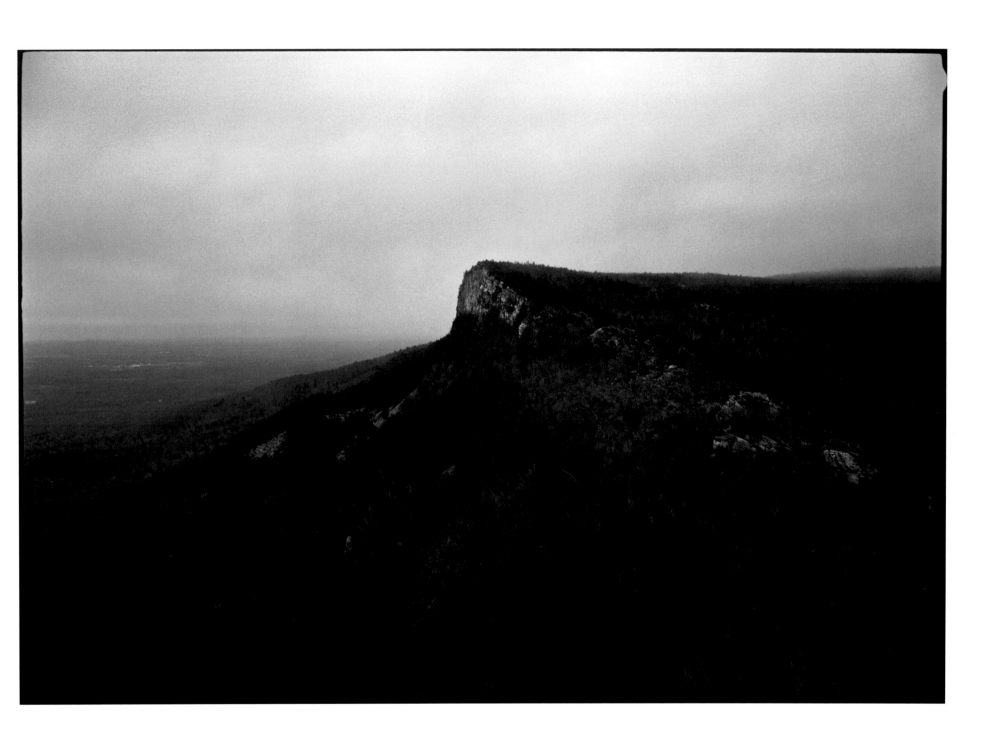

THE SHAWANGUNK CONGLOMERATE CLIFFS. MILLBROOK MOUNTAIN, GARDINER, NEW YORK

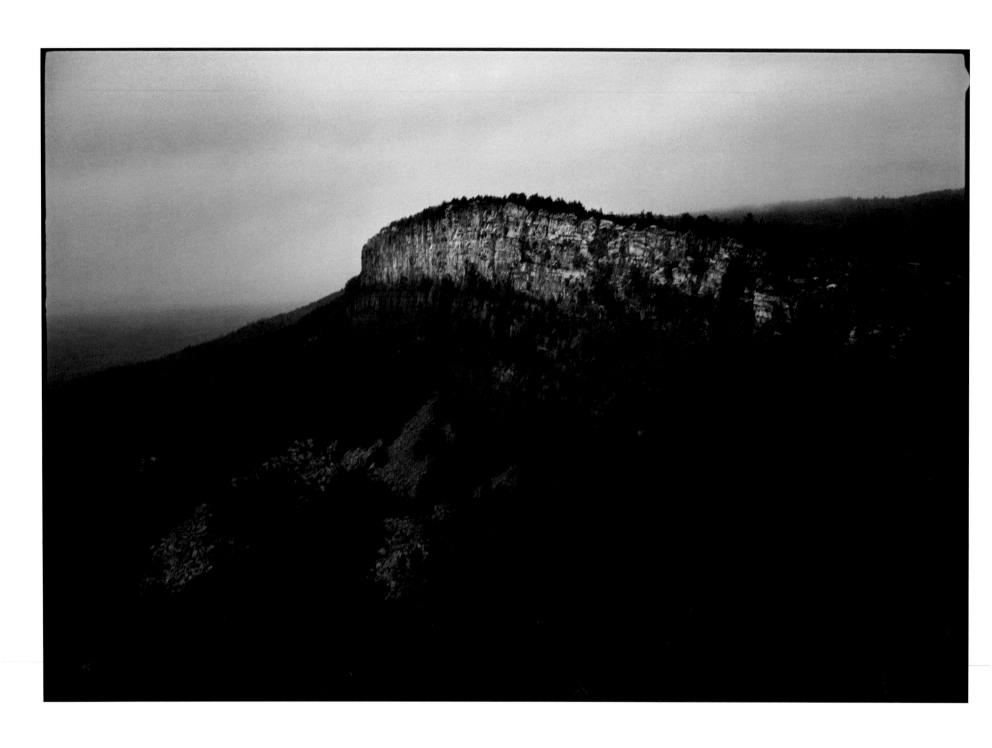

THE SHAWANGUNK CONGLOMERATE CLIFFS AND TALUS FIELDS. MILLBROOK MOUNTAIN, GARDINER, NEW YORK

44

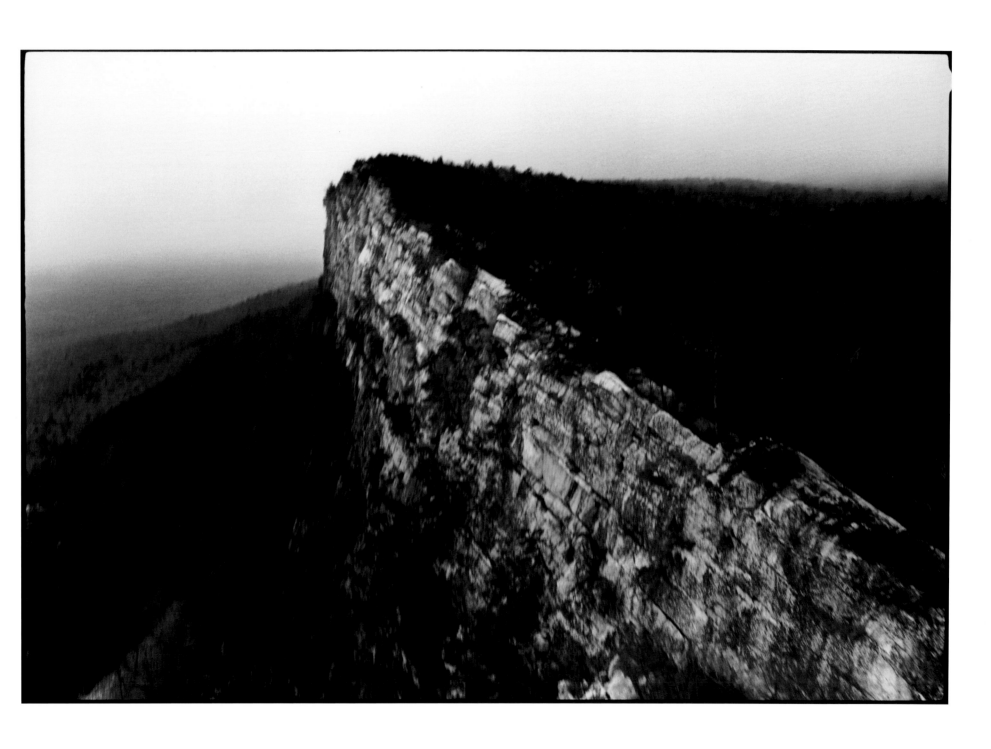

MILLBROOK MOUNTAIN (WHERE THE PEREGRINE FALCON EYRIE IS). MILLBROOK MOUNTAIN, GARDINER, NEW YORK

MARY ELLEN MARK

PRIBILOF ISLANDS, ALASKA · EASTERN SHORE, VIRGINIA

I ALWAYS PHOTOGRAPH PEOPLE AT THE FARTHEST REACHES.

The Pribilof Islands are so austere and barren, very strange and beautiful. There were wild foxes running around, and the landscape is flat with big cliffs that overlook the sea. It was the Fourth of July, and people waved flags, and the supermarket was a great bazaar. The kids were out swimming in the water, even though it was ice-cold. It was like a place you have never seen before.

The Virginia coast could not be farther away from the Pribilofs. There are thousands of miles between, yet both are America. People think of America as pretty much the same, and it's not.

On the Virginia coast, it's like time stopped. It's a very strange aspect of America that I love to photograph. Through this really wonderful woman, I was able to look into a small, closed, African-American community and even get into a church service, which was very beautiful.

In the Pribilofs, I felt isolated and remote. I think the pictures have that sense of remoteness and austerity about them. Whereas in Virginia, it was just so warm and I felt more at home, and the pictures reflect that. —M.E.M.

THE PRIBILOF ISLANDS OF ALASKA, IN THE BERING SEA NORTH OF the Aleutian archipelago, and the Atlantic barrier islands and mainland peninsula of the Virginia coast lie on opposite edges of America. They are separated by extremes of distance, climate, and culture. Yet both are bound together by more than the storms and solitude of the sea around them. They are places of natural abundance and diversity, their productive ecosystems intimately tied to the people who inhabit them.

Known as the Galapagos of the North, the Pribilofs are home to some of the largest breeding colonies of marine birds and mammals in North America—northern fur seals, thick-billed murres, endangered sea lions, and whales. The barrier islands and salt marshes of the Virginia Eastern Shore comprise the East Coast's last great coastal wilderness, a hundred-mile-long respite from oceanside development between Maine and Florida. Here rare and endangered shorebirds such as least terns find haven to nest in the dunes.

Their people are, as Mary Ellen Mark observes, living at the edges. Both of these water-bound communities have seen the collapse of once-lucrative fisheries, the king crab in the Pribilofs, and the blue crab and oyster on the Virginia coast. Prospects for the future—for keeping culture and community intact—hinge on the recovery and protection of the natural systems.

In both the Pribilofs and the Virginia Eastern Shore, as in many other places, the essence of The Nature Conservancy's work has been to build on the bonds between people and their lands and waters. Conservation can and will happen if the connections among vibrant economies, communities, and ecological systems are apparent and strong.

Environmental education has been a fundamental aspect of the conservation work in both places. The Pribilof Islands Stewardship Program engages Alaska Native youth in efforts to rescue fur seals from fishing debris, monitor shorelines, aid in invasive species control, and learn of their natural heritage from Aleutian elders and marine biologists. In Virginia, a Conservancy-led program brings mainland families and communities to the barrier islands, just offshore yet a world away and unknown to most. Often, visits unleash stories and memories of what the world of the shore was like generations ago, reconnecting a new generation with the cultural ties that bind them to place.

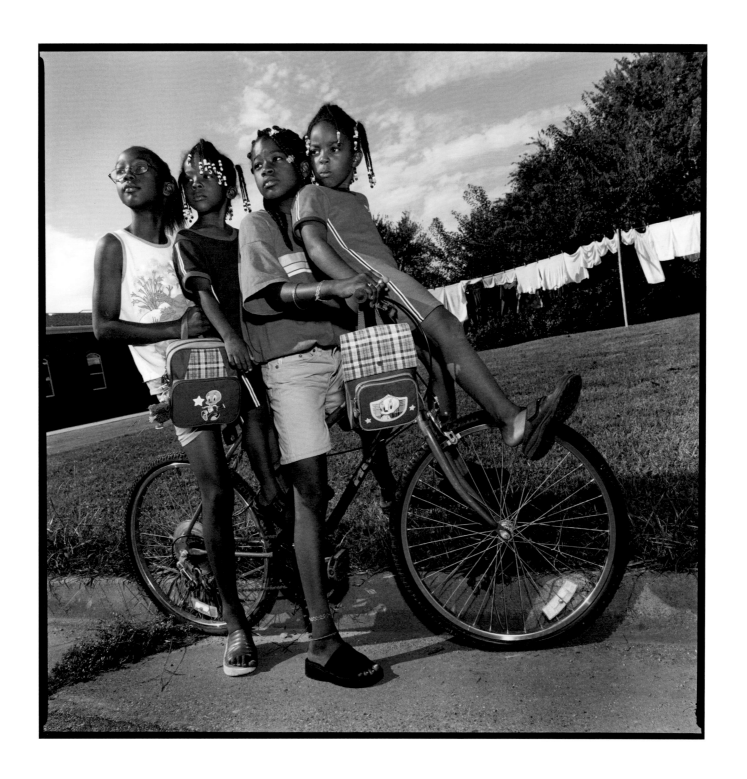

PEACHES, CARISSA, KEE KEE, AND MELISSA, CAPE CHARLES, VIRGINIA

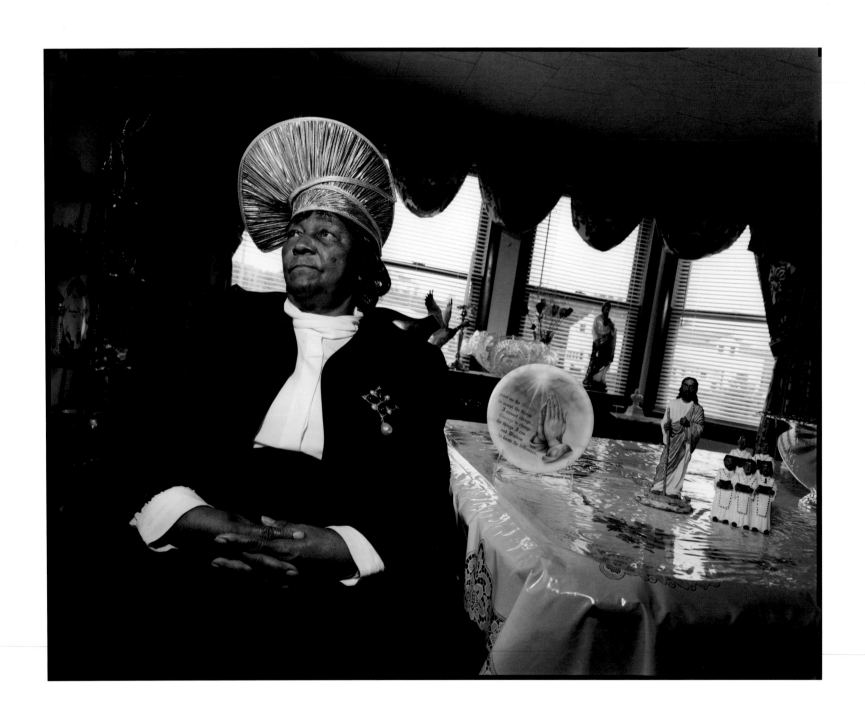

ELDER HELEN O'GILLIS, GREATER MT. SINAI GOSPEL TABERNACLE, CAPE CHARLES, VIRGINIA

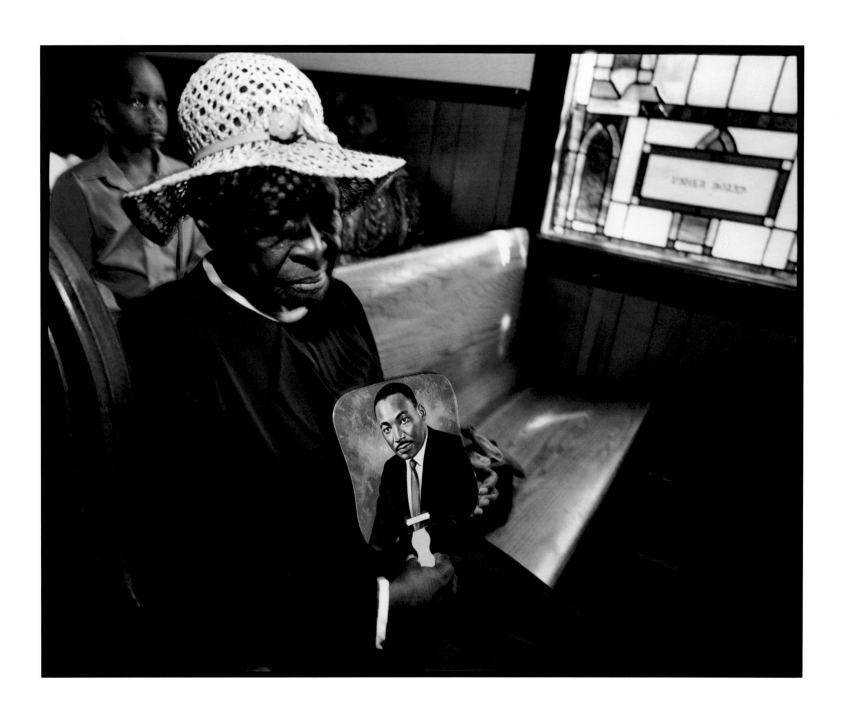

LILLIE MAE LISTER, GREATER MT. SINAI GOSPEL TABERNACLE, CAPE CHARLES, VIRGINIA

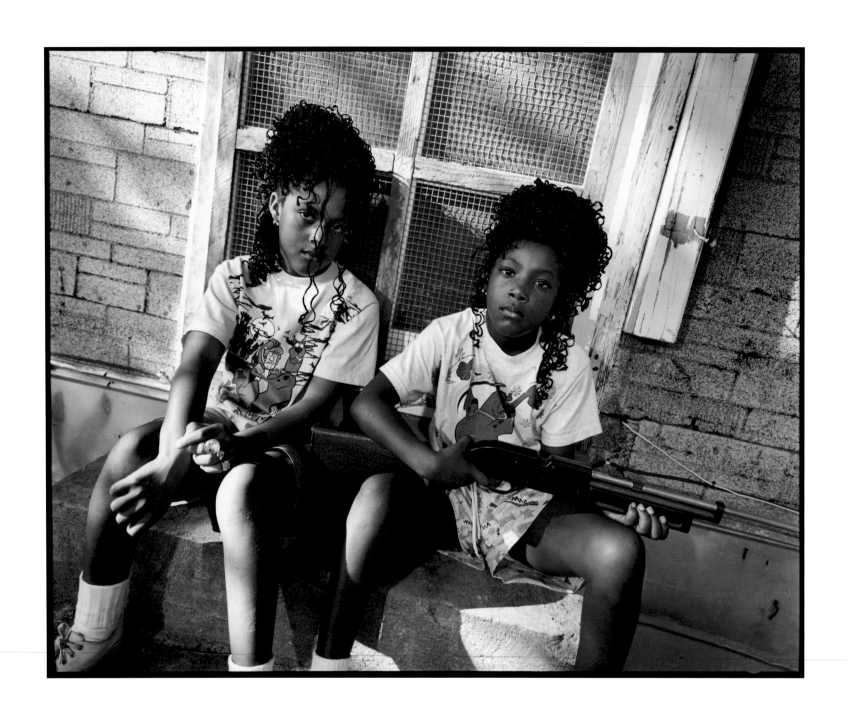

DAKEITTA AND COURTNEY SAMPEL, BAYVIEW, VIRGINIA

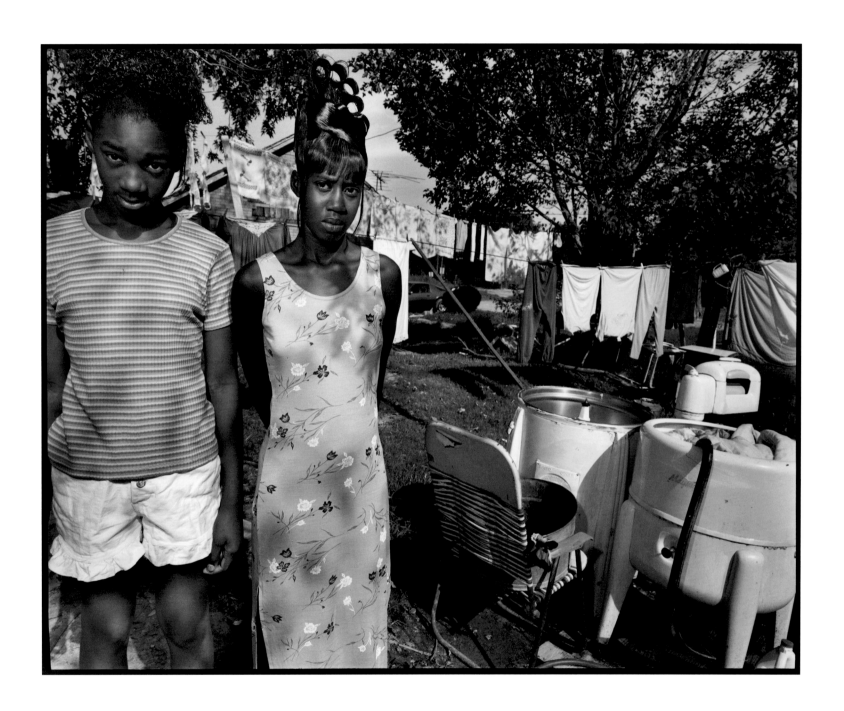

TAQUITA WALTON AND SHYKEA BENTON, BAYVIEW, VIRGINIA

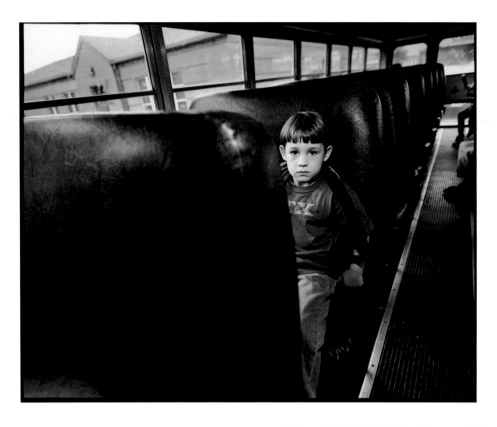

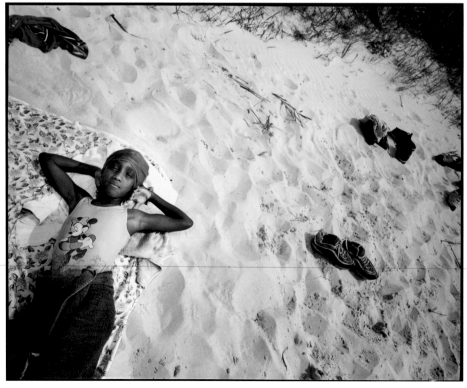

KIPTOPEKE ELEMENTARY SCHOOL BUS, CAPE CHARLES, VIRGINIA; BEACH AT CAPE CHARLES, VIRGINIA

52

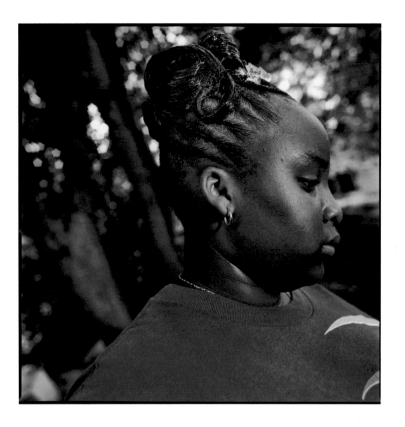

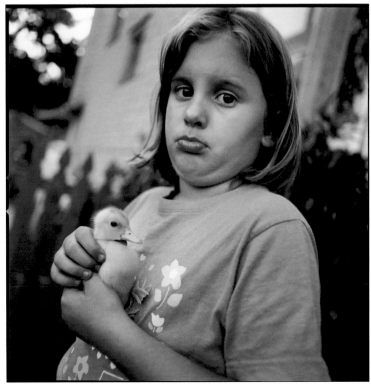

NICOLE DUNCAN WITH DONALD DUCK, CAPE CHARLES, VIRGINIA; JAMIE JOHNSON, BAYVIEW, VIRGINIA

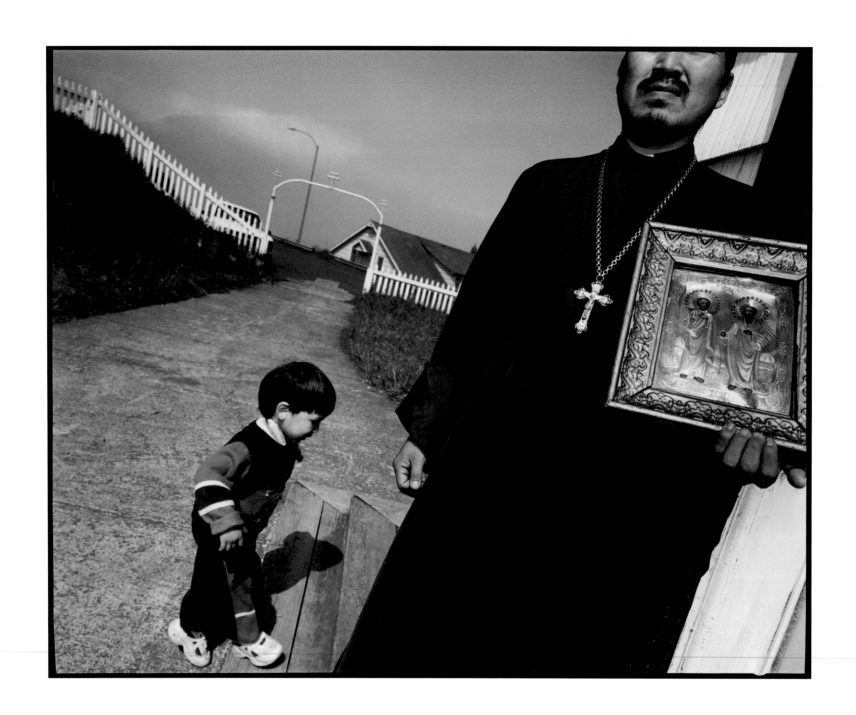

FATHER GEORGE BEREZKIN AND HIS SON, SAINT PAUL ISLAND, PRIBILOF ISLANDS, ALASKA

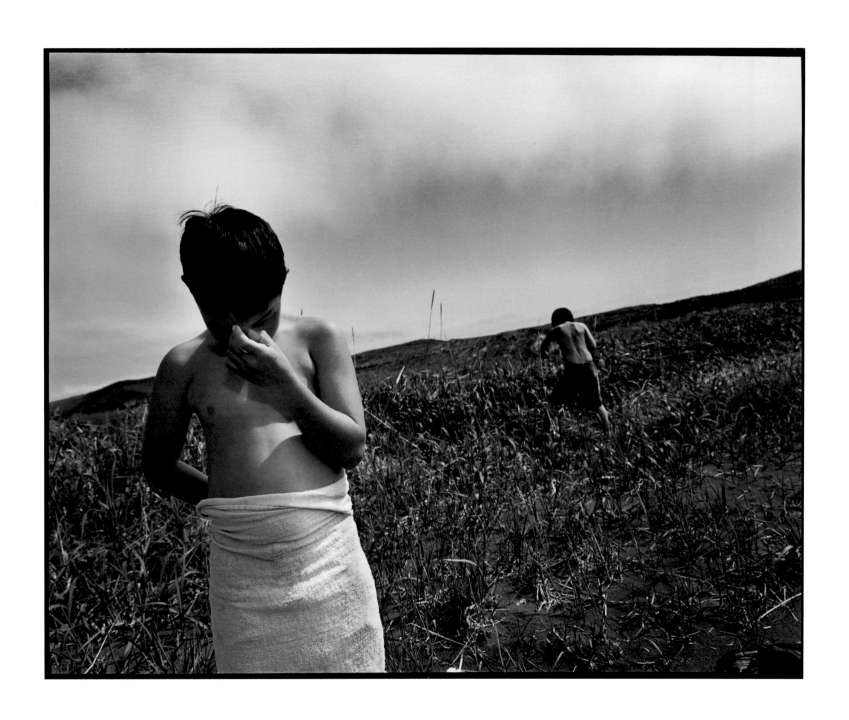

SWIMMER ON A WARM DAY, SAINT PAUL ISLAND, PRIBILOF ISLANDS, ALASKA

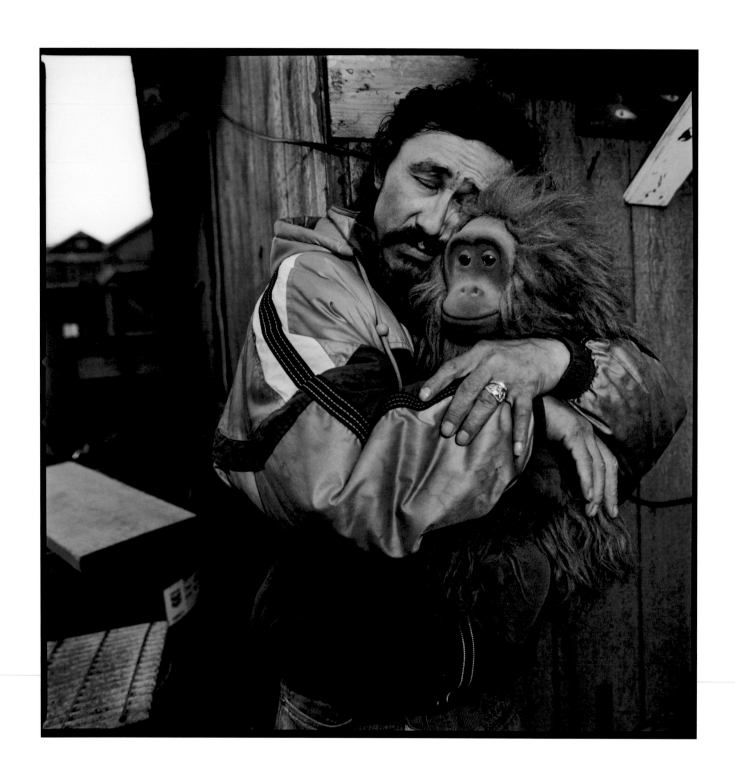

MAN AND HIS BELOVED TOY MONKEY, SAINT PAUL ISLAND, PRIBILOF ISLANDS, ALASKA

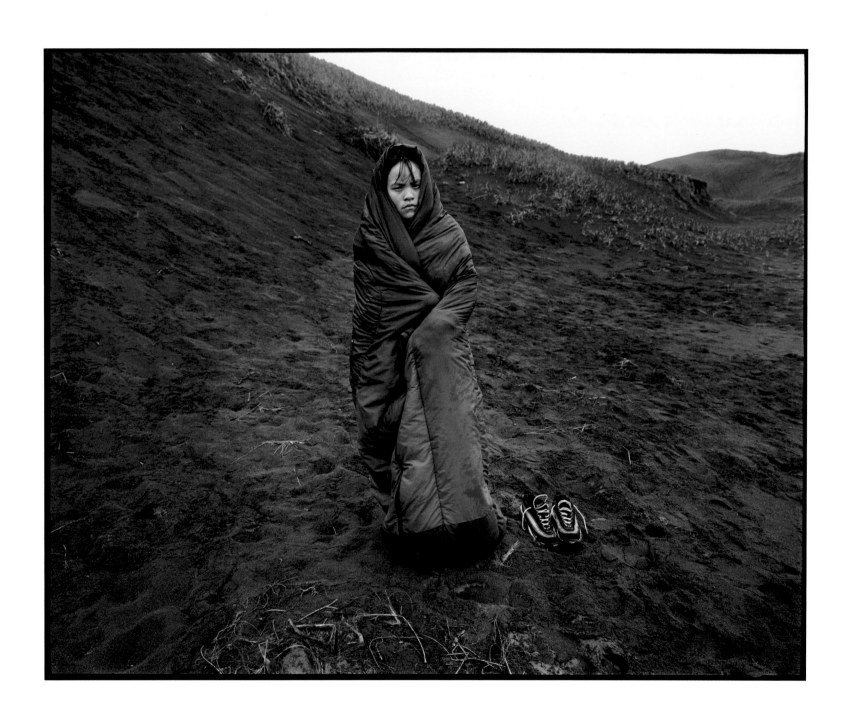

COLD SUMMER DAY, SAINT PAUL ISLAND, PRIBILOF ISLANDS, ALASKA

WILLIAM CHRISTENBERRY

CAHABA RIVER AND BIBB COUNTY GLADES, ALABAMA

ALL OF MY WORK—WHETHER PAINTING, SCULPTURE, OR photography—deals with my affection for the place I am from, Alabama. More and more, I have been focusing on the open landscape, with little man-made on it. Once I heard about the Bibb County Glades, I knew I had to go there.

Back home in Tuscaloosa, where I am from, we have the Black Warrior River, which is sluggish and abused though still beautiful in parts. But it is not a flat, fast-moving river like the Little Cahaba.

The glades are quite special, yet people will say of such a place, "What do you *see* here?" But to me, it's not so much what you see as what you *feel* about the place—its age, its openness, the Native Americans who once knew the place. It's that feeling that you hope will come through the camera and through you as the photographer.

Whenever someone asks why I always photograph in Alabama, I have to answer that, yes, I know there are other places, but Alabama is where my heart is. It's what I really care about. —W.C.

FROM THE FOOTHILLS OF THE APPALACHIANS TO THE GULF COASTAL plain, the Cahaba River flows for 190 miles through the heart of Alabama, one of the nation's hot spots of biological diversity. Its landscapes are places of which people might indeed ask, "What do you *see* here?" Yet the Cahaba's is a remarkable journey, for those 190 miles through what might be considered ordinary terrain harbor one of the country's most extraordinary concentrations of rare and diverse species.

While canoeing the Cahaba one day in 1992, botanist Jim Allison identified at Bibb County Glades eight plant species new to science, a botanical discovery comparable to legendary finds in the tropics. The bedrock outcrops of the glades open the rolling hardwood and longleaf pine forests to the sky, the Ketona dolomite so potent in magnesium that its soils are toxic to trees. These natural prairies, an hour's remove from Birmingham, somehow escaped the quarrying of dolomite that elsewhere fueled Alabama's steel industry.

The state's rivers were not so spared. In the Mobile River basin alone, thirty-three dams have eclipsed more than a thousand miles of free-running rivers, contributing to almost half of all documented extinctions in the United States since European settlement. This is a story told over and over throughout the Southeast, home to the nation's most threatened freshwater systems and aquatic species.

The Cahaba, however, is a brilliant star in the constellation of imperiled southern rivers. Still free-flowing, its waters support 131 species of fish, more than any river its size in North America.

To safeguard the Cahaba, The Nature Conservancy and the Cahaba River Society are working to reduce the farmland erosion and polluted runoff from upstream suburban sprawl that reaches the river. Land donated to the Conservancy by a timber company has become the Bibb County Glades Preserve; another tract of land has become the Cahaba National Wildlife Refuge. And in watersheds throughout the Southeast, the Conservancy is working with dam operators and other river managers to return more natural flows to rivers, seeking to balance human demands for water with the needs of aquatic life.

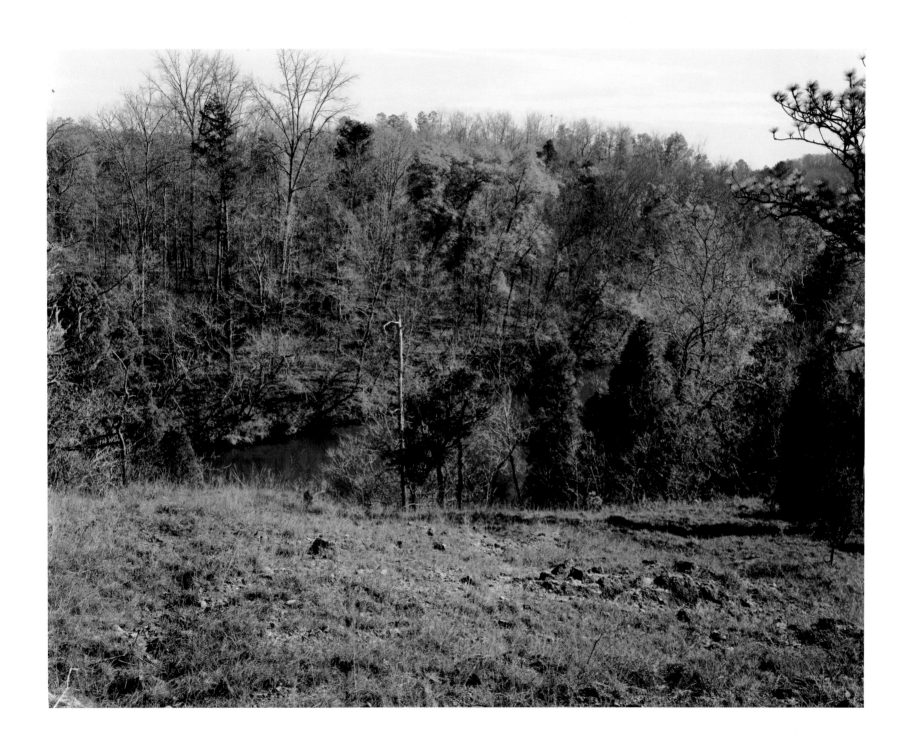

BIBB COUNTY GLADES WITH LITTLE CAHABA RIVER BELOW, DECEMBER

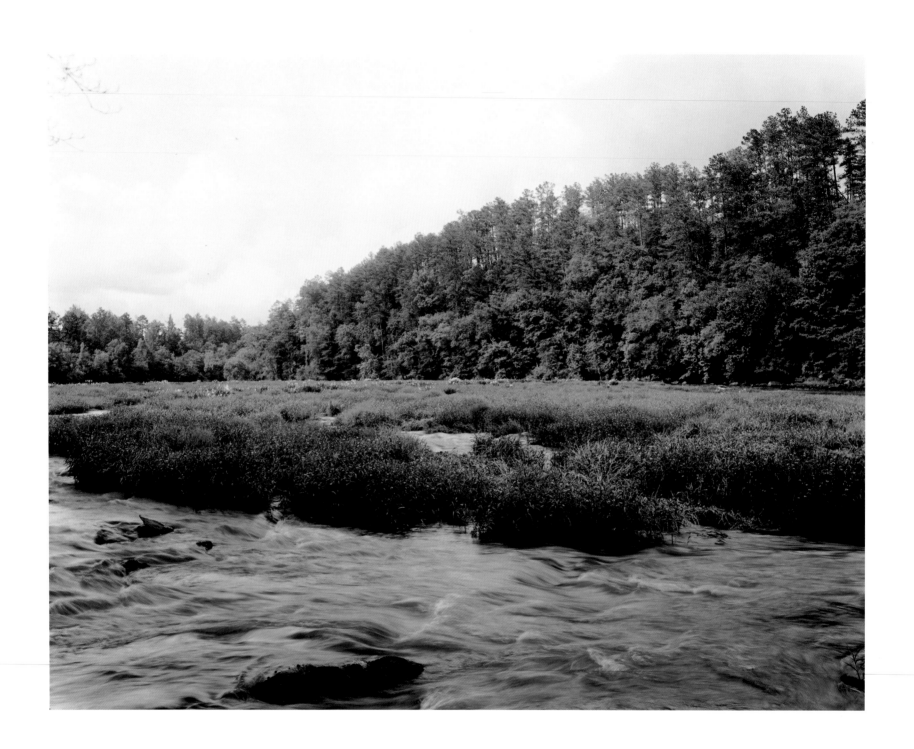

CAHABA LILIES IN BLOOM, JUNE

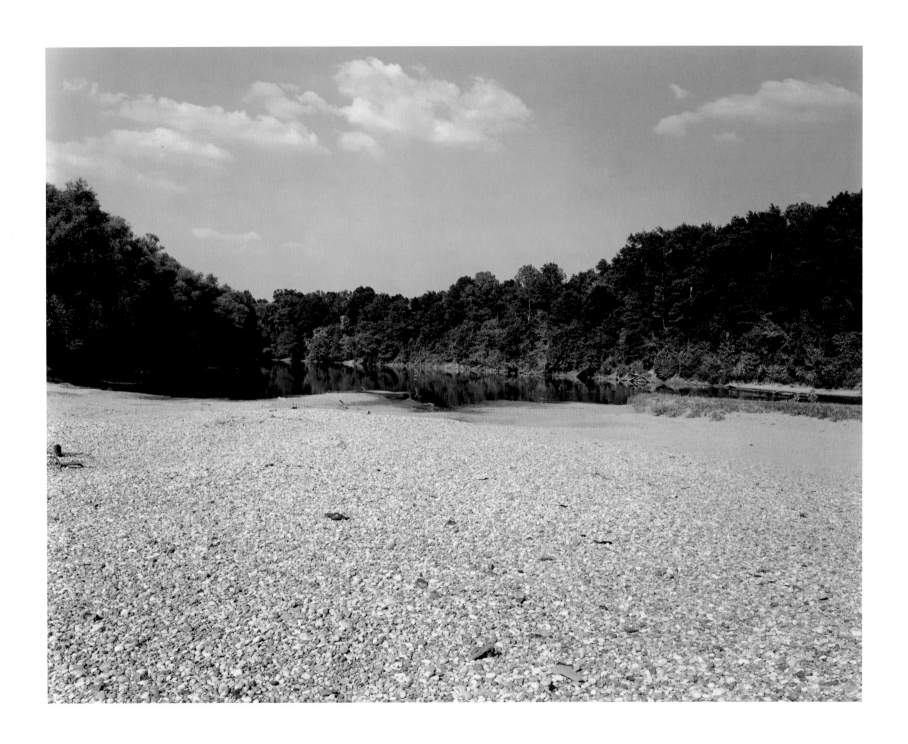

STONE BEACH, CAHABA RIVER, AUGUST

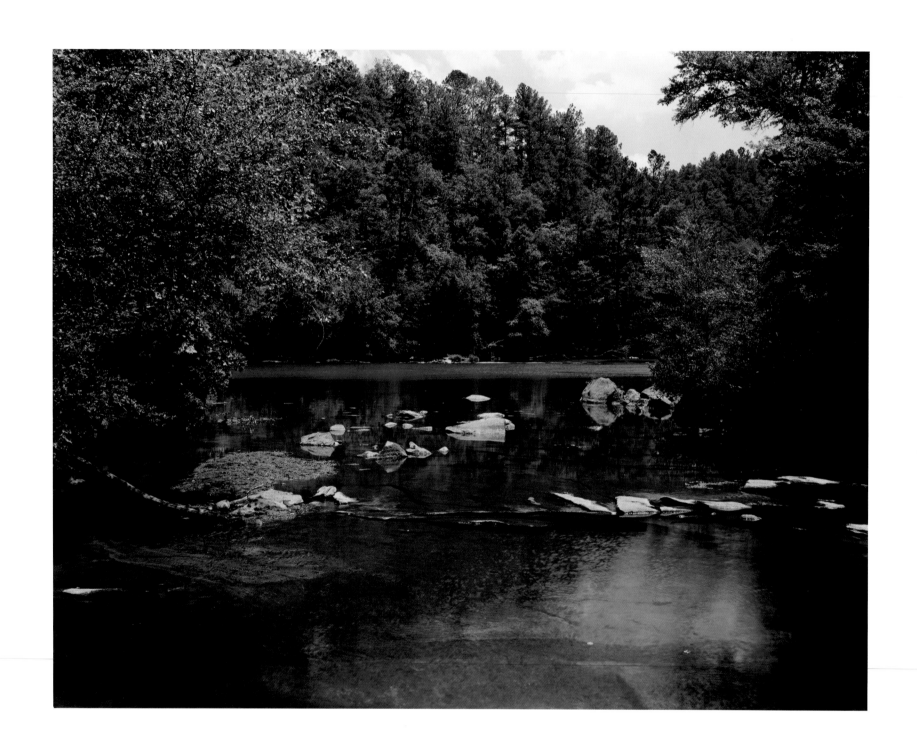

CAHABA RIVER, AUGUST

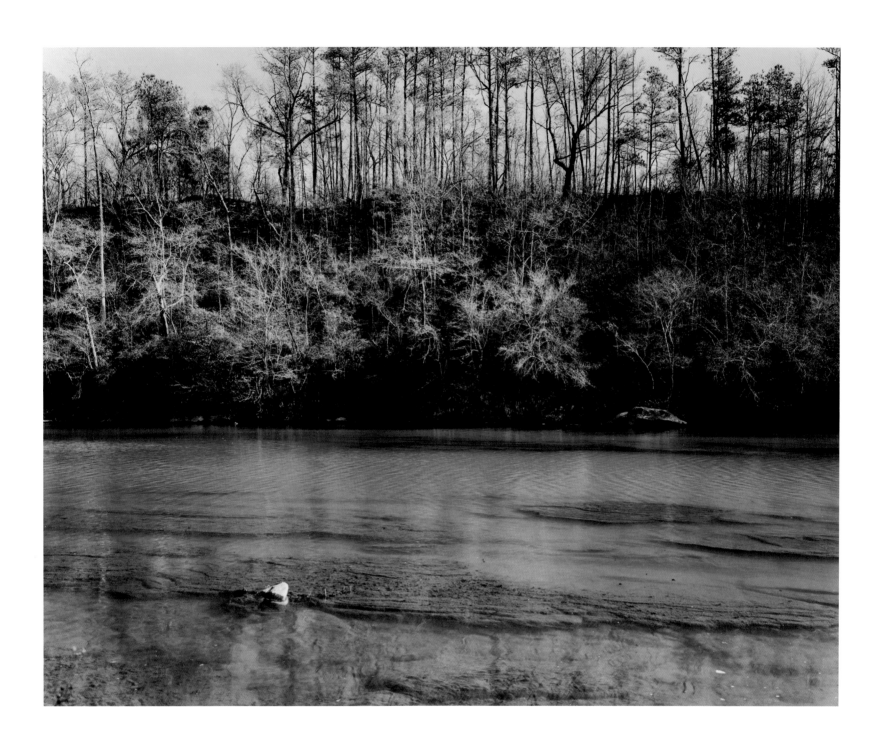

CAHABA RIVER, WINTER DAY, DECEMBER

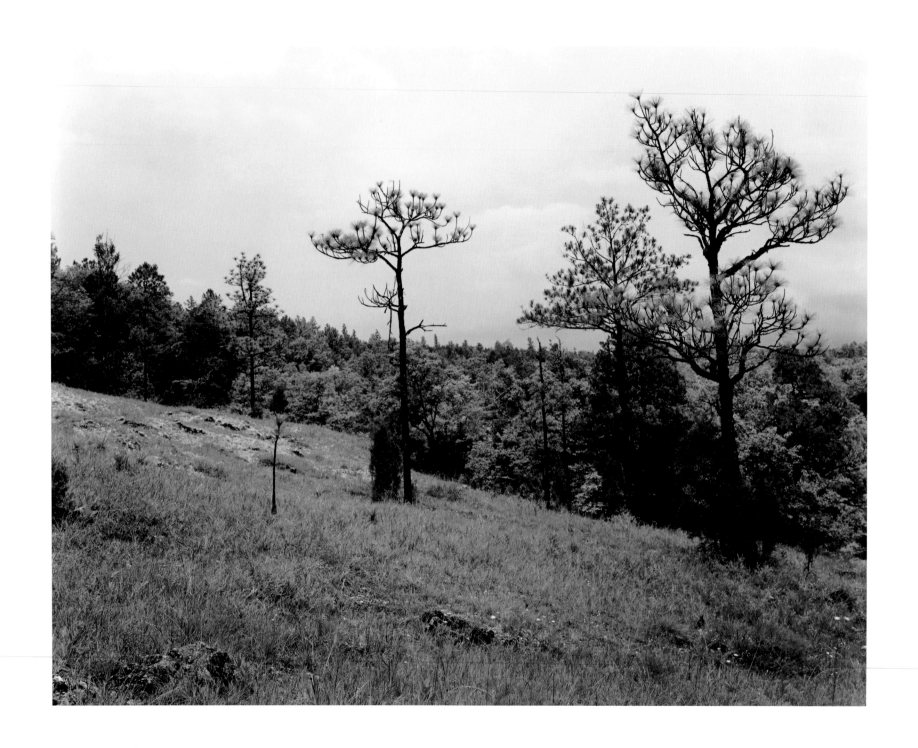

BIBB COUNTY GLADES, RAINY DAY, JUNE (NO. 1)

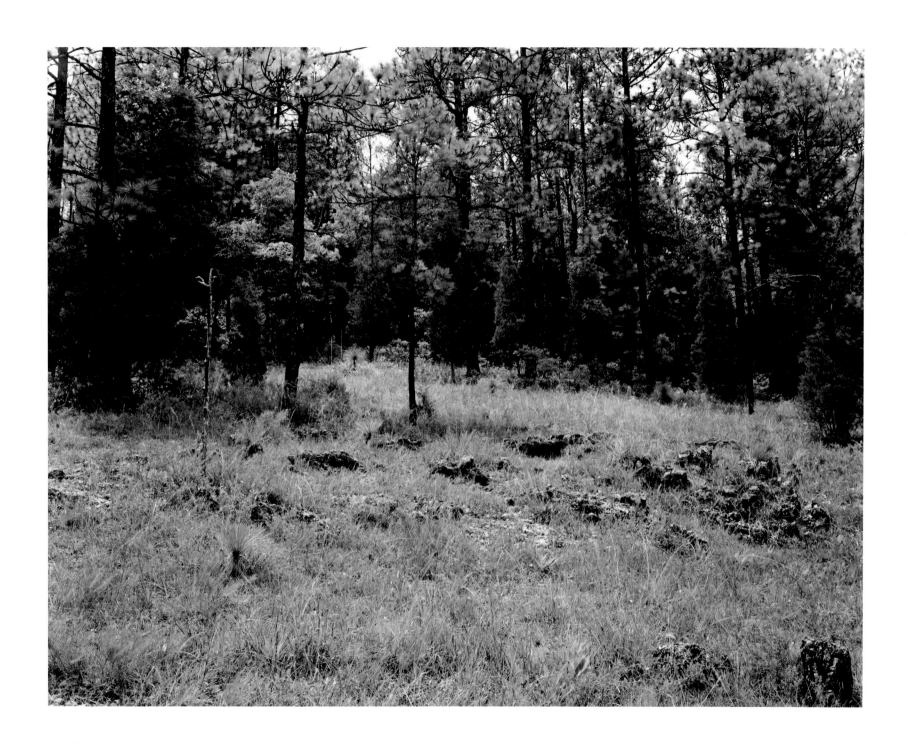

BIBB COUNTY GLADES, RAINY DAY, JUNE (NO. 2)

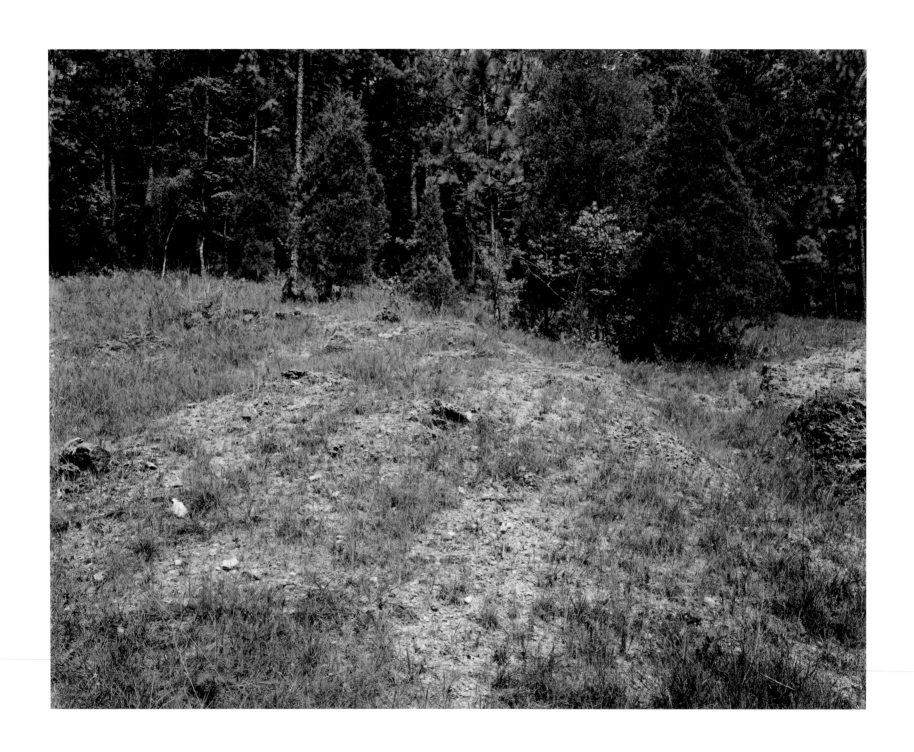

BIBB COUNTY GLADES, SUMMER DAY, AUGUST

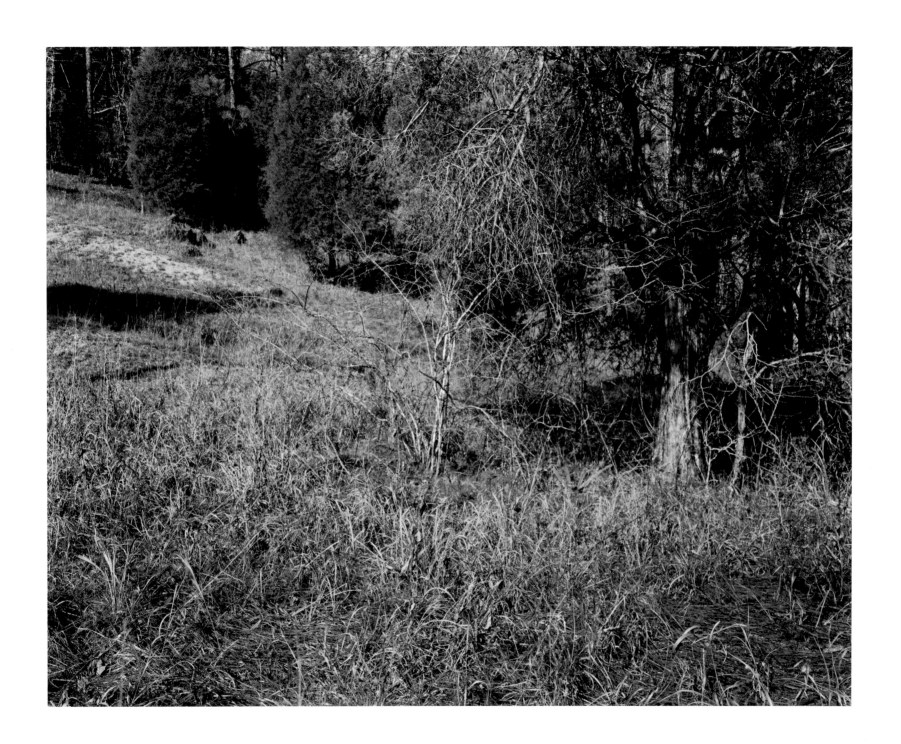

BIBB COUNTY GLADES IN WINTER LIGHT, DECEMBER

TERRY EVANS

TALLGRASS PRAIRIE PRESERVE, OKLAHOMA

MY TASK AS AN ARTIST IS TO TELL THE STORIES OF THE PRAIRIE. I have been doing it for more than twenty years, first looking at undisturbed prairie in Kansas and then inhabited prairie near Chicago. This project brought me full circle: Here, on the Osage prairie in Oklahoma, a complex network of human support enables a healthy ecosystem to flourish.

I arrived early one evening after a frantic week in Chicago, and I could feel my whole body relaxing immediately. I saw bison, birds, coyote, and deer, and I felt such wonder and peace.

The prairie is a subtle landscape; it demands our attention. When we look at it closely, we can see amazing details. Sounds, smell, the wind, the light changing every second—there's no way a photograph can capture that totality of experience.

One day I found folders of plant specimens in the preserve's ranch house where I was staying. I had been shooting other specimens in collections at the Field Museum in Chicago. But at the preserve I could take these specimens outside, find the sites where they had been gathered, and photograph them there. By putting the specimens back in their natural context, we gather information about a place. —T.E.

IN THE OSAGE HILLS, FIFTY-FIVE MILES NORTHWEST OF TULSA, THE Tallgrass Prairie Preserve anchors the southern end of the greatest stretch of tallgrass prairie remaining in North America. Once an ocean of tallgrass extended across 142 million acres of the continent, from Indiana to Kansas, and from Canada to Texas. On the tallgrass, the most eastward of the prairies, fell the most rain. Its waving stems of big bluestem and Indian grass reached up to ten feet high, so high that early settlers had to stand in the saddle to find grazing cattle.

As the nation pushed westward, the tallgrass prairie was plowed under and corn was planted in the deep soil. Less than 10 percent of the tallgrass remains today.

Once a working ranch, the 39,000-acre Tallgrass Prairie Preserve was grazed but never plowed. With, as Terry Evans says, "a complex network of human support," the biological diversity of such land can be re-created, and that has been the goal of The Nature Conservancy for the past decade.

Restoration of a fully functioning prairie ecosystem has meant the return of two critical forces that shaped the American prairies: bison and fire. At one time numbering thirty million, bison graze selectively and move over large areas, their habits affecting the patterns and diversity of native plants across the prairie. Fire once ran throughout the tallgrass, ignited by lightning strikes and Native Americans. It clears dead vegetation and thwarts trees from taking hold—vital to keeping prairie as prairie. But over the past century, wildfire was suppressed and bison almost became extinct.

Today, several years into one of the boldest restoration efforts ever undertaken by conservationists, the natural interactions of fire and bison at the Tallgrass Prairie Preserve sustain an ecologically diverse system. Some 1,200 head of bison roam the prairie; the herd will one day number 3,200. And prescribed fire—that set on purpose for ecological benefit—regularly sweeps the rolling plains.

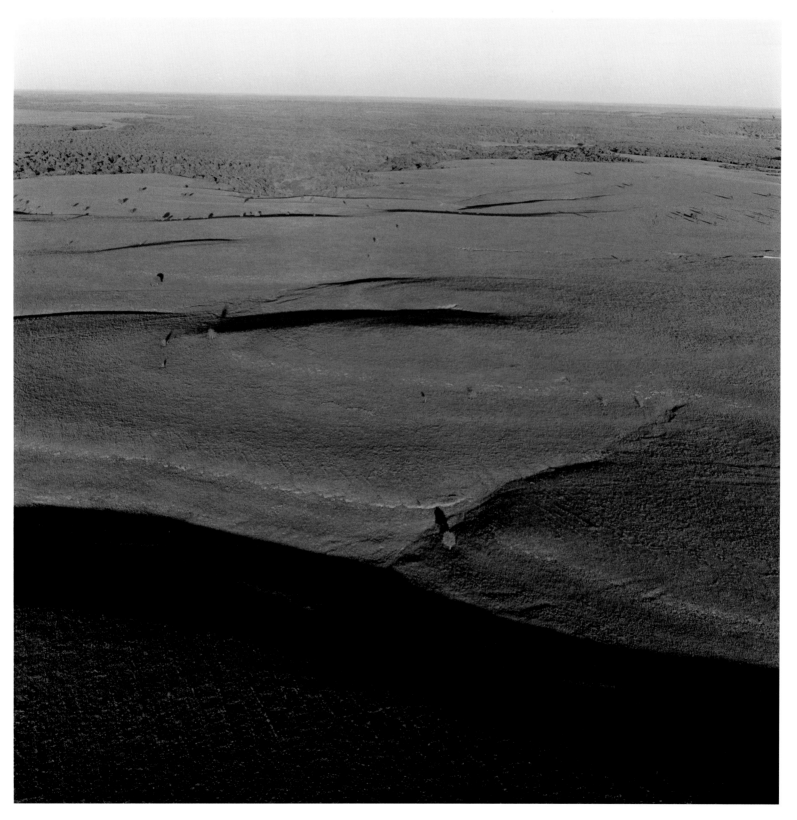

NEWLY BURNED AREA AND GRASSES

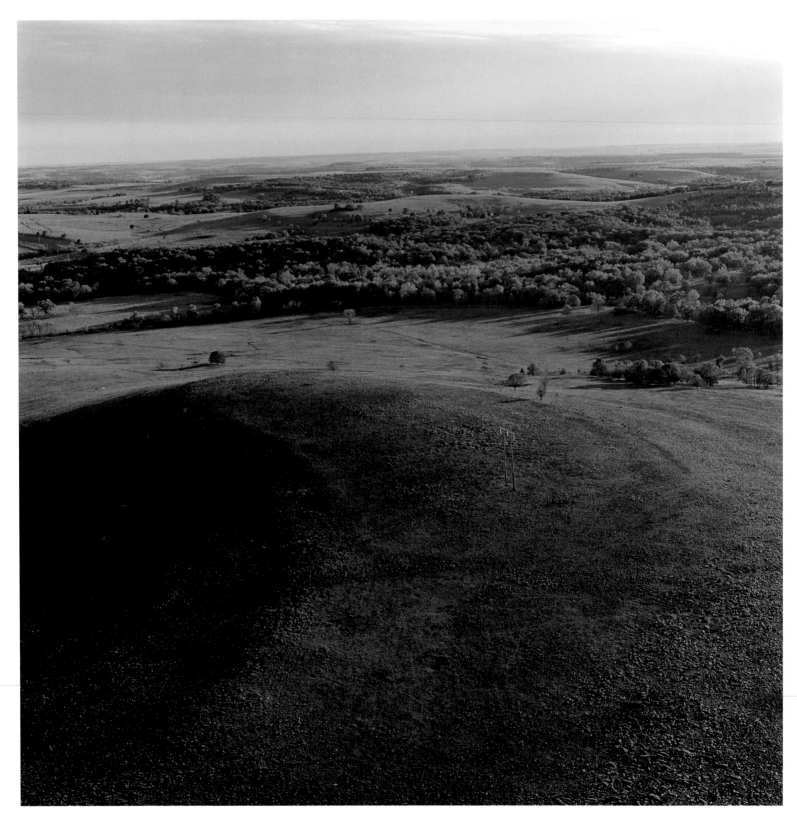

LOOKING SOUTH AT TALLGRASS PRAIRIE PRESERVE

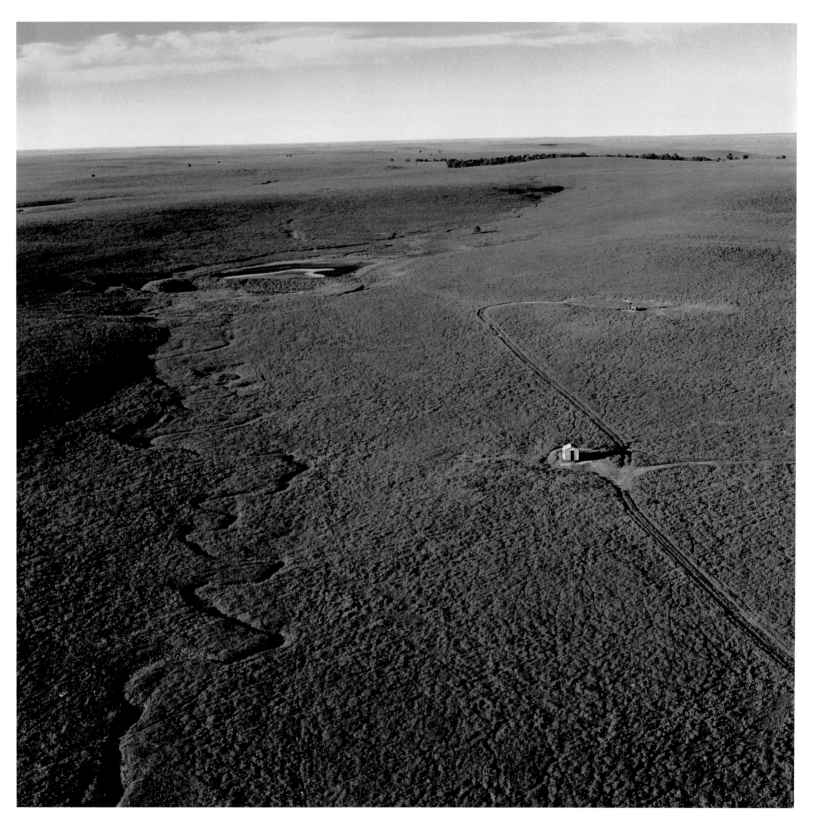

POND AND OIL PUMP HOUSE

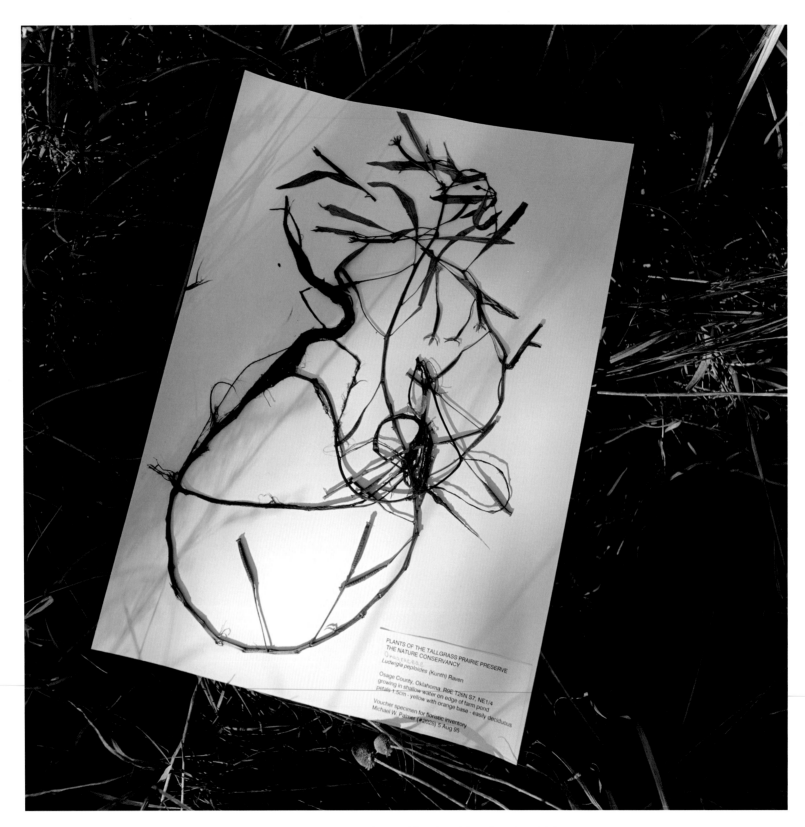

PLANTS OF THE TALLGRASS PRAIRIE PRESERVE
THE NATURE CONSERVANCY

P.N.O.T.S.C.U.S.

Ludwigia peploides (Kunth) Raven

Osage County, Oklahoma. R9E T26N S7, NE1/4
growing in shallow water on edge of farm pond
petals 1.5cm - yellow with orange base - easily deciduous

Voucher specimen for floristic inventory
Michael W. Palmer (#2028) 5 Aug 95

LUDWIGIA PEPLOIDES, FLOATING EVENING PRIMROSE

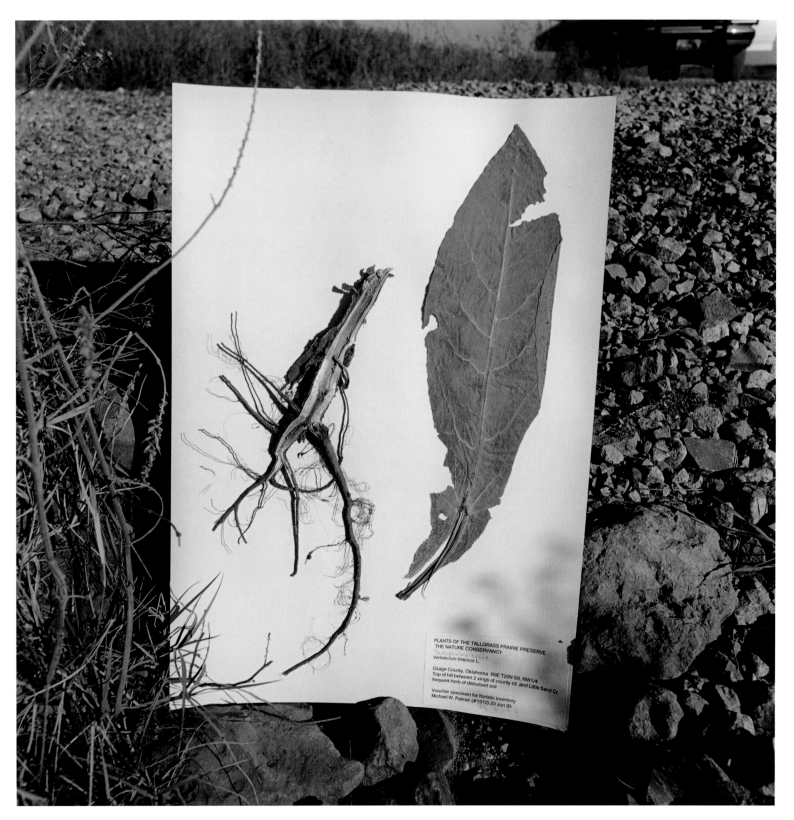

VERBASCUM THAPSUS, COMMON MULLEIN

73

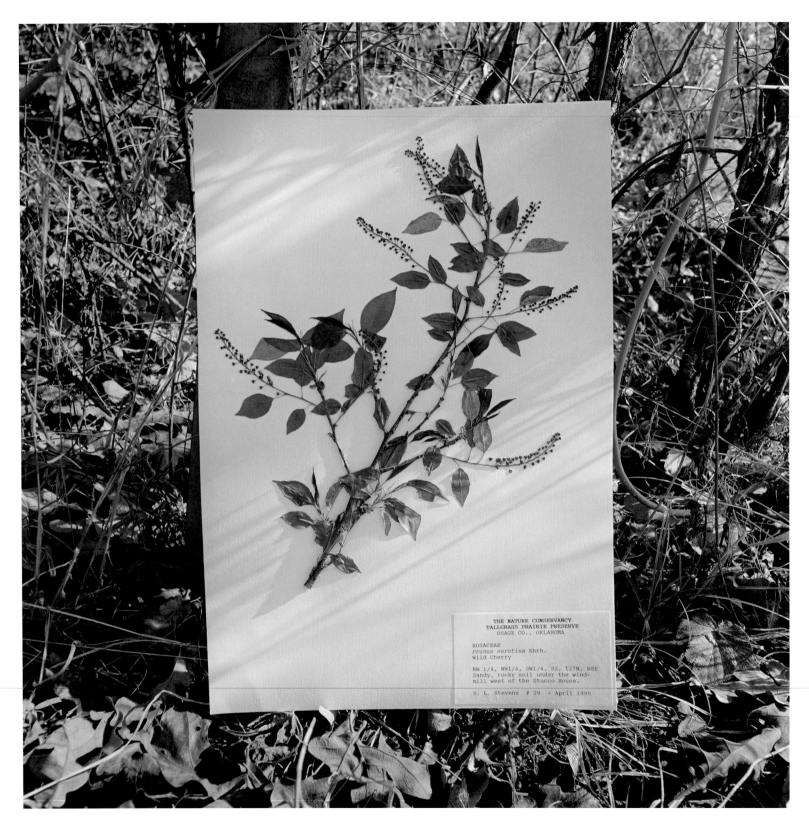

THE NATURE CONSERVANCY
TALLGRASS PRAIRIE PRESERVE
OSAGE CO., OKLAHOMA

ROSACEAE
Prunus serotina Ehrh.
Wild Cherry

NW 1/4, NW1/4, SW1/4, S2, T27N, R8E
Sandy, rocky soil under the wind-
mill west of the Stucco House.

S. L. Stevens # 29 4 April 1995

PRUNUS SEROTINA, BLACK CHERRY

74

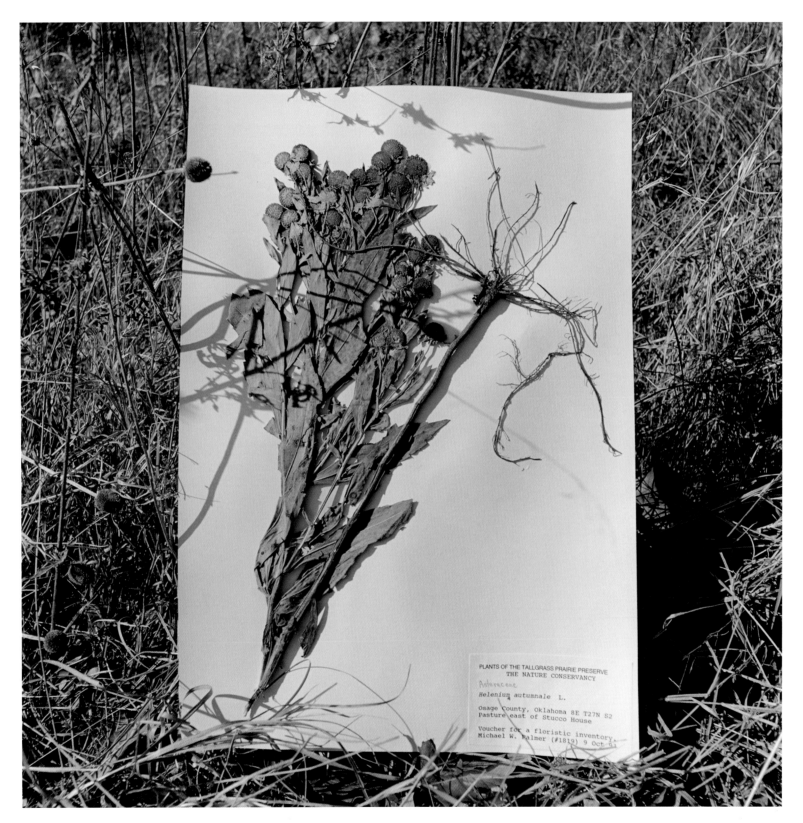

HELENIUM AUTUMNALE, SNEEZEWEED

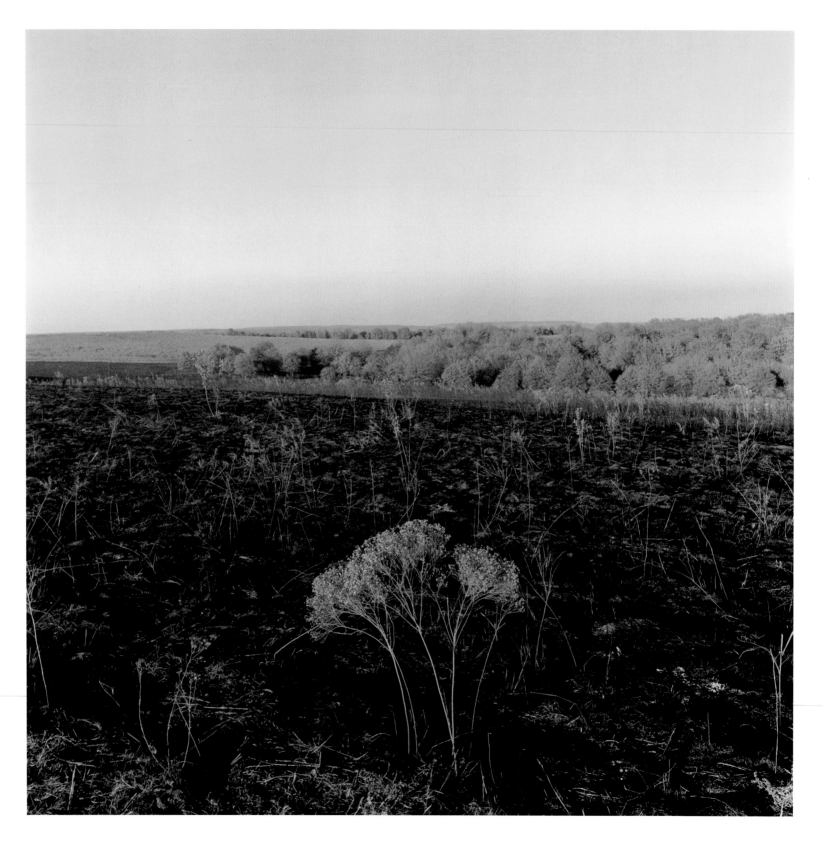

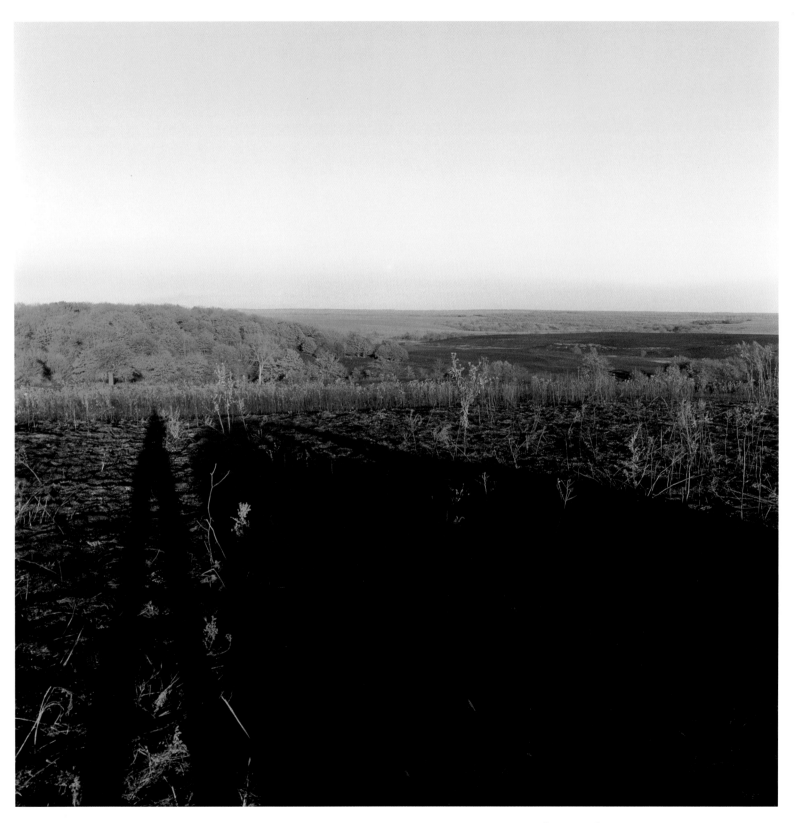

AREA BURNED AS PART OF PRAIRIE MANAGEMENT PROGRAM (DIPTYCH)

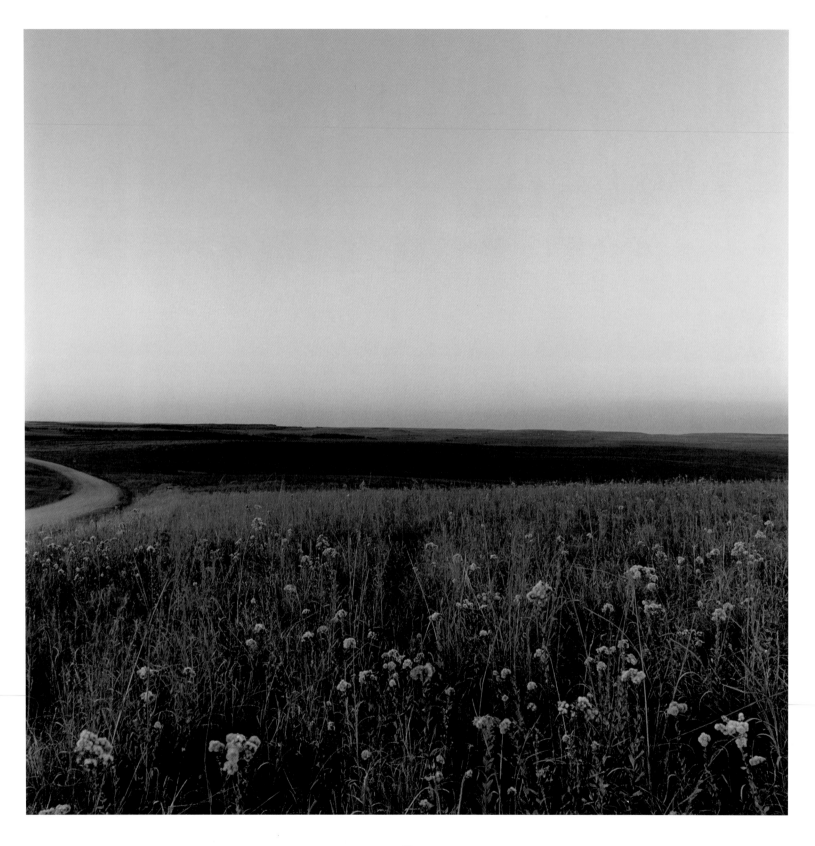

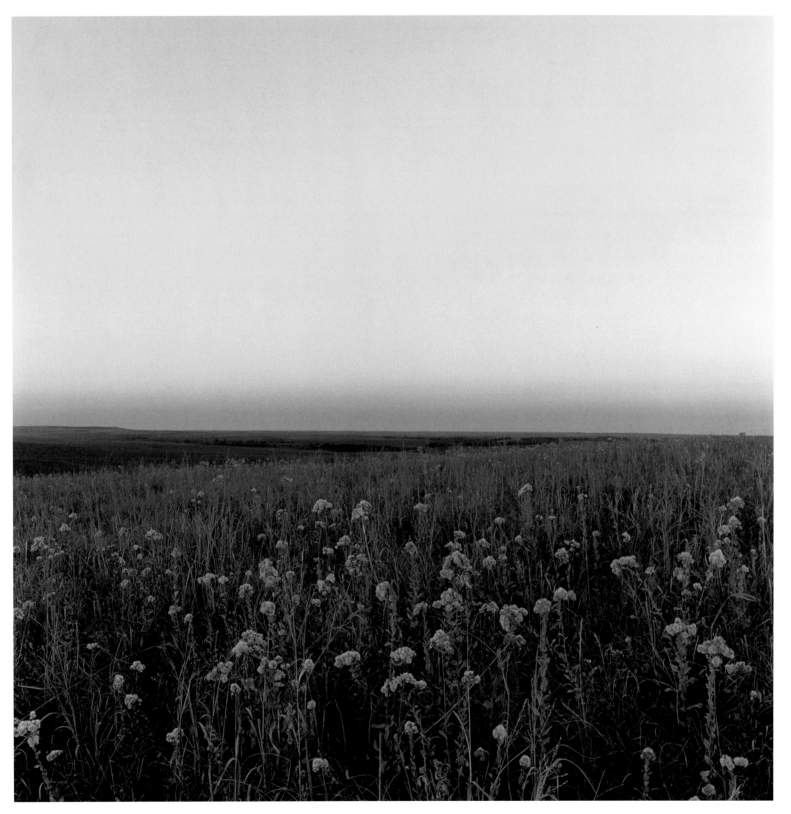

SUNSET (DIPTYCH)

79

LYNN DAVIS

COLORADO PLATEAU, UTAH

OVER THE LAST FIFTEEN YEARS I HAVE BEEN ON THE JOURNEY of exploring great architecture and landscape as it has developed around the world since 6000 B.C. Each place has led me to the next.

I chose the Colorado Plateau of Utah because I had been there about ten years ago and loved it. I wanted to try to see this land differently from the way it has been seen by everyone from Ansel Adams to the newer photographers who have been looking at the developing West.

I found that the land is shrinking rapidly around Arches and other protected parks and monuments here, just as it is in Egypt, where development is coming to the edge of the Plain of Memphis. It is important to me that these entrances to our sacred places be preserved. Part of their greatness—like the greatness of ancient temples—lies in how you enter.

The plateau also appealed to my love of geometry, of form and emptiness, and to my interest in vernacular and man-made monuments as well as natural ones. I feel as if I am starting another period in my work, in which I am trying to interpret our contributions to civilization in terms of the thousands of years that came before. I am extending my earlier body of work right into the American landscape. —L.D.

EVEN AS THE GEOGRAPHICAL OUTLINES OF THE UNITED STATES WERE coming into focus on maps by the 1870s, the Colorado Plateau of southern Utah was still virtually unexplored. Cutting a sinuous canyon through the plateau, the Escalante River was the last river added to a map of the United States, according to Wallace Stegner. Rising above the mesas of the plateau province, the Henry Mountains were the last mountains added to the map. These discoveries were made only after Civil War veteran John Wesley Powell braved a Colorado River journey into the unknown.

For most of the next century, the maze-like canyons, mesas, and mountains of the Colorado Plateau remained remote. Only a handful of miners and ranchers scraped a living from the stark land, and few outsiders found their way into their isolated settlements.

But no more. Today, more than one million people a year are drawn to Arches and Canyonlands national parks, two of the many gems on the plateau. The population of nearby towns has exploded in the past decade, and homes are being built up to the edge of parks, monuments, and other public lands. Through off-road-vehicle use and tourist-catering development, people are leaving their mark on the Colorado Plateau, both scenically and ecologically.

Although the majority of the plateau country is public land, government management—which traditionally has emphasized human use and enjoyment—does not guarantee biodiversity conservation. The Nature Conservancy is working to identify and protect the biologically significant parts of these public lands, collaborating with the National Park Service, Bureau of Land Management, and the U.S. Forest Service to manage those areas for both visitors and biodiversity.

The Conservancy is also working to protect ecologically important private lands like the Dugout Ranch, which forms part of the eastern edge of Canyonlands National Park. In 1997, the Conservancy purchased the Dugout, where today a cattle operation exists alongside ecological monitoring and restoration. To enter the Needles District of the park, you must cross the Dugout—a spectacular and now protected entrance to one of "our sacred places" seen through the lens of Lynn Davis's camera.

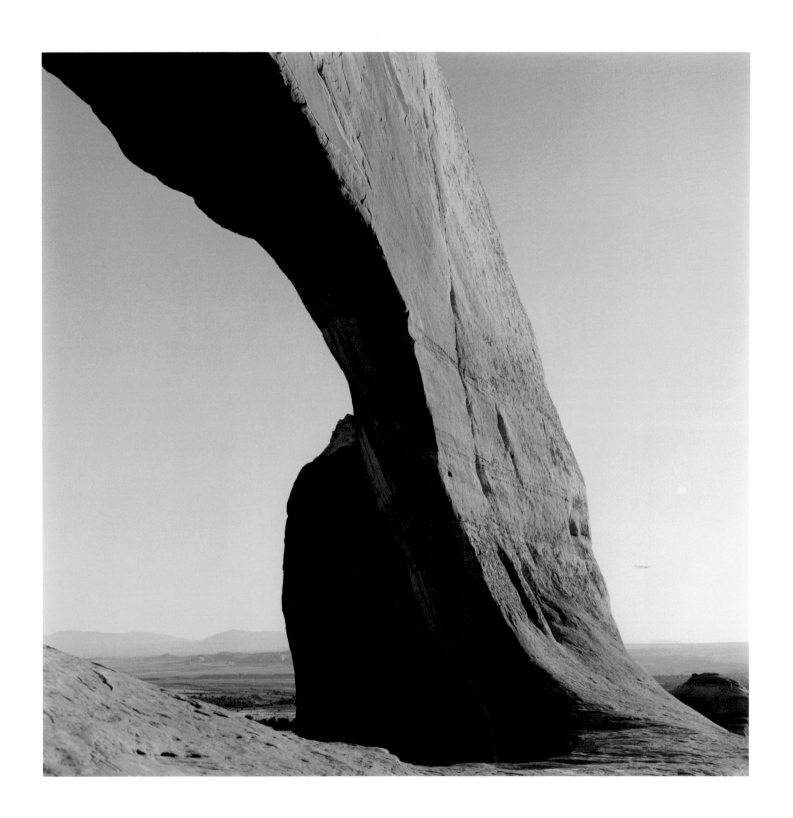

WILSONS ARCH, HIGHWAY 191, UTAH

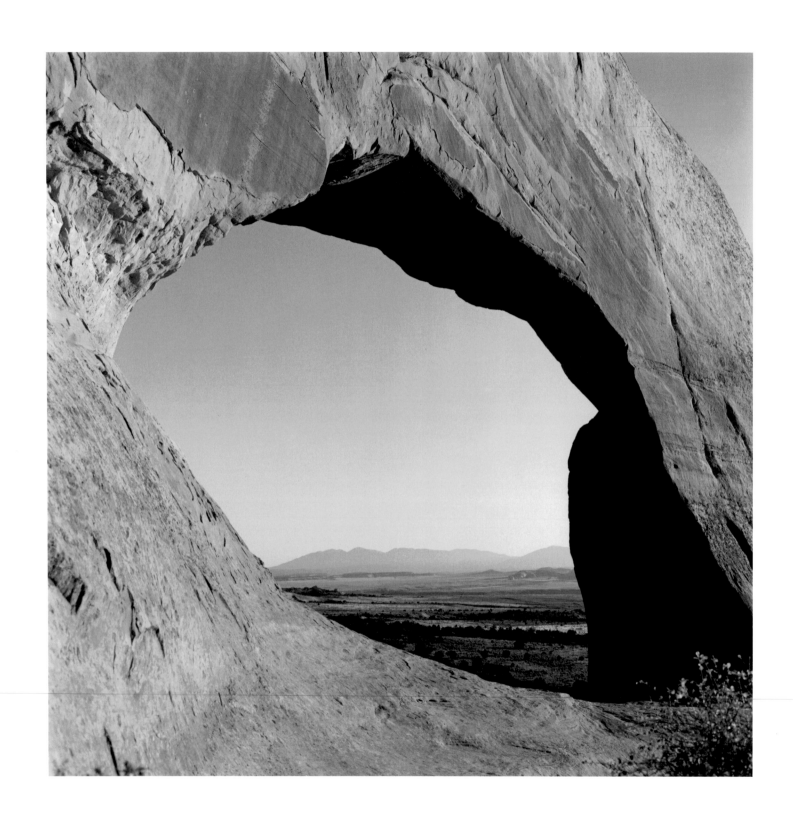

WILSONS ARCH, HIGHWAY 191, UTAH

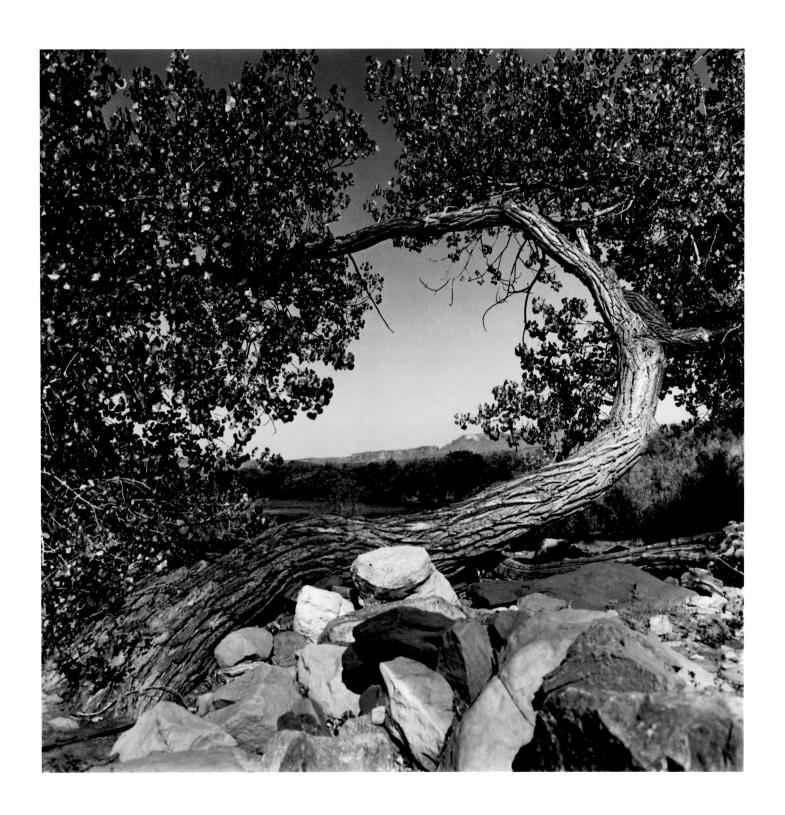

MAYBERRY PRESERVE, GREATER PROFESSOR VALLEY, UTAH

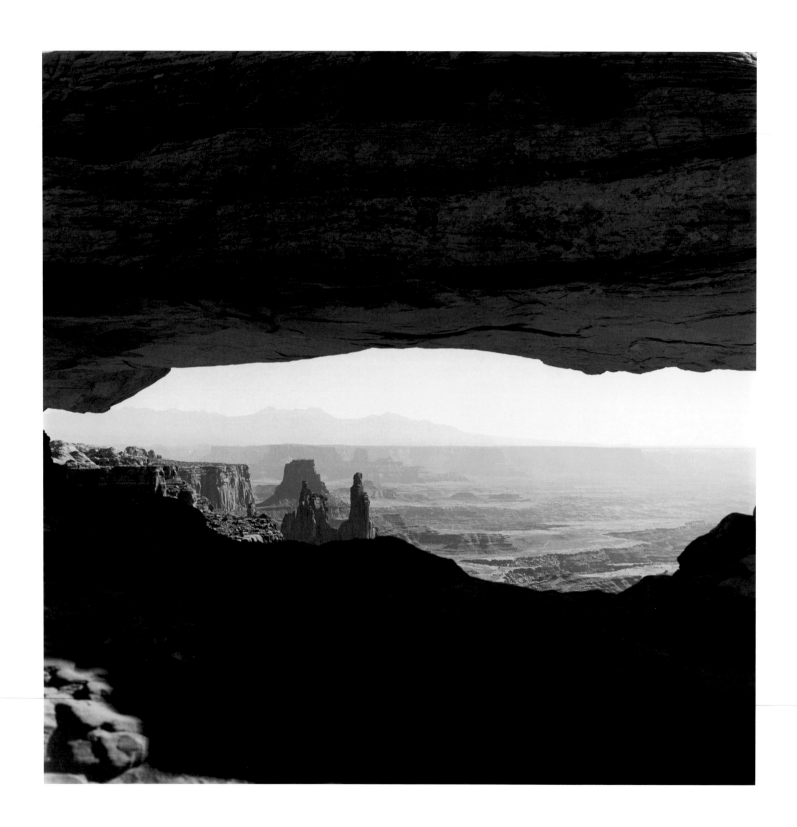

WILSONS ARCH, HIGHWAY 191, UTAH

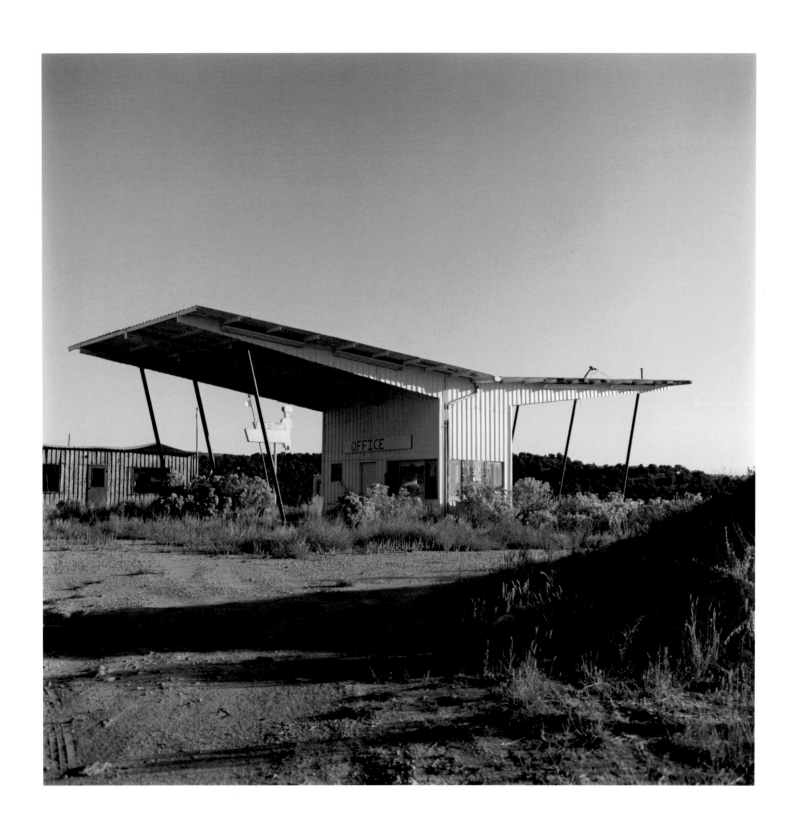

ABANDONED MOTEL, MOAB, UTAH

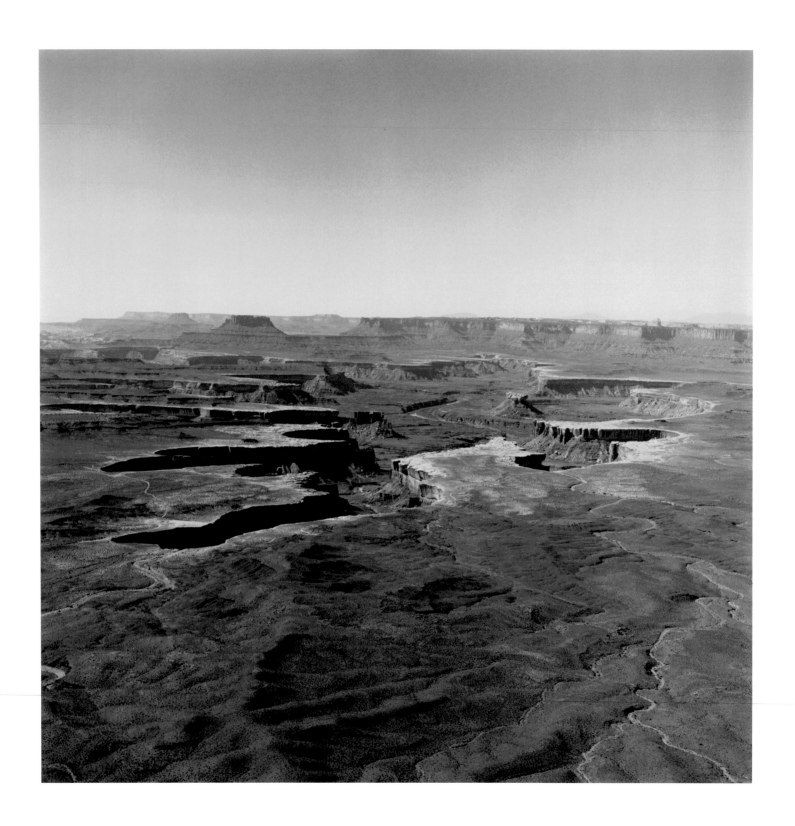

VIEW INTO CANYONLANDS, UTAH

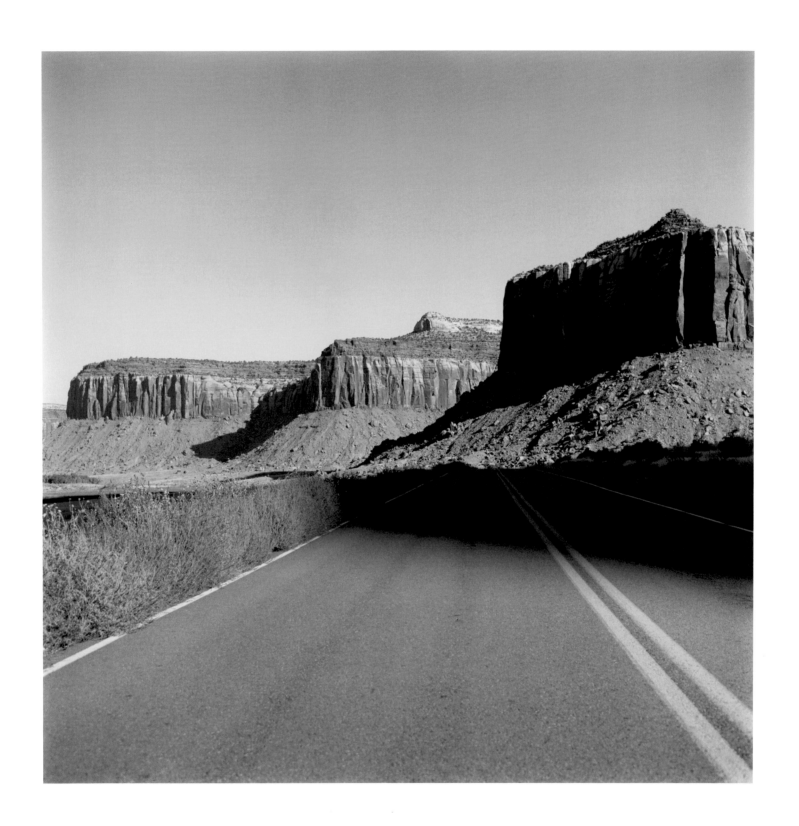

HIGHWAY TO DUGOUT RANCH, UTAH

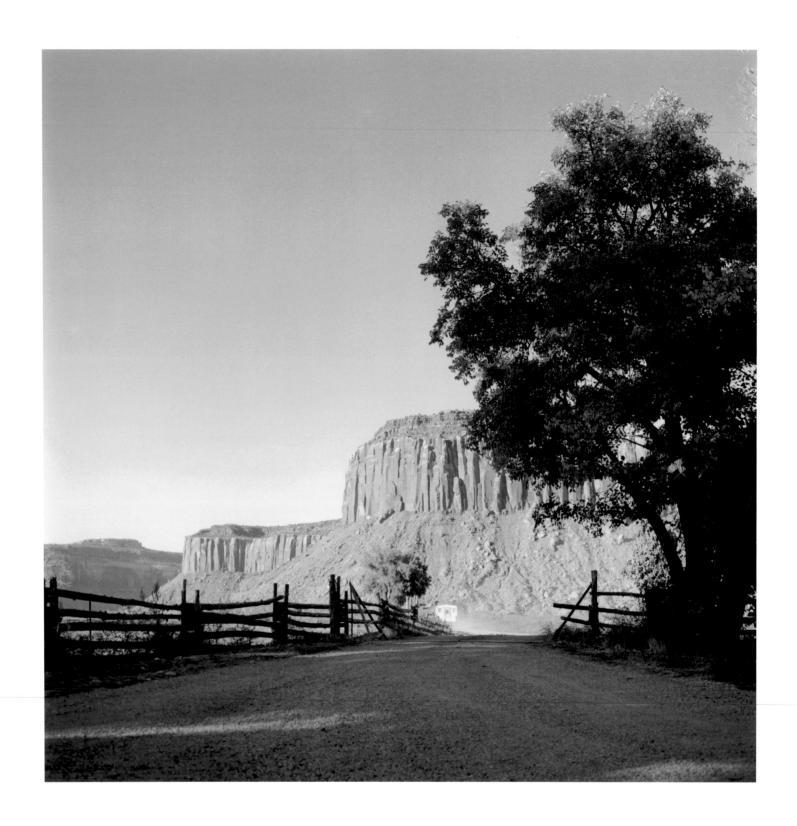

EXIT DUGOUT RANCH, UTAH

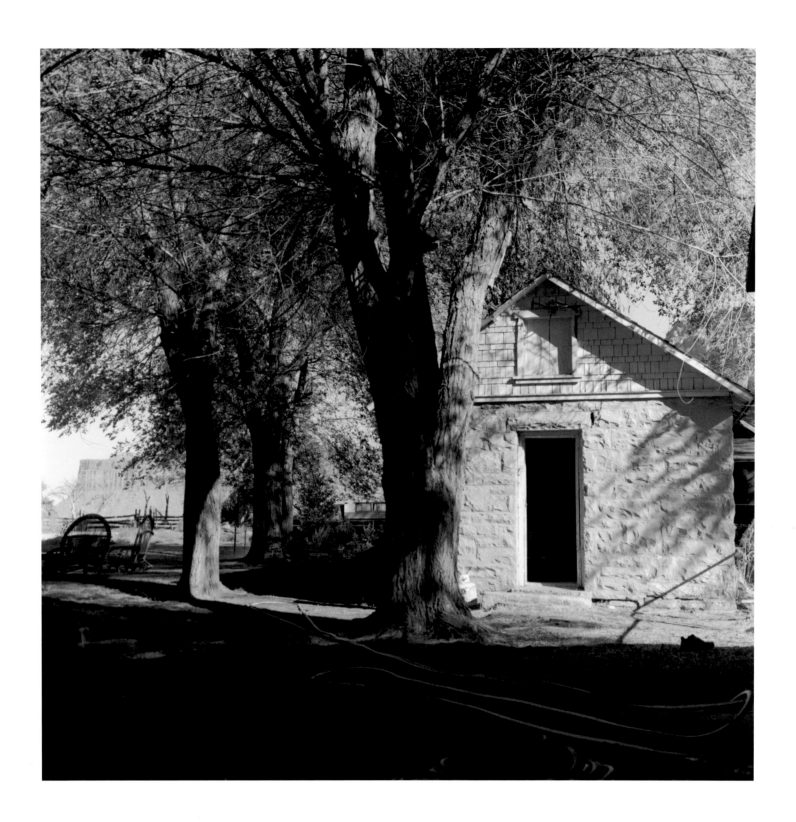

DUGOUT RANCH, UTAH

LEE FRIEDLANDER

SAN PEDRO RIVER, ARIZONA

I HAVE PHOTOGRAPHED EXTENSIVELY IN THE SONORAN Desert in Arizona and Mexico before, but I felt I had not finished southern Arizona. I had never been to its riparian areas, where you have water with desert all around. So I went to the San Pedro, Aravaipa Canyon, and Muleshoe Ranch preserves, and found the strangeness and complexity that I love.

I don't go looking for twisty and sprawling images, but I find them. I guess it suits my personality. When there's not much water available, plants will fight to grow, and all hell breaks loose. I like that. It is all so different from Olympia, Washington, where I come from, which is just the opposite, almost like a rain forest.

I am also a cottonwood freak. So before I went to the San Pedro, I called ahead, and asked whether there were any good places for shooting cottonwoods along the river. "We've got them growing for more than thirty miles—and they're all good," the manager told me. And he was right. I have never seen them in that kind of profusion before. —L.F.

THE SAN PEDRO RIVER IS ONE OF ONLY TWO RIVERS FLOWING NORTH from Mexico into southeastern Arizona. From the flanks of the forested mountain ranges that rise as verdant "sky islands" from the baked desert floor, the San Pedro appears as a green ribbon, its banks lined with increasingly rare cottonwood and willow forests. It is sanctuary in its most primal, basic form.

Throughout the borderlands—the desert badlands that straddle the border between the United States and Mexico—the San Pedro is one of the last great wildlife connections south to north. Through its sheltering corridor travel mountain lions, javelina, and other mammals—the second highest density of mammal species on Earth. The San Pedro watershed also supports nearly four hundred species of birds, half of all those known in the United States.

But the San Pedro is arguably the borderlands' most endangered ecological oasis. Undammed, it is still drying up as agricultural operations and growing cities extract groundwater that would have drained to the river and as the climate changes to an even drier one. River ecologists and residents have watched as once perennially flowing stretches of river now run with water only intermittently.

Lee Friedlander was right to call ahead about the cottonwood groves he sought. Along many of the Southwest's rivers, most of which have been dammed, cottonwoods have been slowly dying for decades, not to be replaced by young trees. To regenerate, they need sandbars built by floods and other dynamics of a wild, free-flowing river. For now, the San Pedro's cottonwoods are part of a healthy system; however, a continued decline in the river's flow may hurt them in time.

The creation of this country's first National Riparian Conservation Area along the San Pedro in 1988 recognized the river's tremendous importance. Since then, many individuals, agencies, and organizations have come together to find ways to protect the San Pedro.

The Nature Conservancy has been doing its share to ensure the river's continued protection on its own lands and in the communities along the river. At the Ramsey Canyon, Muleshoe, Aravaipa Canyon, and San Pedro River preserves, it has pioneered scientific research and sound watershed management and restoration practices. Working with partners on both sides of the border, it is helping inform policy and local decisions about water use and conservation—all aimed at keeping the San Pedro flowing.

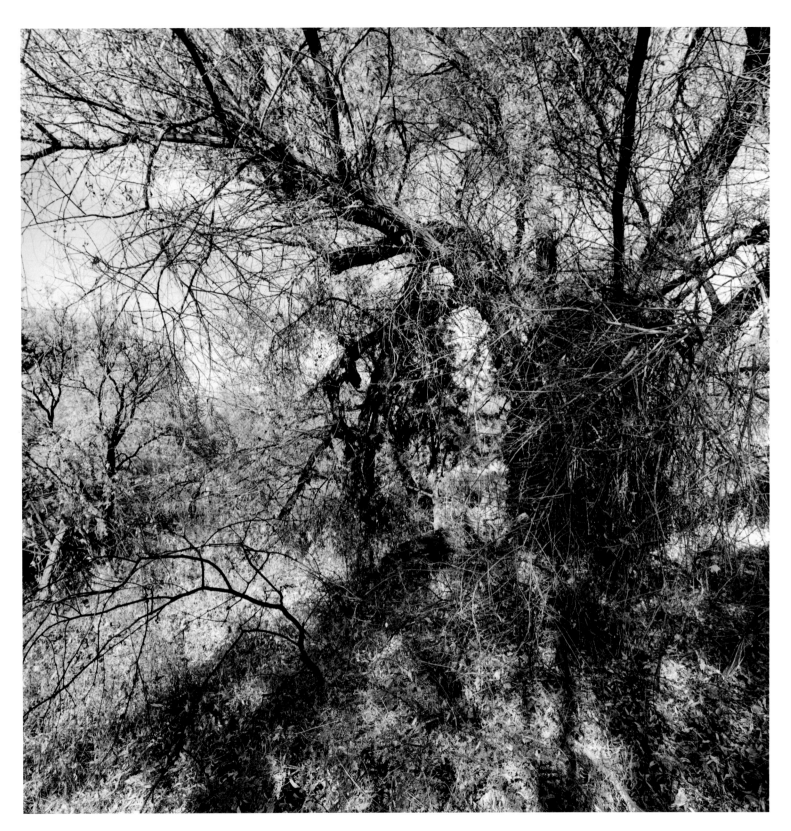

MULESHOE RANCH, ARIZONA

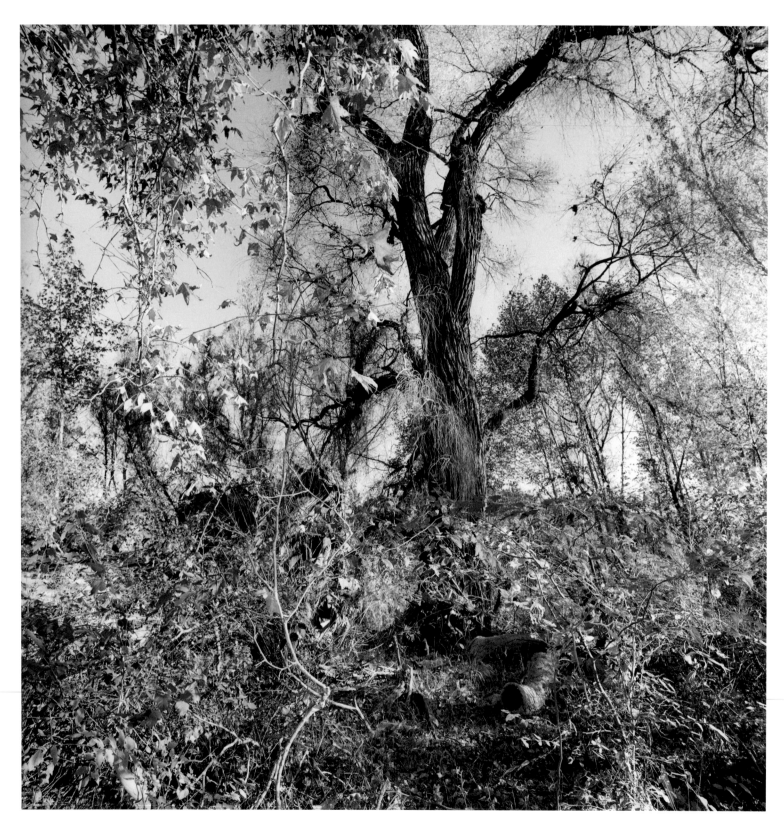

ARAVAIPA CANYON, ARIZONA

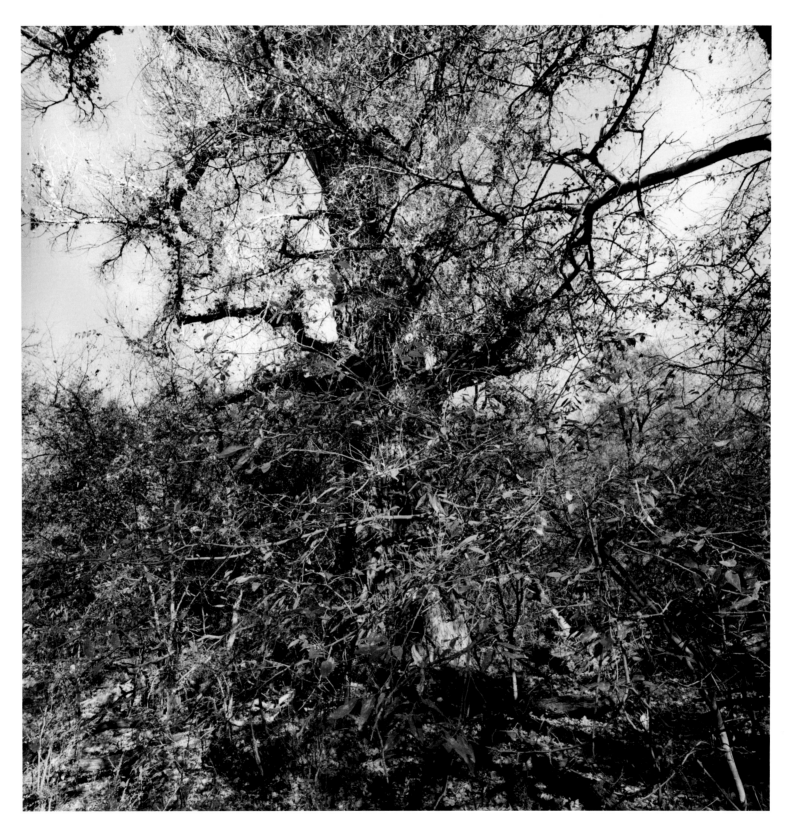

ARAVAIPA CANYON, ARIZONA

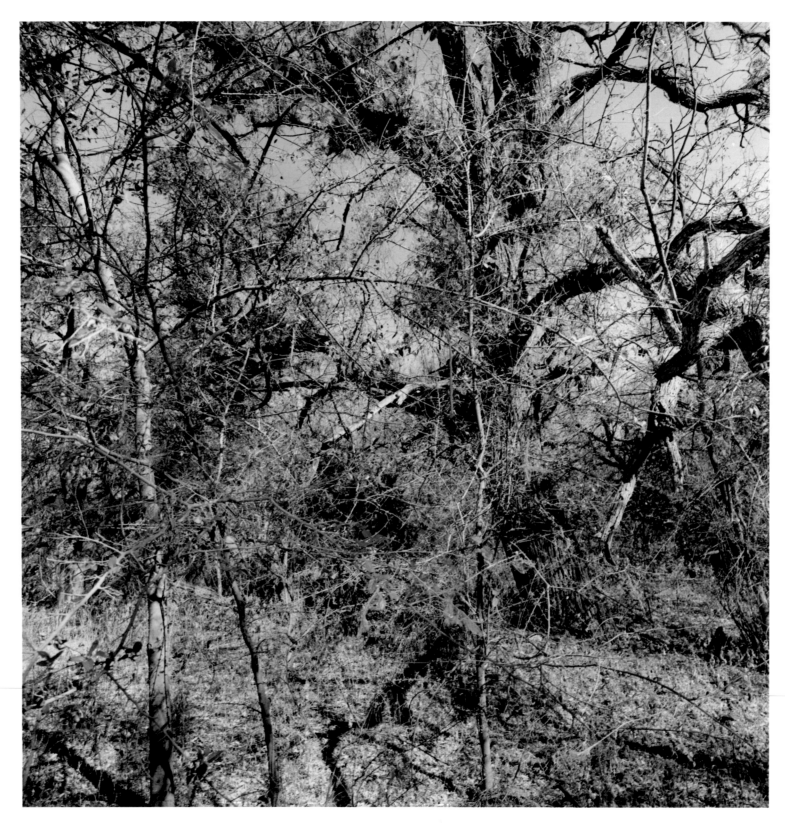

MULESHOE RANCH, ARIZONA

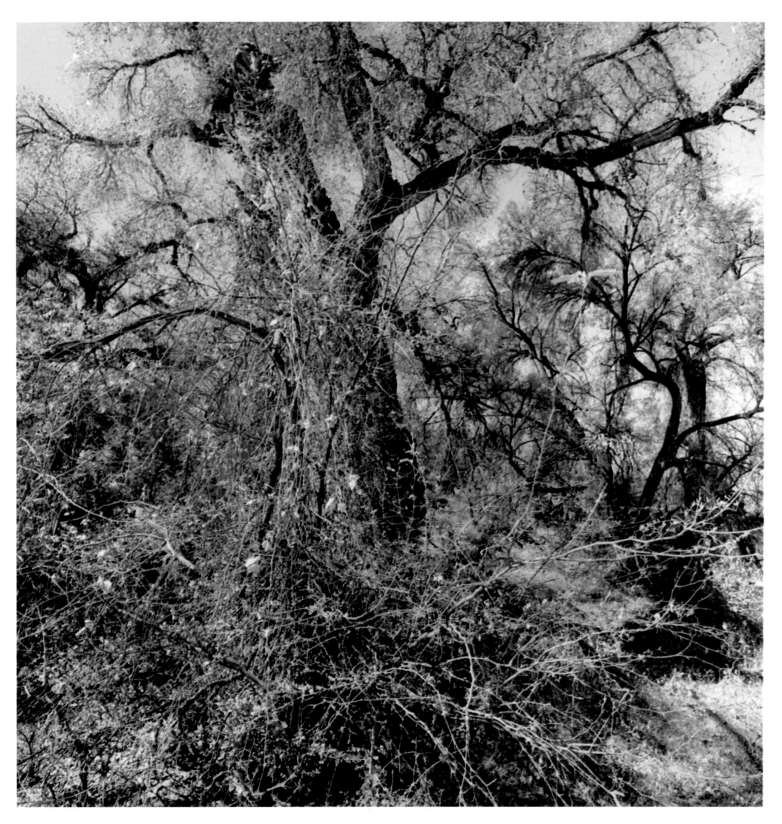

LOWER SAN PEDRO, ARIZONA

95

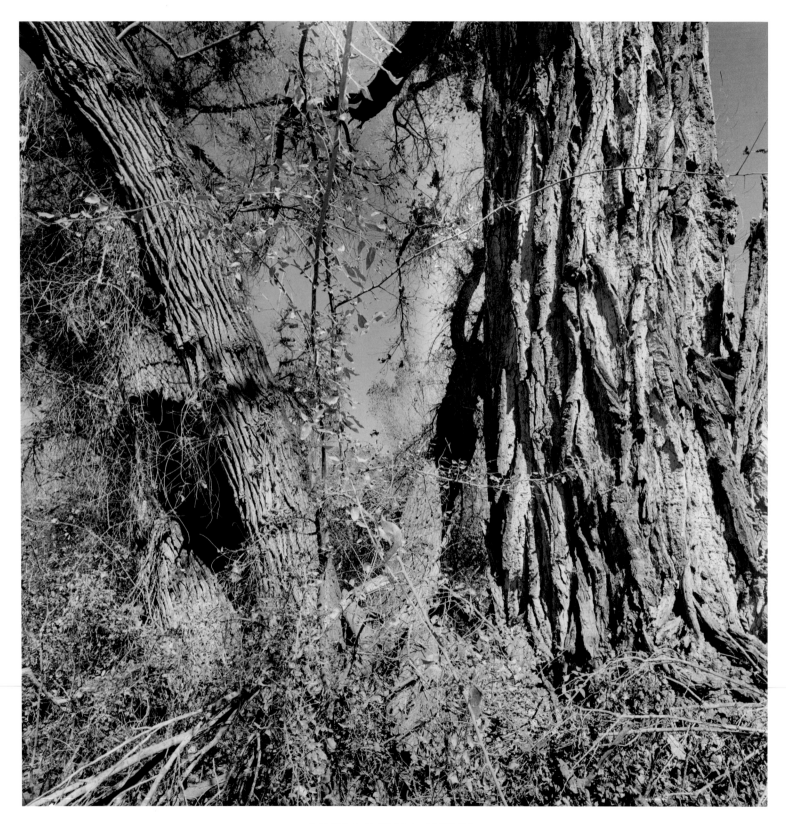

LOWER SAN PEDRO, ARIZONA

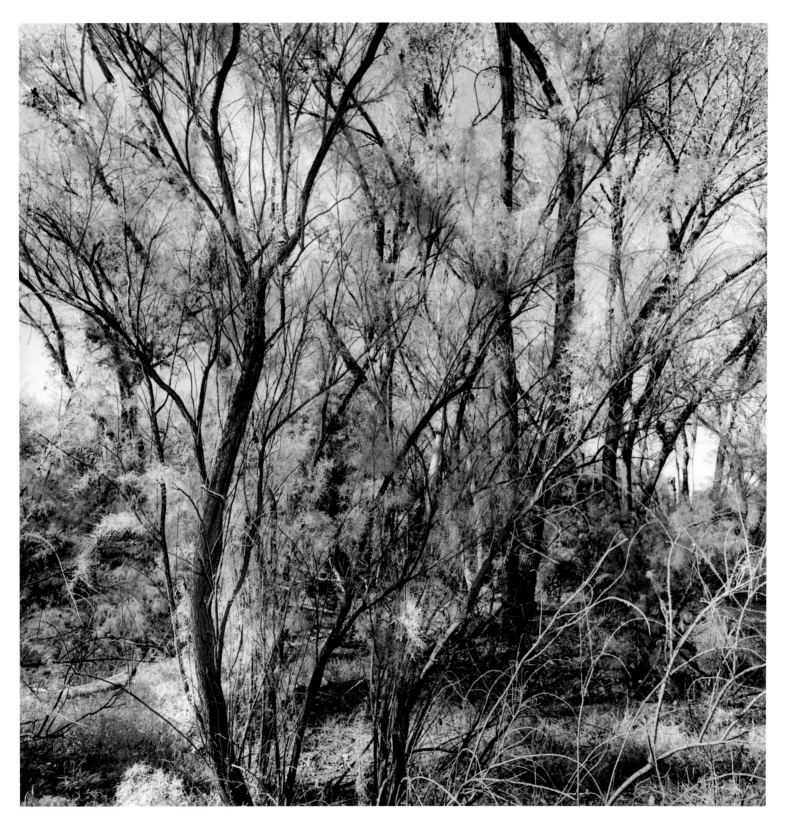

LOWER SAN PEDRO, ARIZONA

97

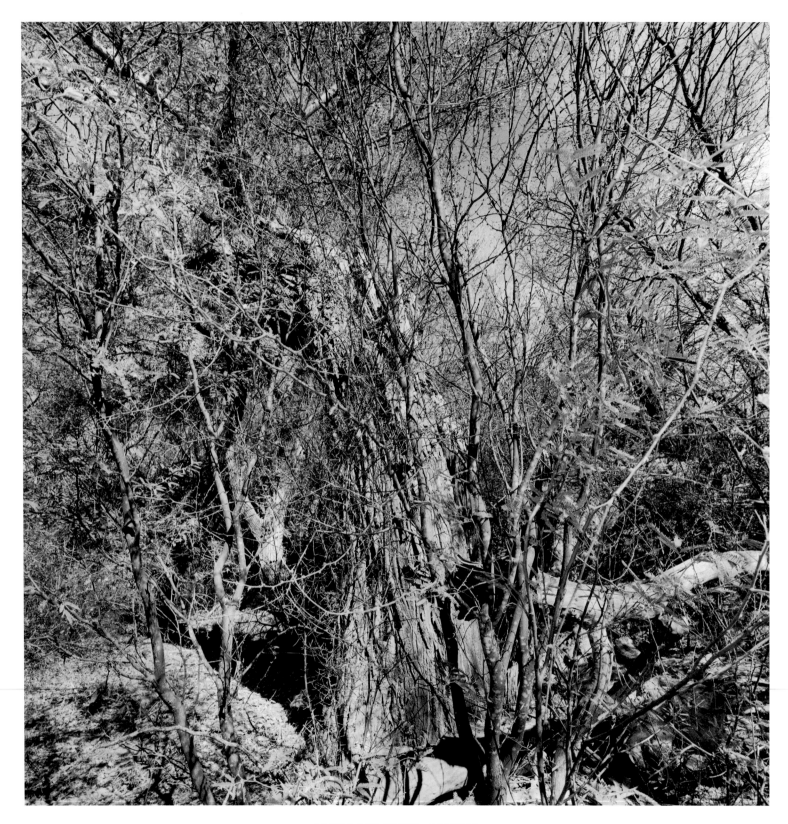

LOWER SAN PEDRO, ARIZONA

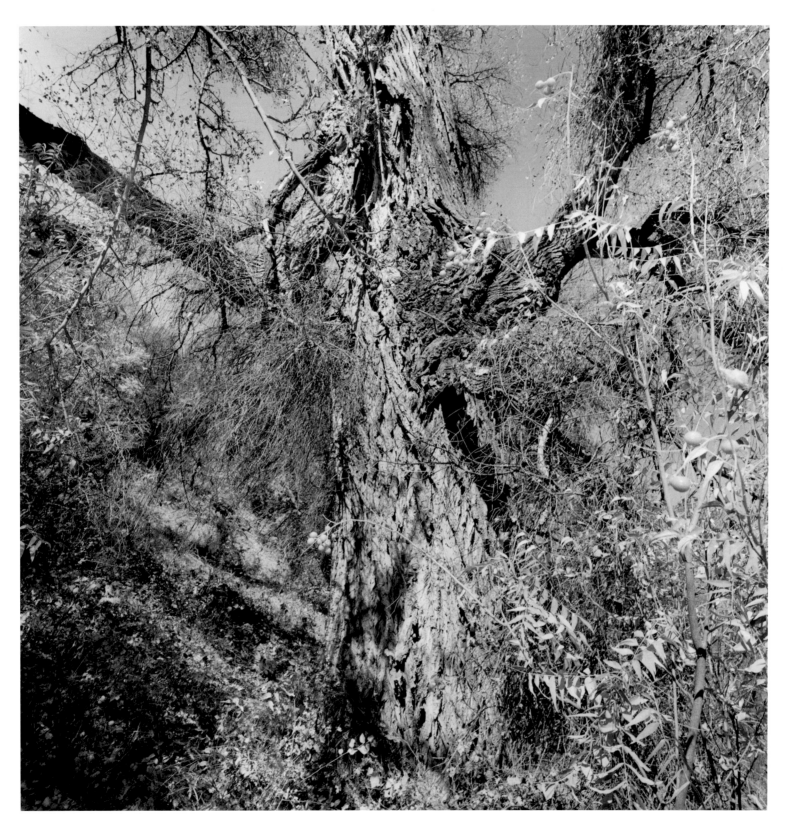

LOWER SAN PEDRO, ARIZONA

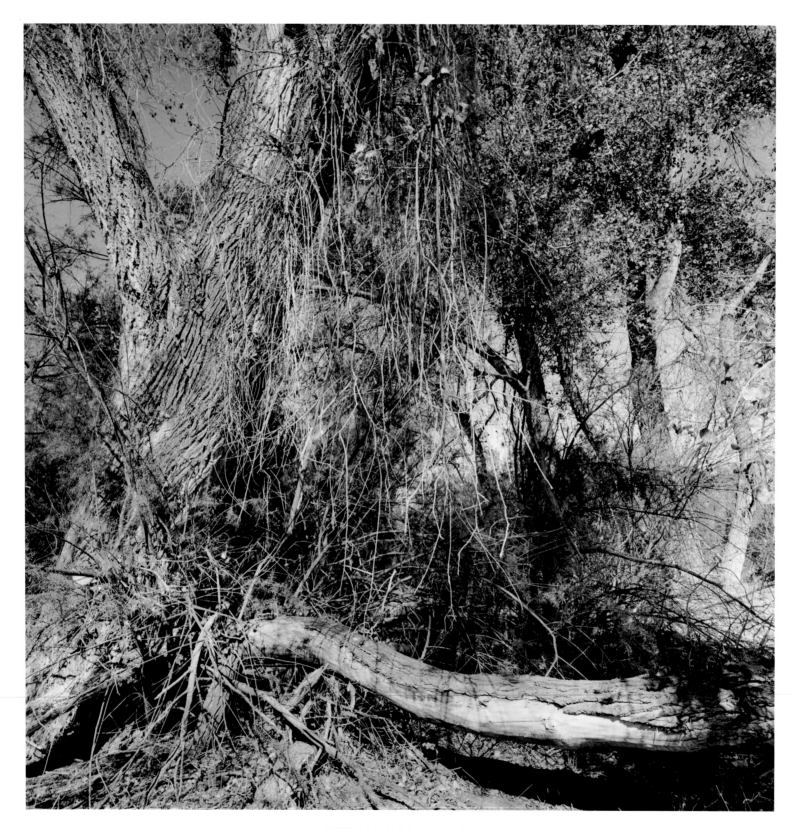

LOWER SAN PEDRO, ARIZONA

100

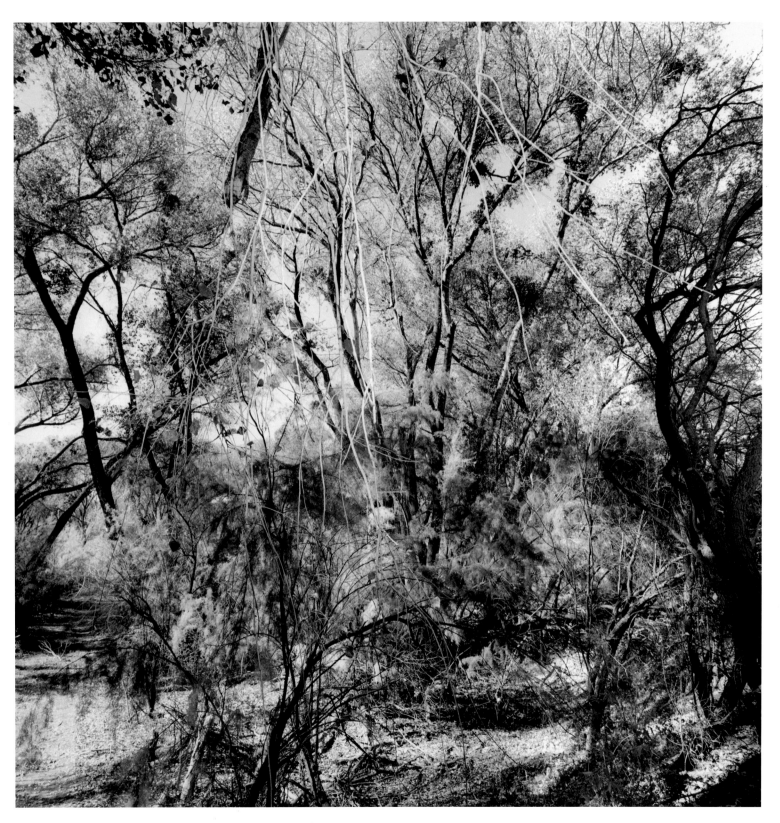

LOWER SAN PEDRO, ARIZONA

101

RICHARD MISRACH

PYRAMID LAKE AND LAHONTAN VALLEY WETLANDS, NEVADA

WHEN I WAS A KID, WE USED TO DRIVE ACROSS THE Mojave Desert from Los Angeles, and I would get scared. The desert seemed so barren and dry and foreboding. Much later, I began to appreciate the solitude and the subtlety of light and the extremes of climate that force you to grasp basic, primal notions of what life is about.

In twenty-five years of wandering the American desert, I have never seen sand dunes surrounded by water like we found here in the Carson Sink. It happens very rarely, maybe once every twelve years, when you get enough rain for dry places to start filling up. The play of light on water was like nothing I've seen anywhere else.

Often the work I do has explicit political connotations. But this work is about the play of light and the remarkable nature of water.

One afternoon, the clouds moved and blocked the sun. In the moment when the sunshine was first blocked out, there was a spectacular nuance of light. There's no way to anticipate a shot like that. That's the adventure. After all these years in the desert, I am still making discoveries. —R.M.

WATER IS THE DEFINING ELEMENT OF THE AMERICAN WEST. Feuds have been waged over it, fortunes broken, cities built, landscapes profoundly altered.

Pyramid Lake and the Lahontan Valley wetlands are among those altered landscapes, yet they support an abundance of life still. Fed by the Truckee and Carson rivers flowing from the high Sierra Nevada, they are oases in the most arid state in the country. Fifty percent of Nevada's migratory waterfowl funnel through these critical points on the Pacific Flyway, and American white pelicans and white-faced ibis have established huge colonies here. For generations, these waters have also sustained the people who settled near them, from the Paiute people to pioneering ranchers.

A century ago, the Truckee and Carson rivers became entwined in the first federal water irrigation project. It set in motion a chain of events that led to water diversions, the shrinking of Pyramid Lake, a lack of fresh water reaching the Lahontan Valley wetlands, and the decline of native fish.

Since 1990, The Nature Conservancy has worked with many partners to protect the lands and waters of these wetlands and the larger watersheds in which they lie. It has helped to develop and implement an innovative program through which water rights are purchased for conservation, to keep water in-stream and to nourish the wetlands. With the Pyramid Lake Paiute Tribe and others, the Conservancy has helped to change the operation of upstream reservoirs to mimic natural river rhythms—the pulses that give life to new cottonwood trees and send fish the signal to spawn. The Conservancy also aims to protect and restore a twenty-mile segment of the lower Truckee River through the acquisition of ranchland and partnerships with private landowners.

All of this work pays homage, as do Richard Misrach's photographs, to the remarkable nature of water in the desert.

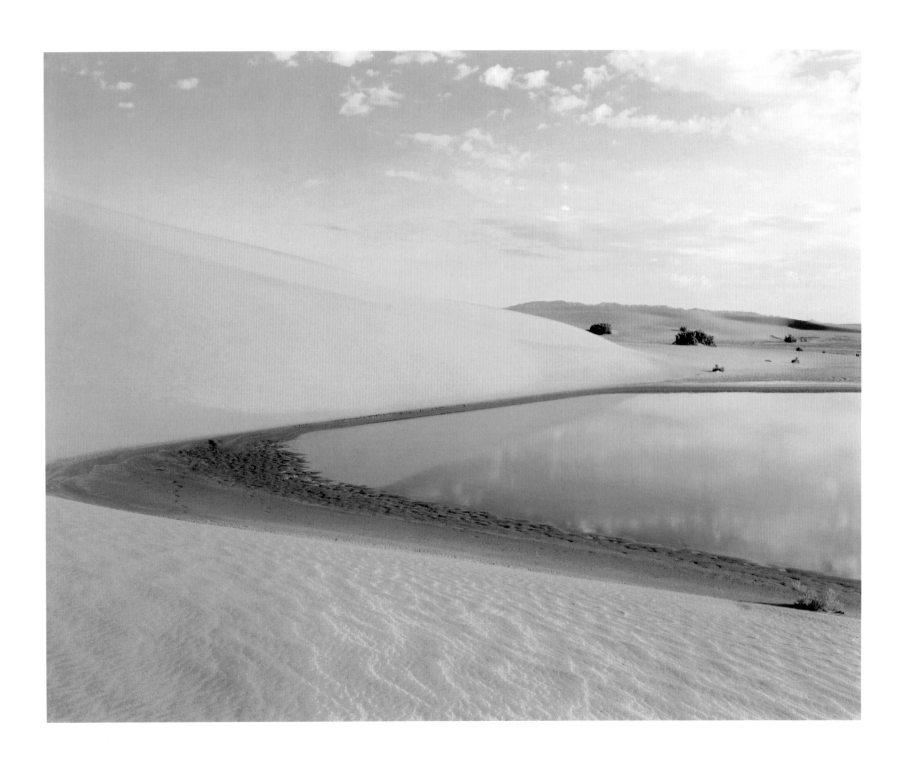

BATTLEGROUND POINT #8

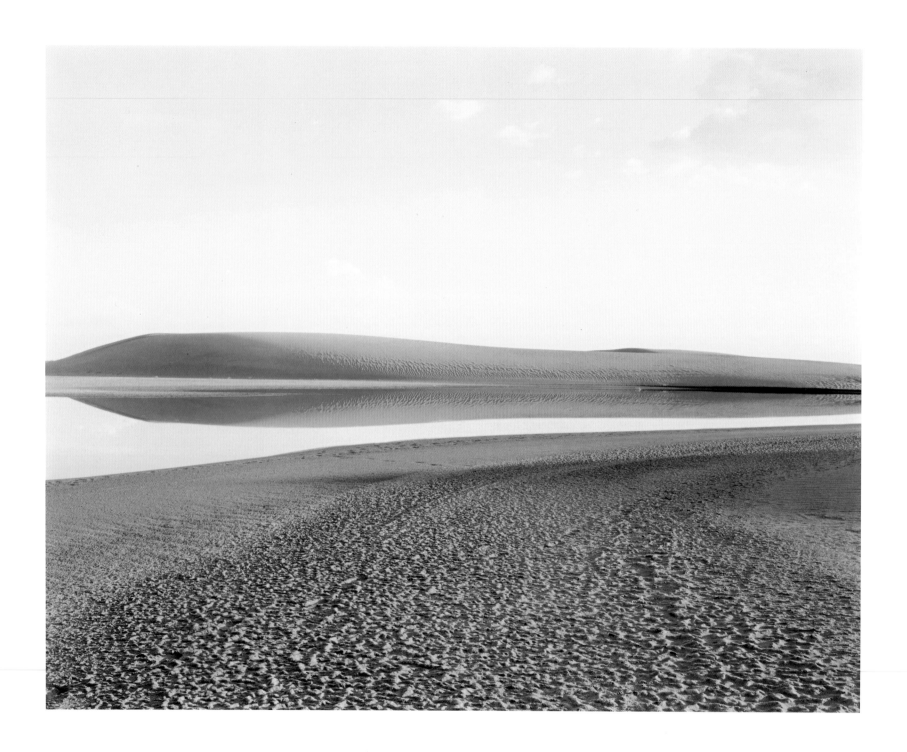

BATTLEGROUND POINT #6

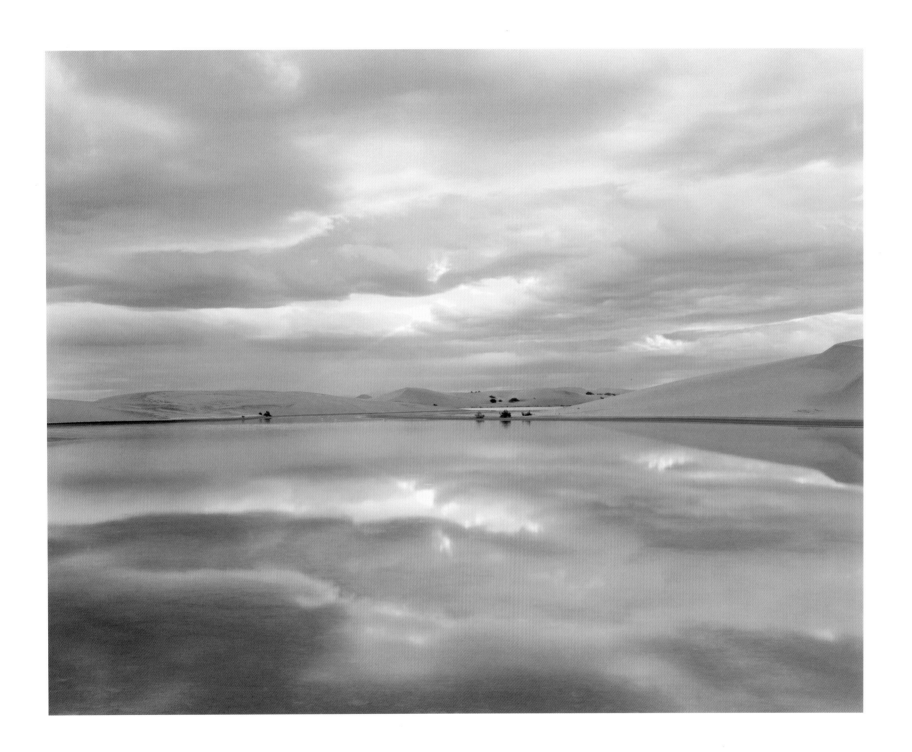

BATTLEGROUND POINT #9

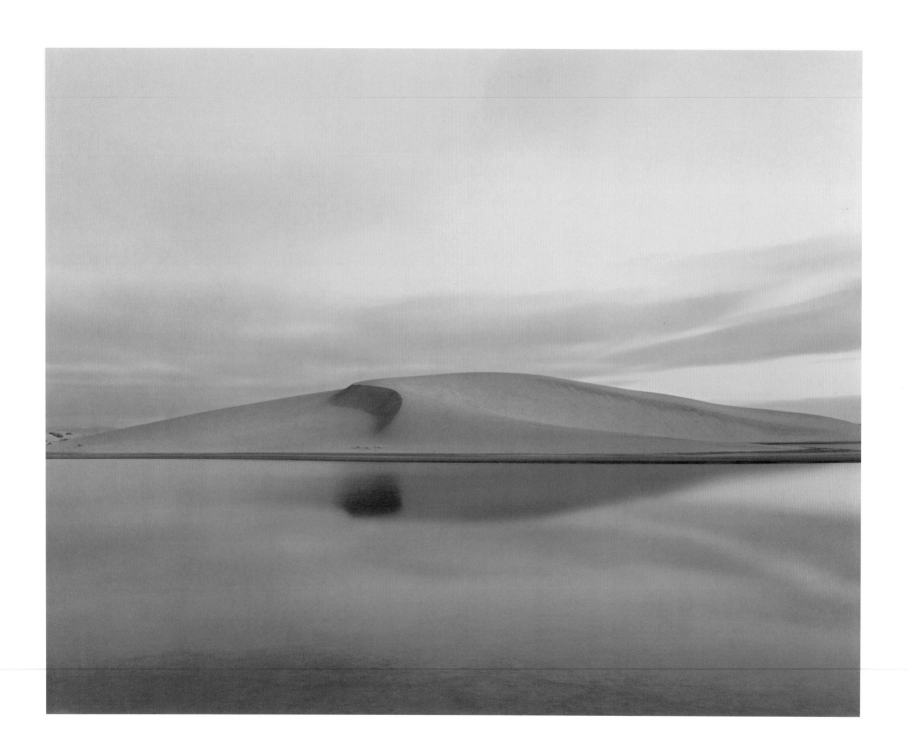

BATTLEGROUND POINT #14

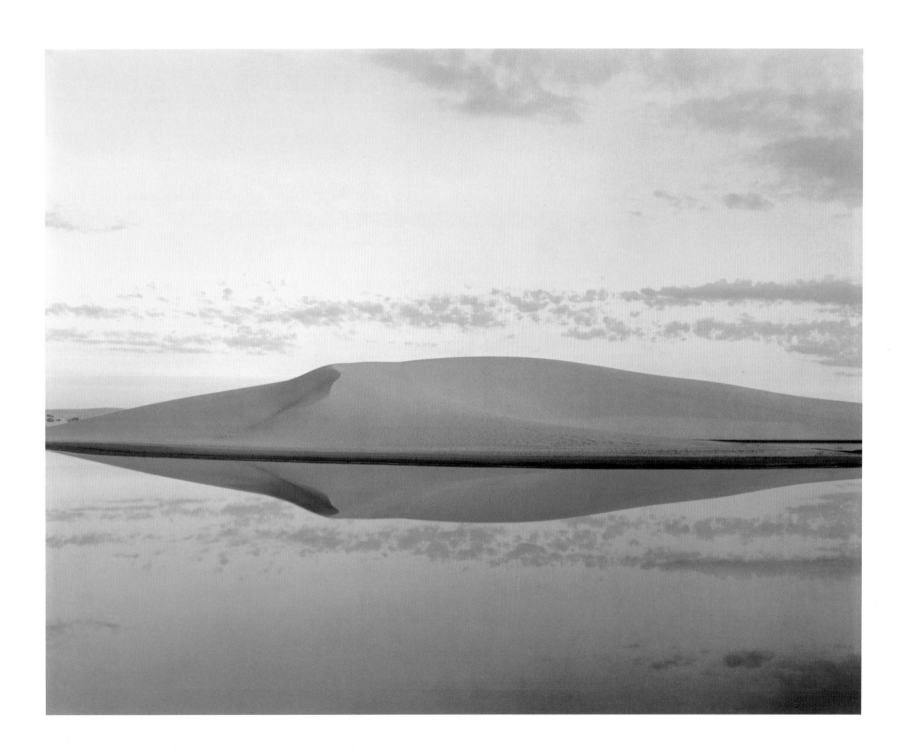

BATTLEGROUND POINT #22

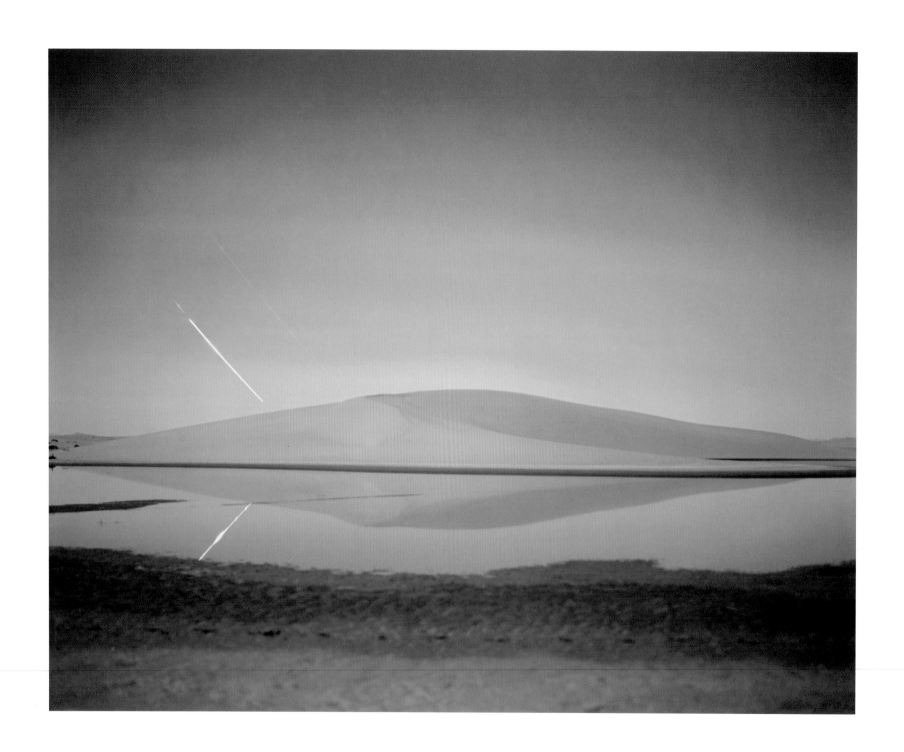

BATTLEGROUND POINT #19

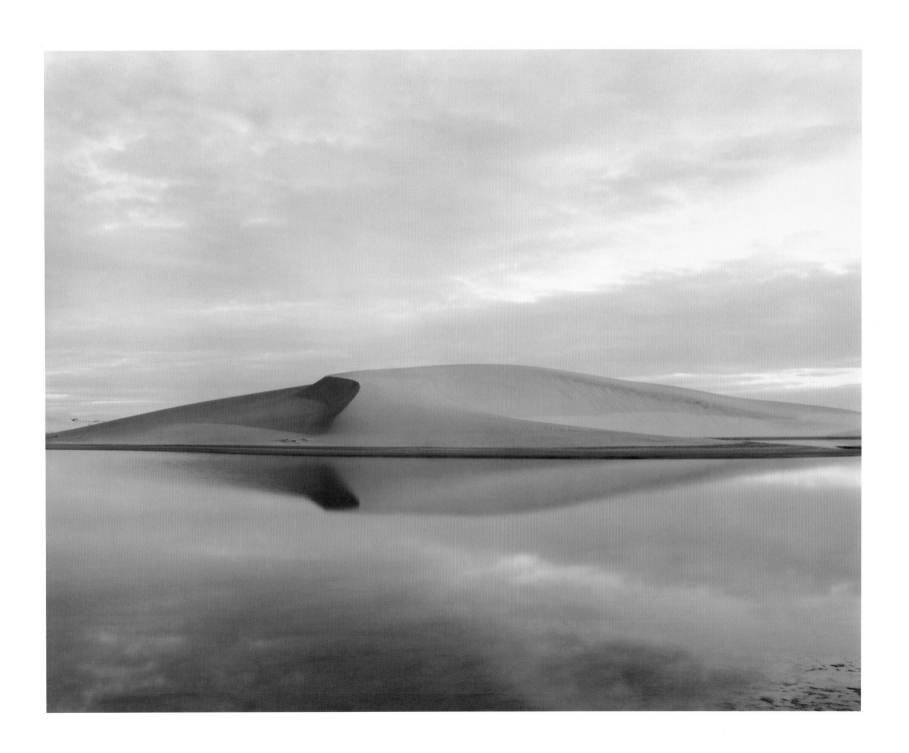

BATTLEGROUND POINT #20

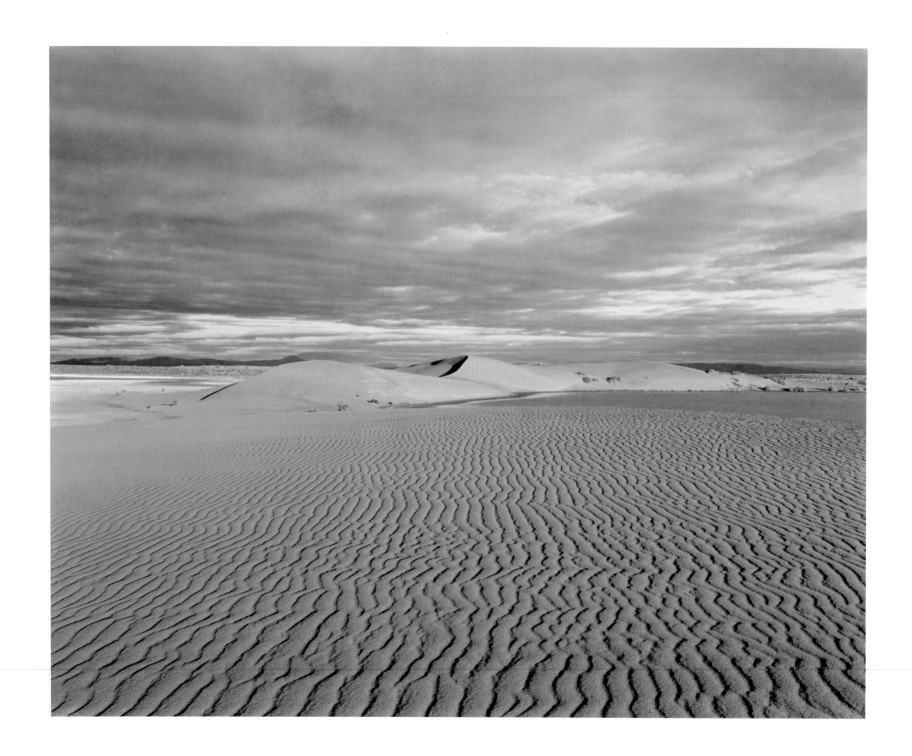

BATTLEGROUND POINT #5

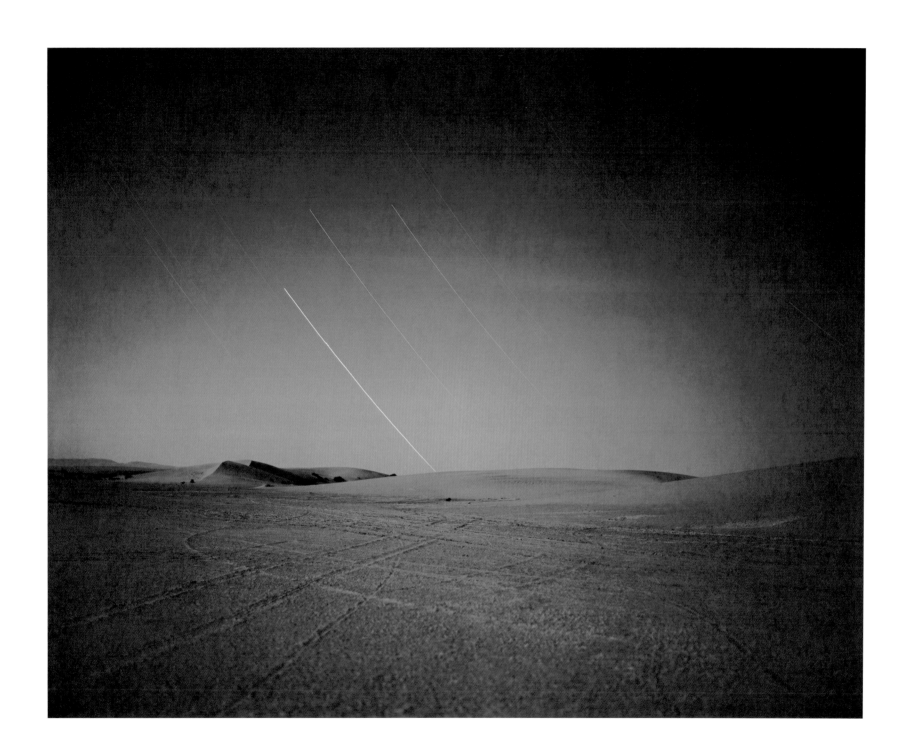

BATTLEGROUND POINT #15

KAREN HALVERSON

COSUMNES RIVER, CALIFORNIA

NO MATTER WHAT THE STATE OF A RIVER, I FIND BEAUTY, desecration, and sometimes a perplexing combination. I am never interested in showing just the beauty, or just the mess we've made. Both things are true. Both interest me because they are *there*.

Since I have photographed dammed rivers like the Colorado in the past, I chose to go to the Cosumnes River, which is still free-flowing. I focused on trees, which interest me right now. The valley oaks were budding and formed wonderful canopies as they extended to the ground. But even when there is something unnatural, like a palm tree—not normally found here—planted in front of an early twentieth-century barn, it is not always ugly. It is part of what's there; it is here and now.

Man-made objects like cars and buildings can become symbols of access and incursion. They state the presence of people in a natural place. The integration of the different forms can be interesting. It is not ironic juxtaposition that interests me. I simply accept what I see. It's all there and all remarkable.

I was alone while photographing at the Cosumnes. There is something very special about being there by yourself. There is just you and the place. There were birds, and they were making a racket, but they moved away as soon as they sensed my presence. They know we can't be trusted. —K.H.

WITHIN A FEW YEARS OF THE CALIFORNIA GOLD RUSH OF 1849, settlers by the score began taming the wide, lush depression running nearly the length of the would-be state of California. Draining sloughs, felling forests, planting crops—eventually harnessing the Sierra-born rivers for irrigation—they transformed the Great Central Valley into the most productive farmland in the United States.

But the Cosumnes River they left undammed. It is the last free-flowing river on the western slope of the Sierra Nevada. Its fertile floodplain of wetlands, grasslands, and farm fields beckons flock upon flock of migratory ducks, geese, cranes, and songbirds, which fuel their long journeys with feasts here of aquatic creatures and rice stubble.

Karen Halverson captures another vital floodplain feature in her images of the increasingly rare valley oaks. Forming what John Muir called "a tropical luxuriance," the oaks of the Cosumnes can reach a hundred feet into the sky, their trunks twelve feet wide. The boughs of these craggy giants once spread across much of the Great Central Valley, but today they are few, their progeny even fewer. They still belong to the Cosumnes, however, because the river moves in its ancient rhythms across the floodplain, and the oaks have evolved in concert with this movement. The Nature Conservancy has found that by breaching key levees on the banks of the river, new groves of valley oaks germinate and flourish.

Today the landscape of the Cosumnes is threatened by the spread of suburbia. In this land squeezed between the fast-growing cities of Sacramento and Stockton, working ranches are being subdivided into "ranchettes," and housing developments are sprouting up where oak groves once did. The Conservancy's strategies include helping farmers and ranchers find ways to stay economically viable and to keep their practices ecologically sound—the best defense against selling out to development. And a major impediment to development along the river has been the 40,000-acre Cosumnes River Preserve itself, the anchor of all the Conservancy's efforts along this still-wild river.

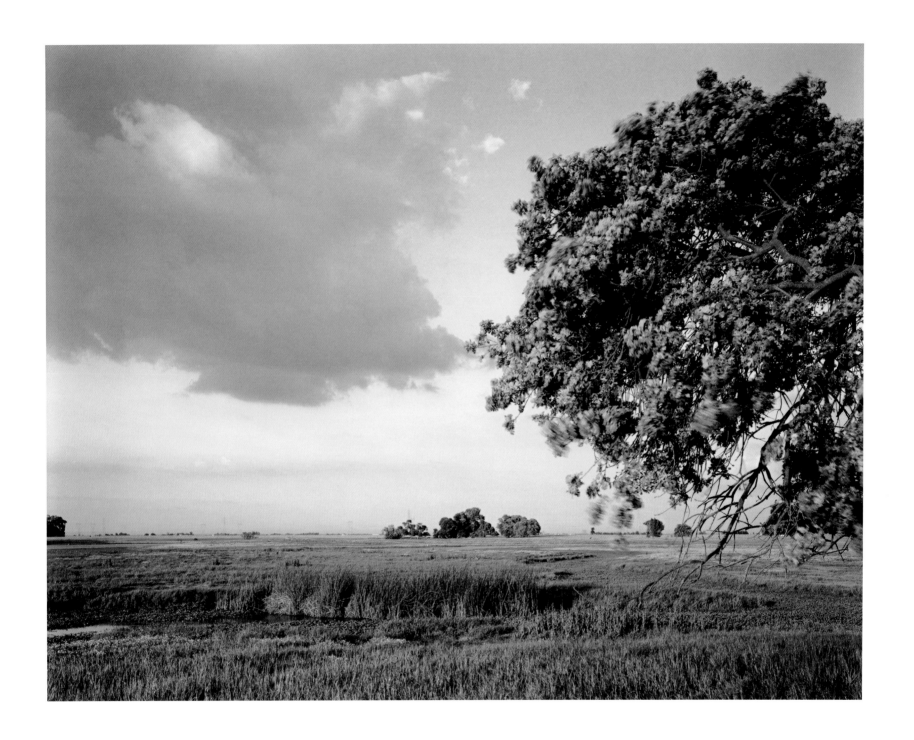

VALLEY OAK TREE, MOYER SLOUGH, COSUMNES RIVER PRESERVE

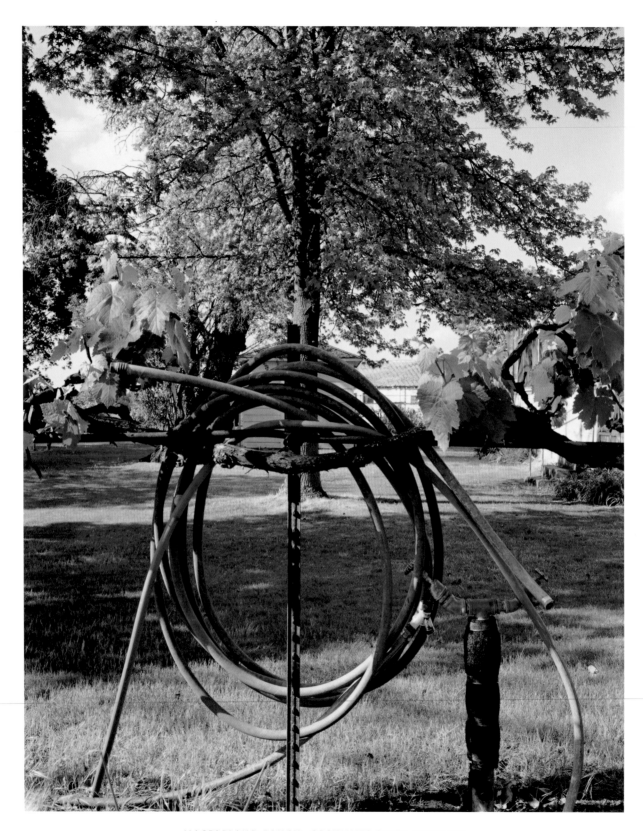

MACFARLAND RANCH, COSUMNES RIVER PRESERVE

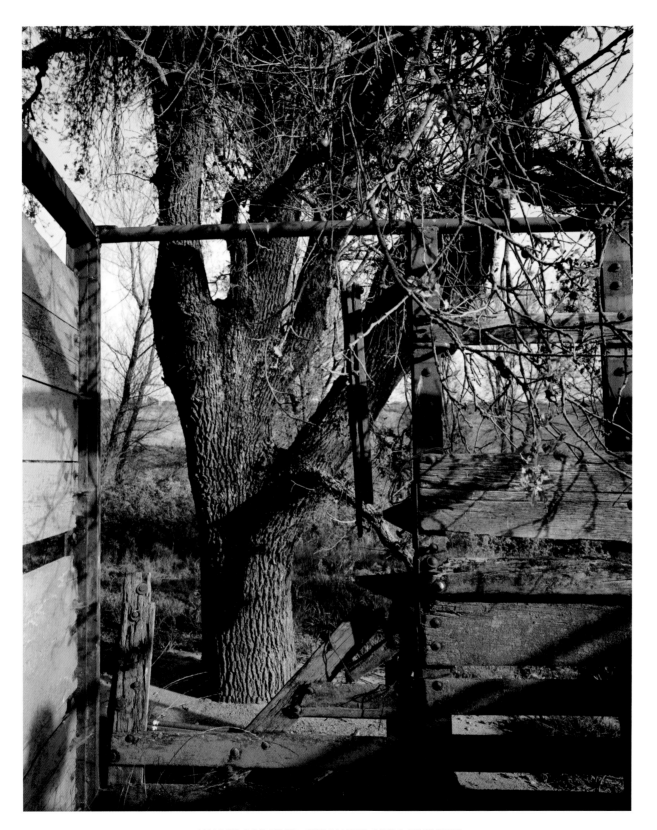

VALLEY OAK TREE, COSUMNES RIVER PRESERVE

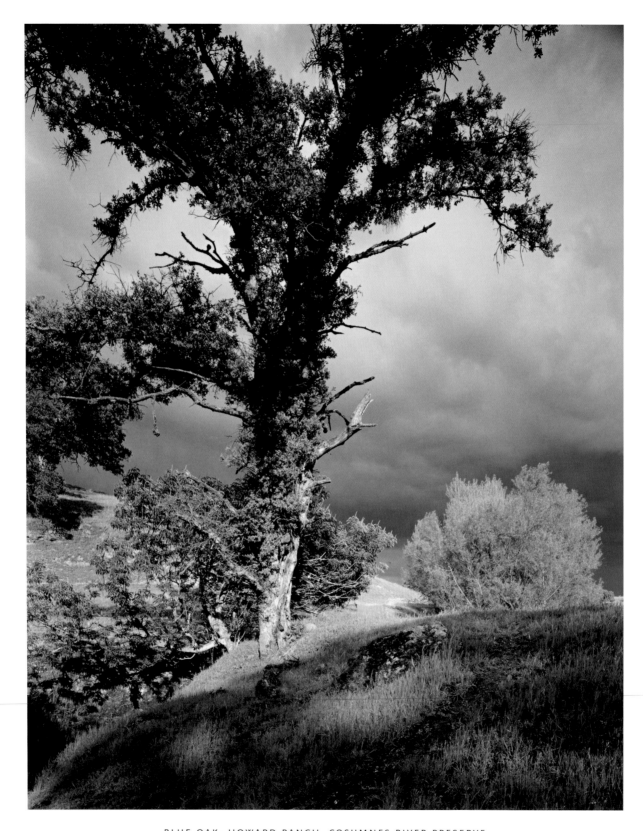

BLUE OAK, HOWARD RANCH, COSUMNES RIVER PRESERVE

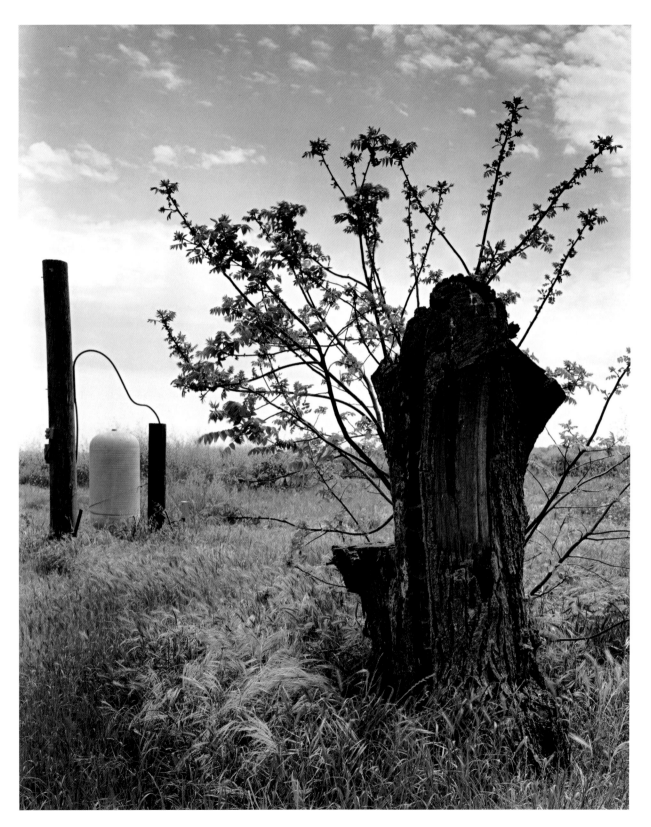

NICHOLAS RANCH, COSUMNES RIVER PRESERVE

CALIFORNIA BUCKEYE TREE, MOYER SLOUGH, COSUMNES RIVER PRESERVE

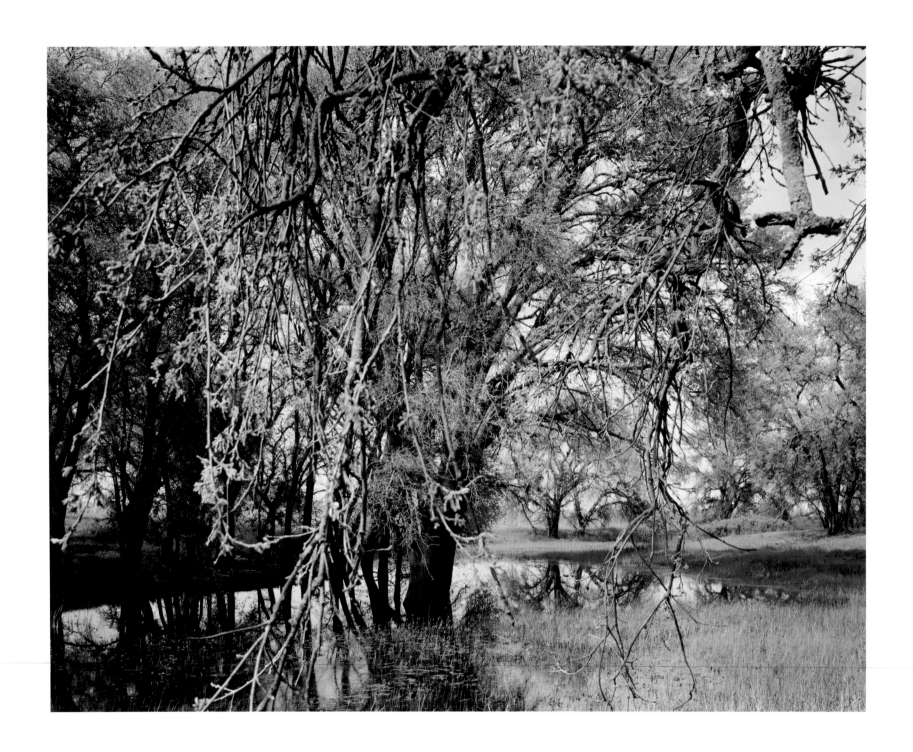

VALLEY OAK TREE, MOYER SLOUGH, COSUMNES RIVER PRESERVE

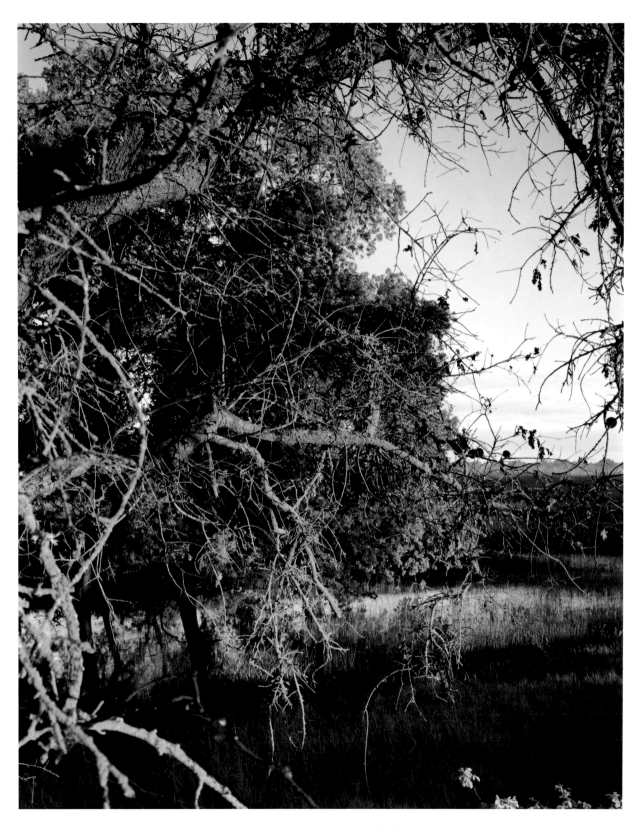

COSUMNES RIVER PRESERVE

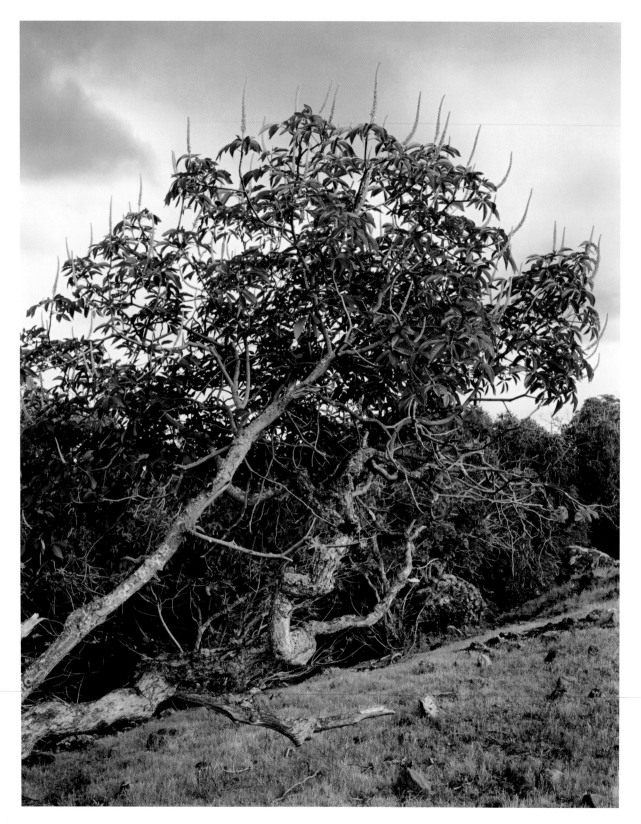

COSUMNES RIVER PRESERVE

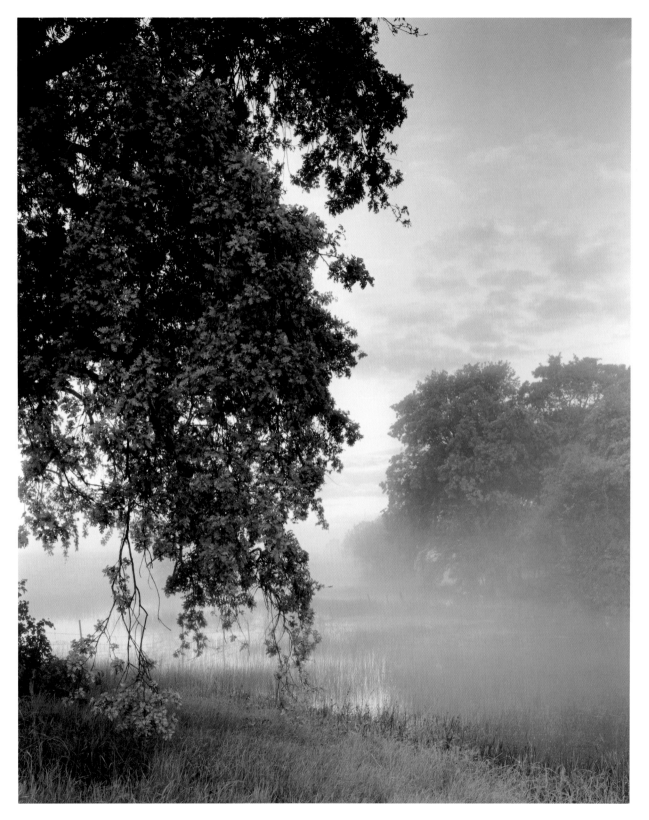

VALLEY OAK TREE, MOYER SLOUGH, COSUMNES RIVER PRESERVE

SALLY MANN

CALAKMUL BIOSPHERE RESERVE, MEXICO

CALAKMUL IS SO REMOTE AND PRISTINE AND UNDEVELOPED. It's jungle, and there are thousands of ruins that are being excavated by young Mayan people. Many of the ruins rise above the canopy of trees, which are rooted in the ground through holes in the debris.

To get there, we drove for hours through a devastated forest, big areas where the trees had been slashed and burned. We didn't see a soul. As we entered the reserve, the foliage encroached and got thicker and thicker; it was like being in a tunnel. When we could drive no farther, we walked through the dense forest. Suddenly, it opened out into a huge cathedral-like place where the pyramids are, rising up to the sky, on out to the solar system. It made you want to genuflect. I couldn't help but feel like one of the discoverers of the place.

I have a sweet spot in my heart for Mexico. Thirty years ago, we were living out on an idyllic crescent of sand in Baja. There was a fishing village and a small beatnik-filled tourist-town. Now that crescent of beach is completely developed. I wanted to come to Calakmul where good work is being done to protect this beautiful part of Mexico.

In Calakmul, I decided to shoot in color. I think I broke some new aesthetic ground. The pictures are like black-and-whites with a subtle watercolor wash. There's a golden fusion to them, conveying the vitality of the place. The sun is so important to the Maya, and it's symbolic in my work here as well. —S.M.

THE TROPICAL FOREST OF CALAKMUL COVERS MORE THAN 1.8 MILLION acres of the southern state of Campeche in the Yucatán Peninsula—once the thriving heart of the Maya Empire. Although the Maya culture lives on in its people, the great temples, pyramids, and palaces of the past have long been engulfed by green jungle, now the protected expanse of the Calakmul Biosphere Reserve.

The forest and ruins form a complex web of cultural and ecological legacies, intricately entwined for centuries. As Sally Mann discovered, the ruins are organic to the forest now, tree trunk rooting cut stone into place. And the same riotous vegetation that has obscured the ruins has also saved them, shielding them from exploitation for decades.

Calakmul blankets the northern end of the humid lowland jungle known as the Maya Forest, which stretches south into Guatemala and Belize—the largest remaining forested expanse in Mexico and Central America. It is inhabited by jaguar, puma, and howler monkeys. It sustains toucans and three hundred other species of birds, including many migratory ones like the indigo bunting and scarlet tanager that winter in the Yutcatán.

The Mexican government declared Calakmul a biosphere reserve in 1987, and six years later, UNESCO recognized its global ecological importance, naming it a Man and the Biosphere Site. But the designations have not been enough to protect it from human-wrought pressures. Within the reserve, only 45 percent of the land is federally owned; the remainder is occupied by *ejidos,* or communal lands that are farmed and logged. From beyond, in waves of migration, people from all parts of Mexico arrive in search of land and opportunity. They bring with them slash-and-burn agriculture and demands for new roads and scarce water supplies.

For the past decade, The Nature Conservancy has worked with the Mexican conservation organization Pronatura Peninsula de Yucatán to protect Calakmul. The partners have trained patrol guards and taught methods of fire prevention and control. They help communities within the reserve develop alternative approaches to agriculture, such as organic farming, and methods that enhance soils and productivity. And they are working to develop incentives for private lands protection, such as conservation easements—a standard tool for conservation in the United States but one that until recently did not legally exist in Mexico.

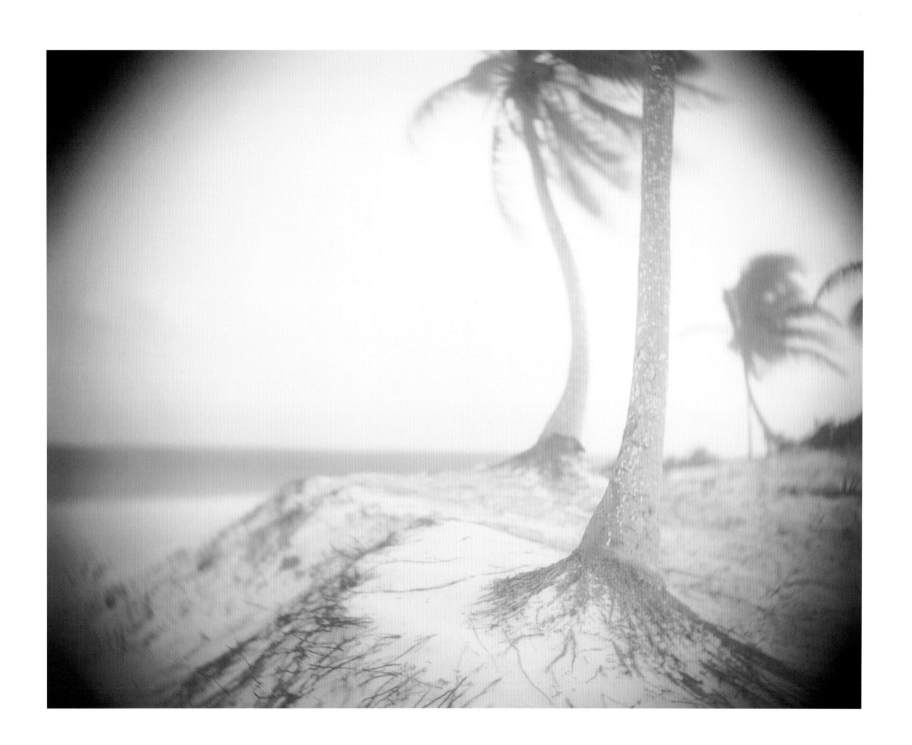

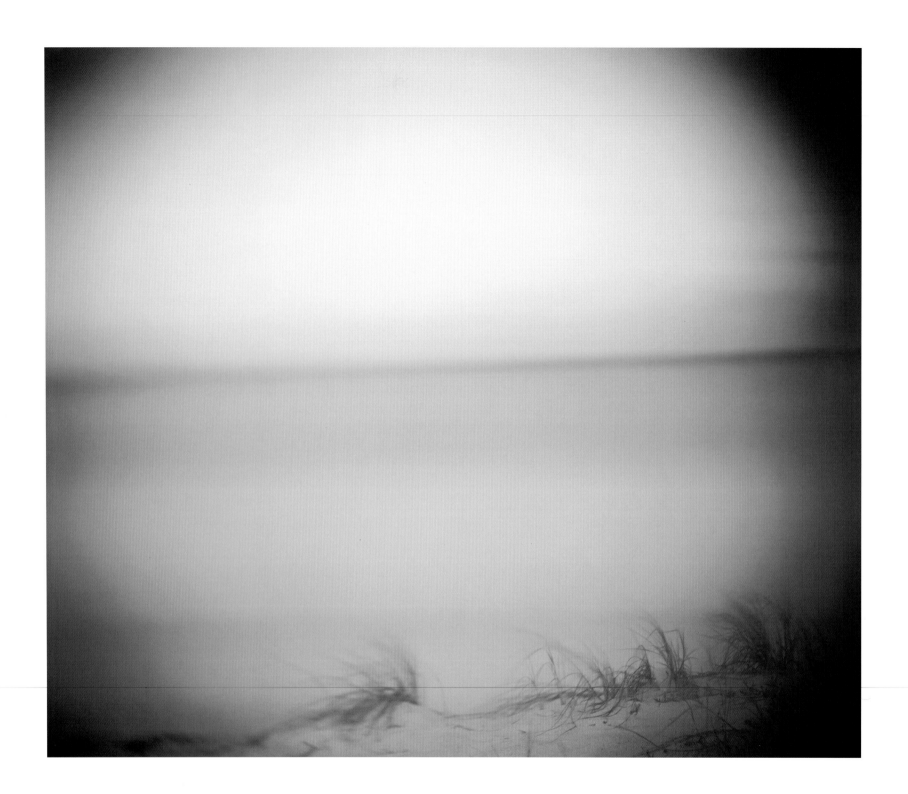

SIAN KA'AN

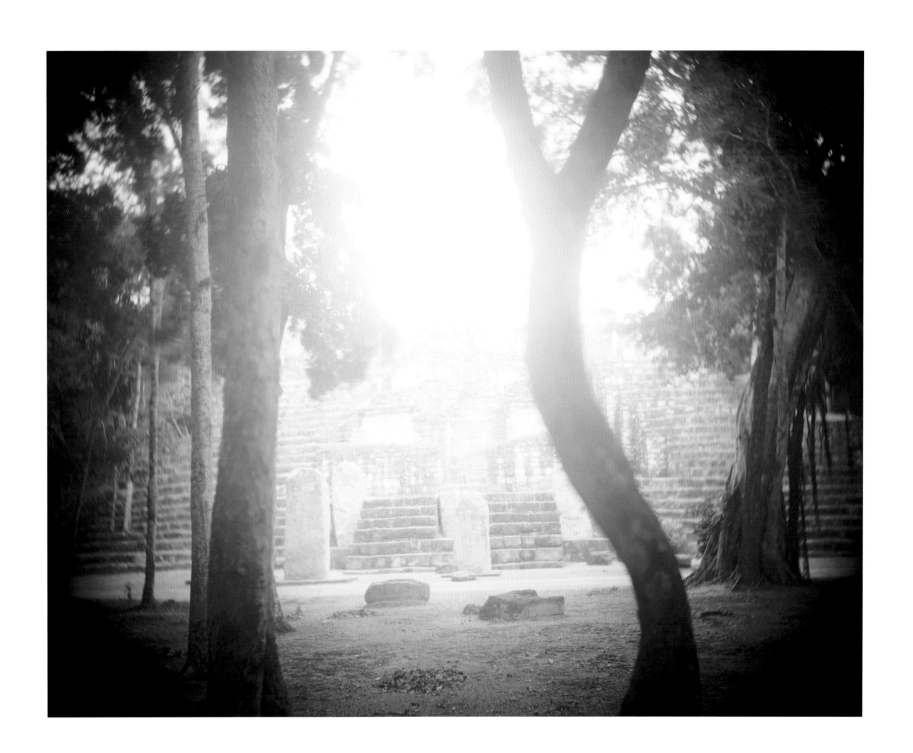

CALAKMUL

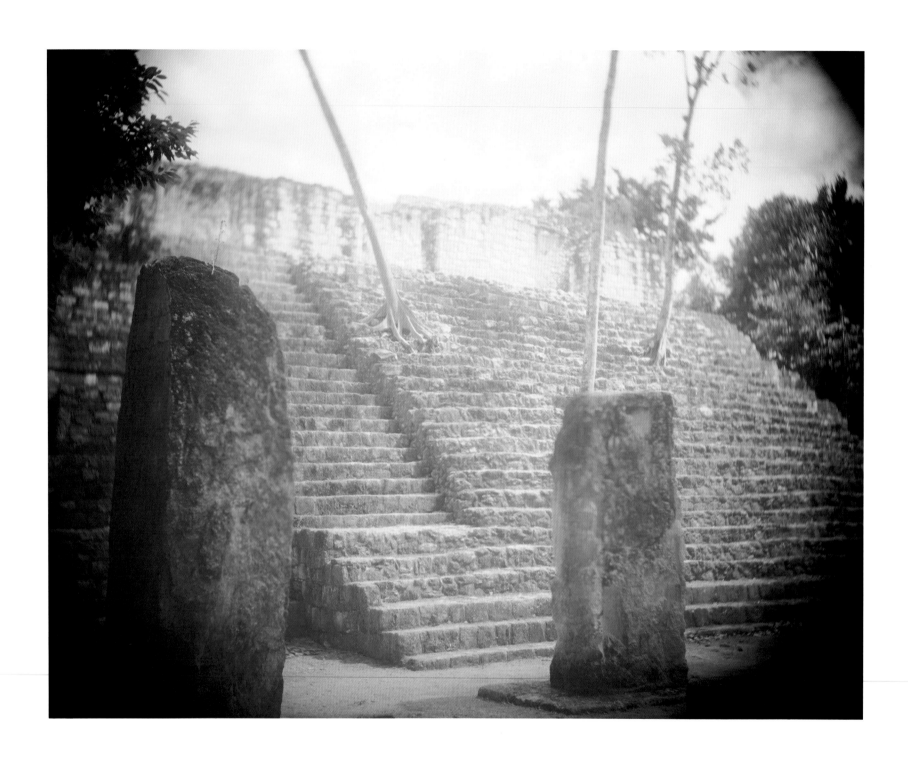

CALAKMUL

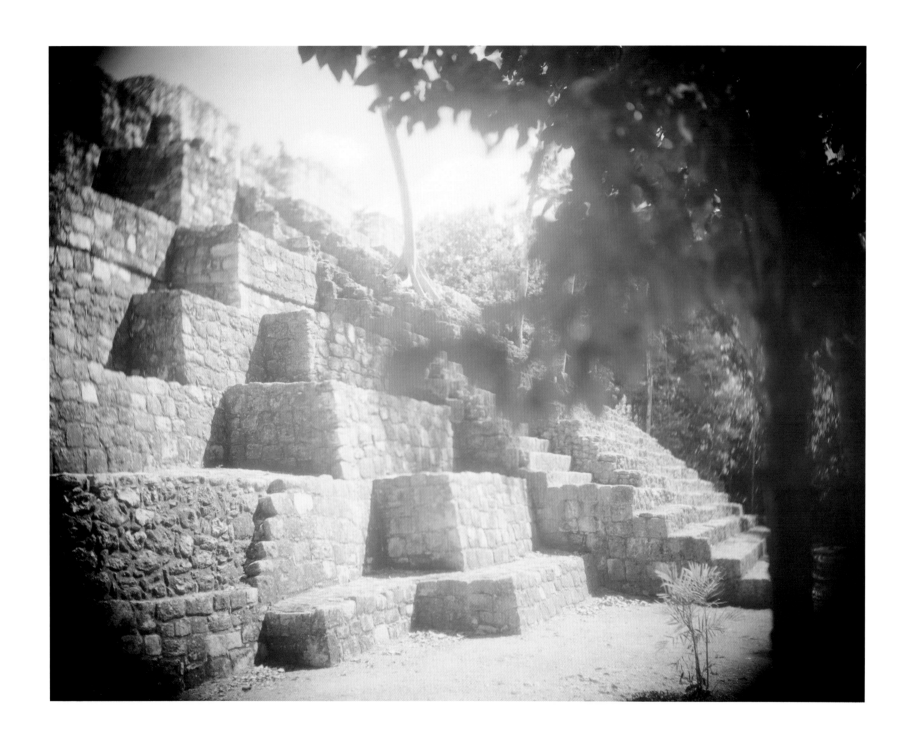

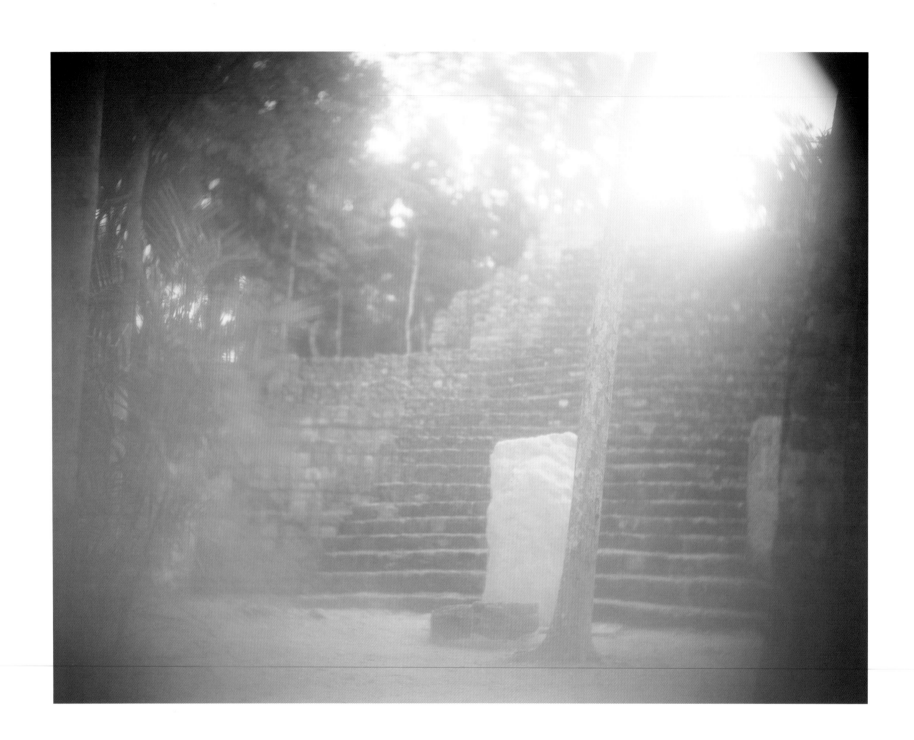

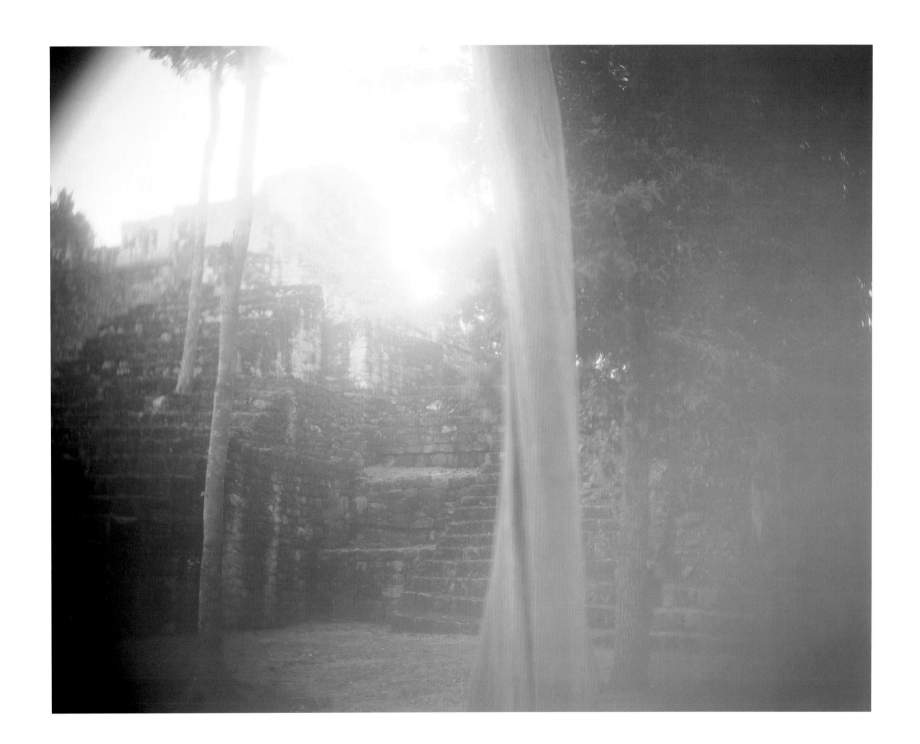

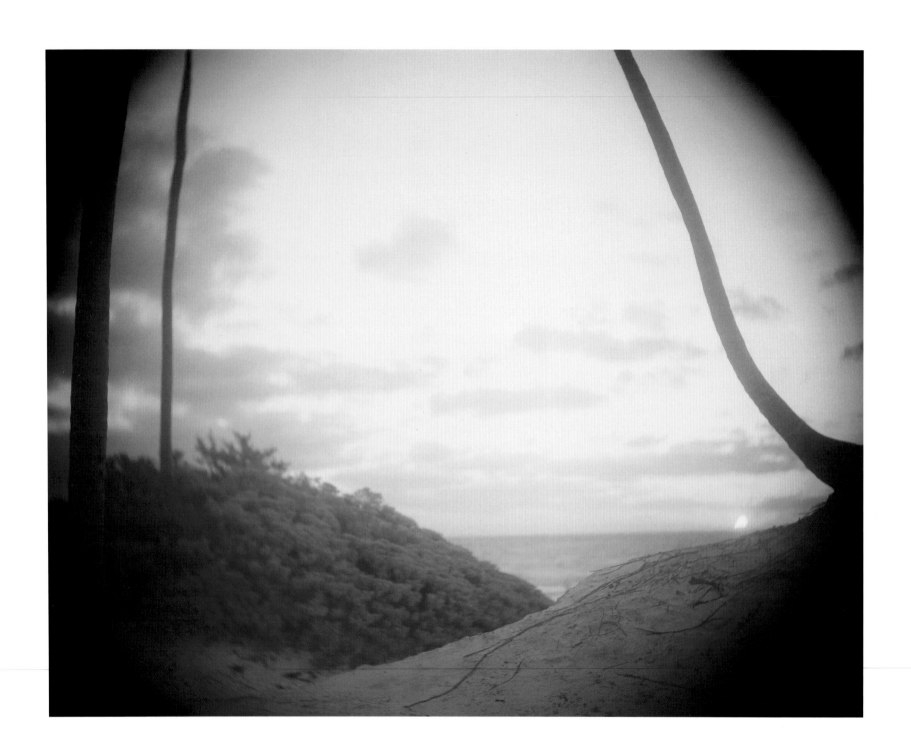

CALAKMUL

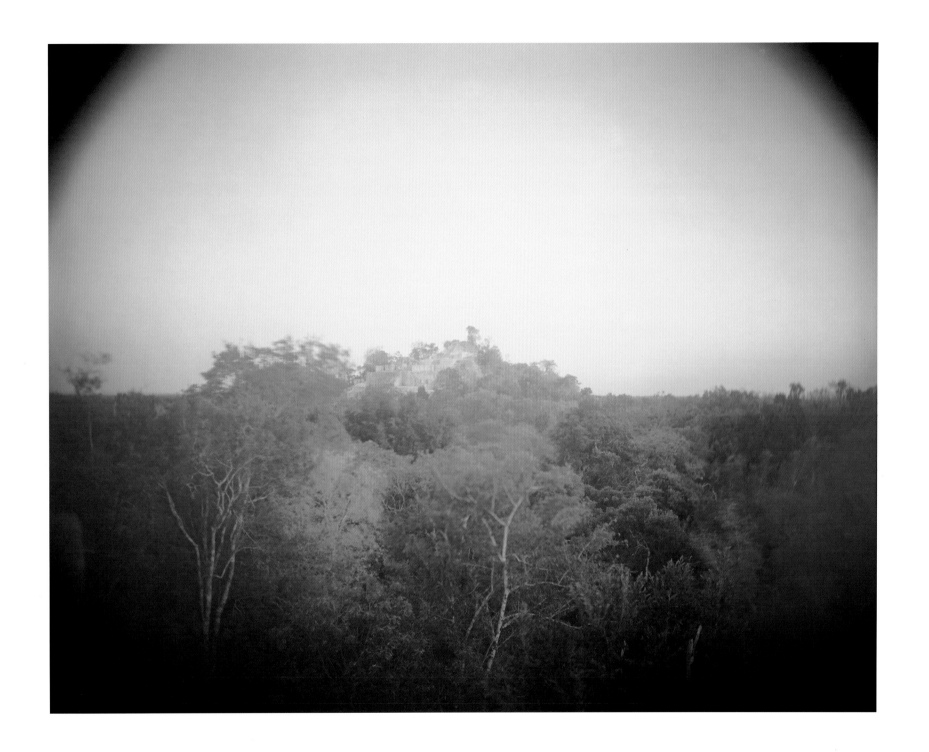

CALAKMUL

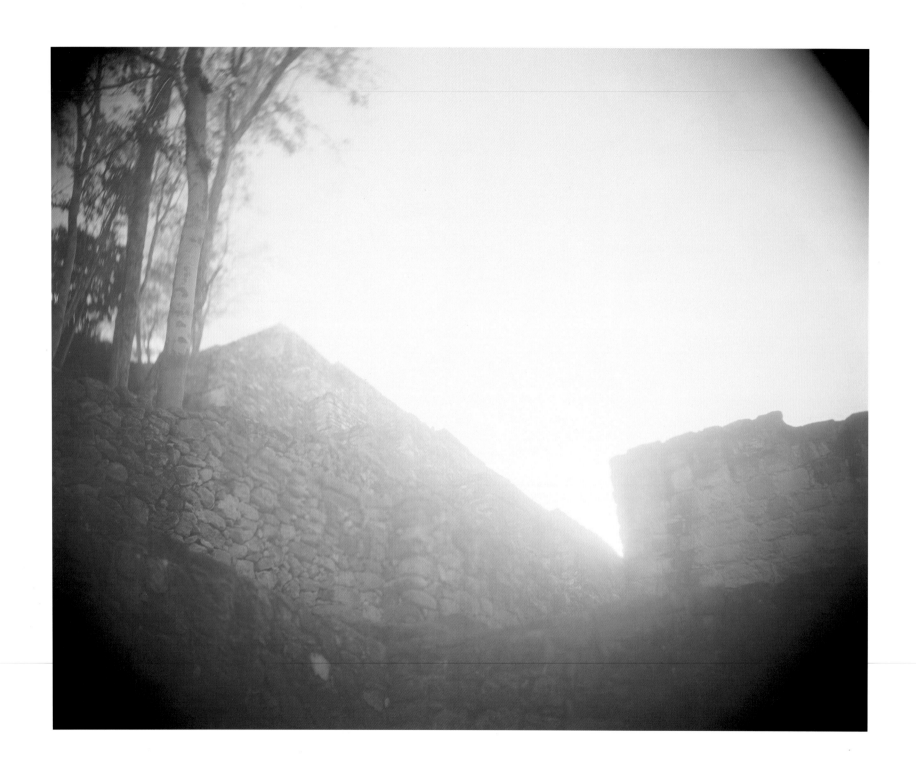

CALAKMUL

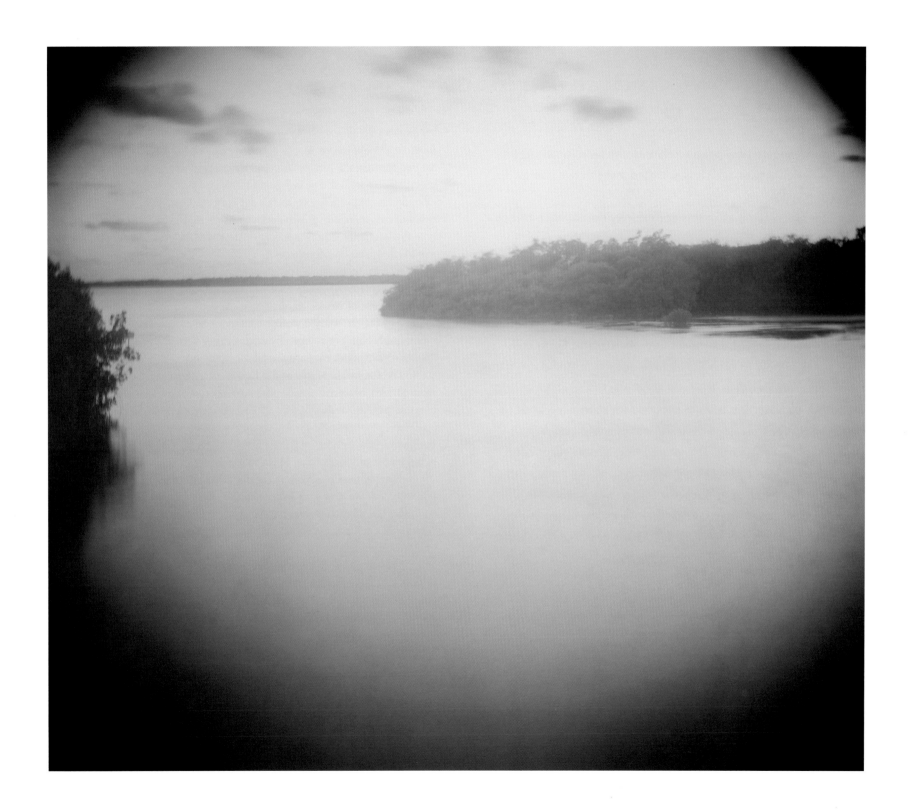

SIAN KA'AN

FAZAL SHEIKH

GRANDE SERTÃO VEREDAS NATIONAL PARK, BRAZIL

MY MAIN CONCERN AS A PHOTOGRAPHER IS COMMUNITY. I like to investigate how people relate to the land in settings like this national park, which is secreted away in the interior of Brazil.

The ninety families in this community do not have title to the land they farm. Their tiny farms sustain just their families. Their ideas about community and themselves are completely constructed around what they know from this spot on Earth.

In a short time, they shared their feelings with me about place, rituals, and connections to the land, which they view with a kind of enchantment—a mix of Catholicism and Earth cult. They speak of how to keep the evil eye away from the door. If the rains come late one year, they will send one of the children into the woods to water the termite mounds for nine days, and the rains will come. They have beautiful notions and beliefs.

As in my earlier work, I explored how people reconcile themselves to loss through their belief system. As I made my photographs I listened to people's voices, which resonate with the images. Through their voices, their faces, and their hands, they teach us about the landscape and how they survive. Theirs is a story of land lost, exile, and sanctuary. —F.S.

THE CERRADO IS A VAST SAVANNA-LIKE REGION SPRAWLING ACROSS more than a quarter of Brazil. A tragedy of loss has been playing out here for two centuries, a loss of land and natural habitats that can be likened to what was lost with the plowing and taming of the American prairie. The Cerrado has become the country's agricultural heartland, with cattle and fields of commercially grown soybeans, rice, and corn coming to dominate the landscape, and water quality degraded by erosion and the heavy use of chemicals and fertilizers.

By some estimates, only 10 percent of the true Cerrado remains. On part of this land was created Grande Sertão Veredas National Park— 200,000 acres of native grasslands, palm communities, and forests roamed by jaguar, maned wolves, and giant anteaters. Yet the park is increasingly being enveloped by encroaching agriculture, threatening the sources of water that are the park's lifeblood.

The forgotten people of the Cerrado are those photographed by Fazal Sheikh. They are people who have scraped a living from the land for generations but do not own it. They are the ones trampled by the onslaught of large-scale commercial agriculture. Their continued presence within the bounds of the national park is at odds with the law. This is the "exile" of which Fazal Sheikh speaks.

The Nature Conservancy and Brazilian partner organization Funatura are working with Brazil's land reform ministry to relocate these communities of subsistence farmers to land outside the park, land with better soils for farming. More, they will be given title to their new land. They will have a certainty about their futures that they have never had before. Funatura and the Conservancy hope to help these people build sources of alternative income from the budding ecotourist industry at Grande Sertão Veredas National Park. Whether as park guards or nature guides or traditional farmers, they will remain fundamentally connected to their homeland.

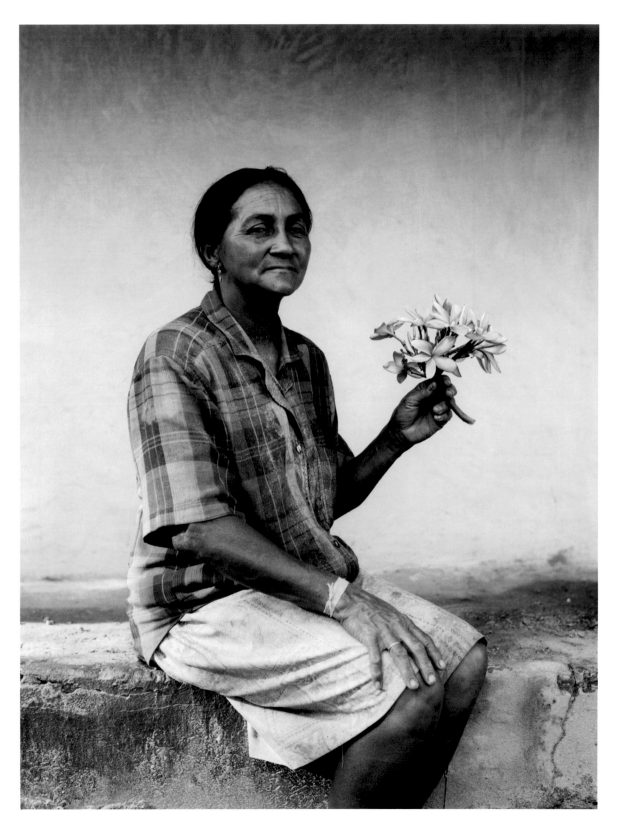

DONA ANTÔNIA

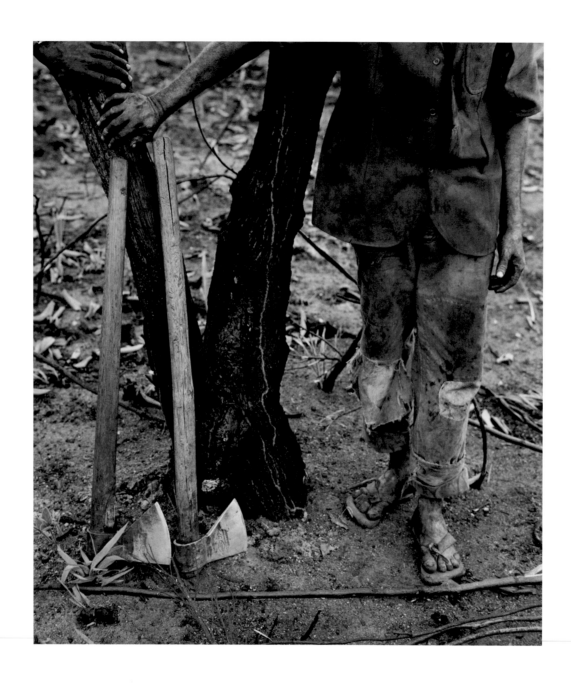

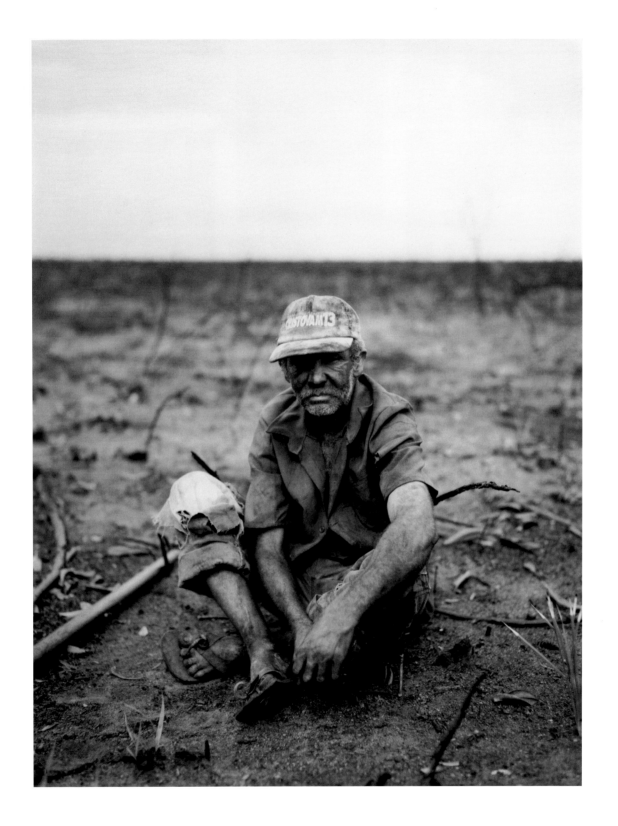

MAURO FERREIRA DAS NEVES WORKS AS A MIGRANT LABORER BURNING AND CLEARING THE LAND
ON THE FARMS AROUND GRANDE SERTÃO VEREDAS (ABOVE AND OPPOSITE).

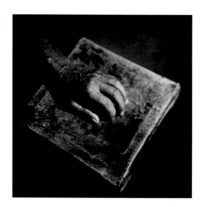

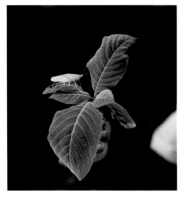

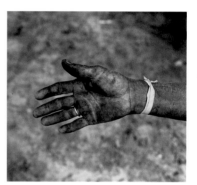

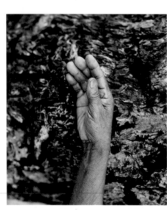

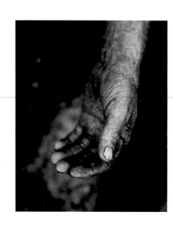

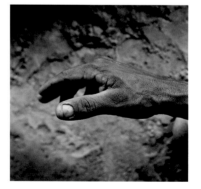

THE HOPE GRASSHOPPER. DONA ANTÔNIA'S WISH-RIBBON BRACELET. FIVE CENTURIES WORK THE LAND AT BLACK RIVER.

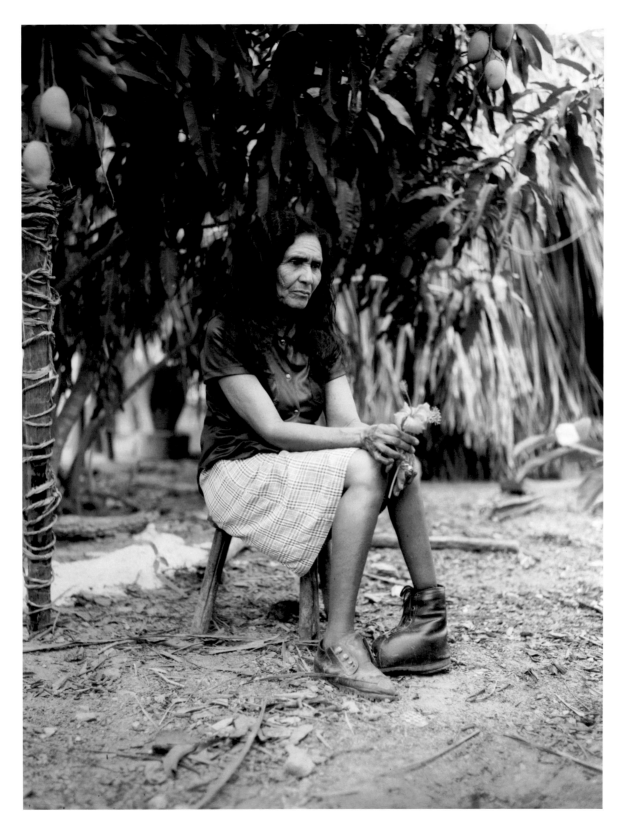

DONA NIKA IN HER GARDEN

TO CURE IMPOTENCE:
FIRST CATCH A FREE-RANGE CHICKEN. CUT THE CLAWS FROM ITS BACK FEET AND ROAST THEM.
THEN, PUT THE POWDERED CLAWS INTO A LITER OF WHITE WINE.
AFTER NINE DAYS SERVE A GLASS OF THE WINE TO THE PERSON AT LUNCH AND AGAIN AT DINNER.
NOTE: THE PERSON WHO IS TAKING IT SHOULD NOT KNOW WHAT IT IS FOR.

TO MAKE THE RAINS COME: IF THE RAINY SEASON COMES AND THERE IS NO RAIN,
SEND THE CHILDREN INTO THE HEART OF THE FOREST NINE DAYS IN A ROW.
TELL THEM TO WATER THE TERMITES. WHEN THIS IS DONE, THE RAINS WILL SOON ARRIVE.

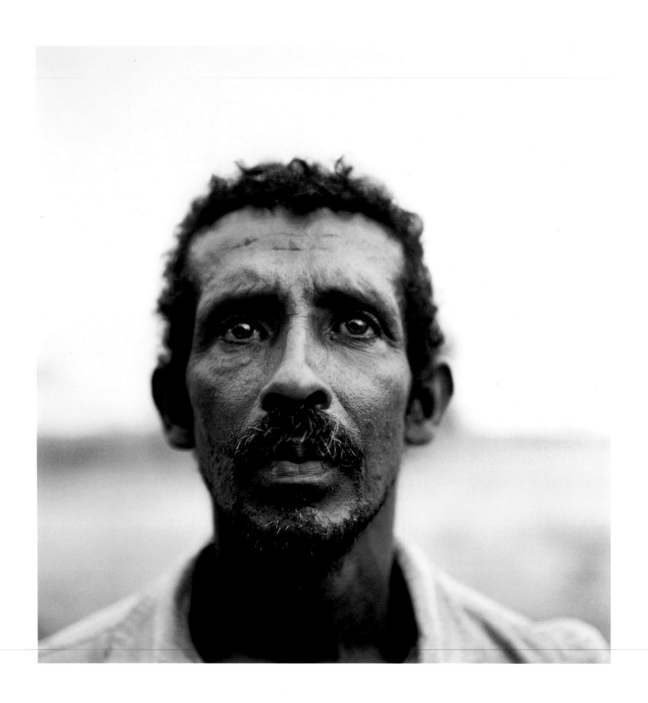

GUMERCINDO LISBOA SUPPORTS HIS FAMILY BY WORKING AS A MIGRANT LABORER
ON PAOLO'S FARM NEAR THE GRANDE SERTÃO VEREDAS.

DONA ANTÔNIA'S PORCH

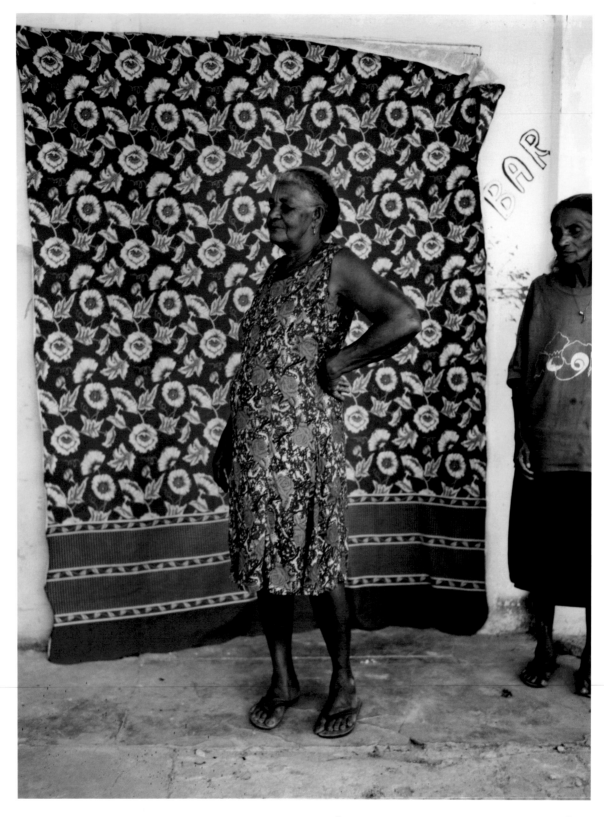

GLORI RODRIGUES DA SILVA IN SERRA DAS ARARAS, "LISTENING TO THE COWBOYS TELL LIES"

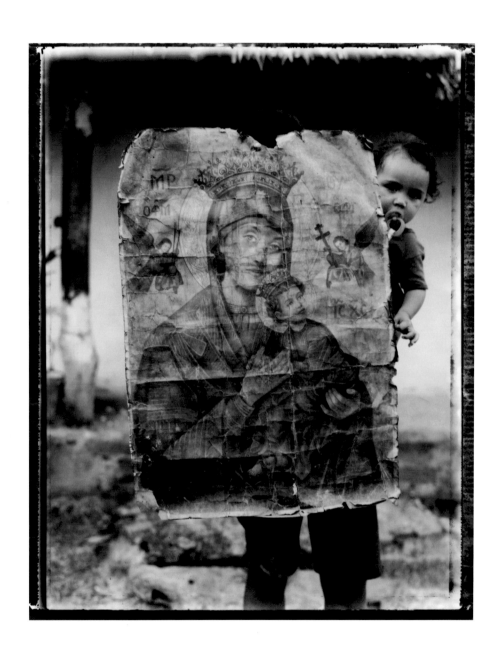

DONA ANTÔNIA'S DAUGHTER AND GRANDDAUGHTER WITH THE FAMILY ICON

HOPE SANDROW

KOMODO NATIONAL PARK, INDONESIA

MY WORK IN WATER IS ABOUT MOVEMENT AND CHANGE and flow. I let myself become one with the flow of the water, so that my picture making is actually part of being in the water.

There's great energy at Komodo. I had never been in such fast currents before. These are huge bodies of water, and when the tides change, they filter through Komodo and all the small islands, creating an incredible rush of water back and forth.

I would put my head down, snorkeling with my camera, and when I looked up I'd have moved a thousand feet downstream. It was the perfect place to be. Always, there was that sense of the unknown as I took my first step off the boat. It gave me great respect for nature—those huge bodies of water, with so much energy underneath.

The most startling moment was when we first arrived in the harbor, which you could tell hasn't changed since its creation. Wild boars came out of the hills, and there were manta rays in the water. You feel that nothing ever changes. Yet people there believe life is in constant flux. They carve out of soft materials because they have this idea that things are not going to last long. —H.S.

THE INDONESIAN ARCHIPELAGO FLOATS BETWEEN THE REALMS OF Asia and Australia. At this biogeographical crossroads have evolved fantastic creatures such as the Komodo dragon and a diversity of coral species unmatched anywhere in the world.

Komodo National Park, a U.N. World Heritage Site, covers more than 500 square miles of three large islands, many smaller ones, and the marine habitats among them. Flowing constantly on the strong currents in which Hope Sandrow swam, their waters are nutrient-rich and brimming with sea cows, green turtles, giant clams, whales, and more than a thousand species of fish.

Yet destructive fishing practices are devastating the park's marine wealth at an alarming rate. Blast fishing, in which explosives are dropped onto the reefs, has reduced more than half of Indonesia's coral reefs to fields of rubble, the dead hulls of once live and colorful organisms. Throughout the seas of Southeast Asia, blast fishing and an equally harmful practice—dumping sodium cyanide to stun and capture fish alive—are used to meet the demand for exotic live reef fish from restaurants in Hong Kong, Taiwan, and mainland China.

To counter this live reef fish trade and protect the region's remaining coral ecosystems, The Nature Conservancy has worked to bring the problem into the international spotlight, as well as to find more local solutions. At Komodo, it is developing a mariculture project to farm commercially prized fish such as grouper and coral trout. Experts gauge that a thriving fish-farming industry will reduce the pressure on coral reefs and increase the standard of living for islanders.

Already in Komodo, incentives for local fishermen have reduced blast fishing by 90 percent, and ecologists have seen new coral growth in the rubble fields. If the project is successful, the Conservancy hopes to replicate it at other priority conservation sites in the region. The work is part of a vision to protect the fantastic life and energy of the Pacific's coral seas that Hope Sandrow saw and felt in the Komodo straits.

Hope Sandrow's multi-image panorama photographs reproduced here are one element of an artist's installation that also includes boxes filled with the ground remains of dead coral and an online component, TIME(space), that is accessible from the artist's Web site, www.hopesandrow.com

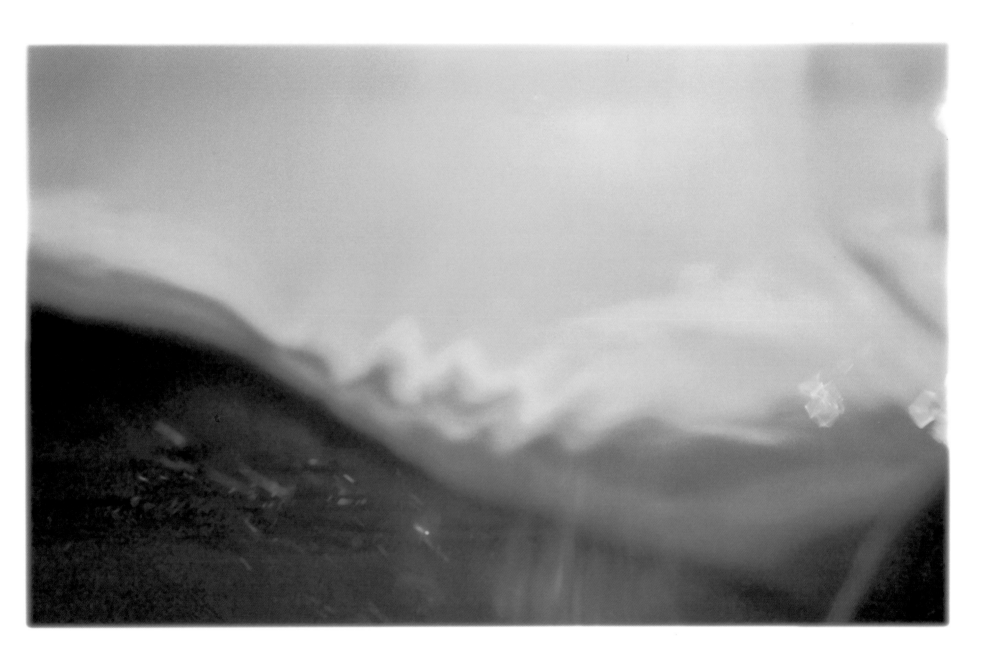

SELAT FLORES, INDONESIA (PANEL ONE)

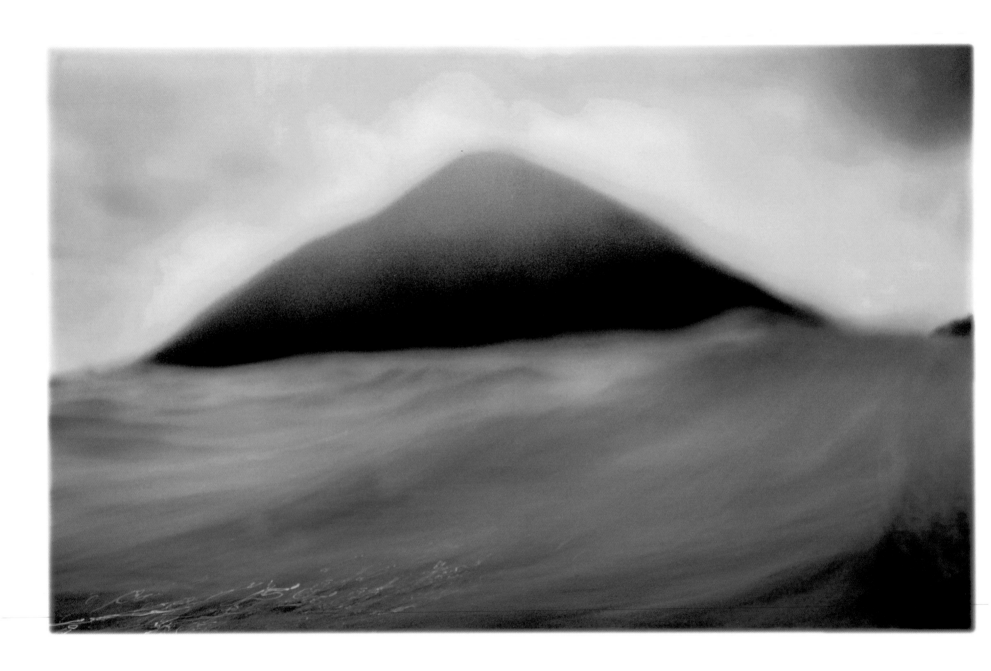

SELAT FLORES, INDONESIA (PANEL TWO)

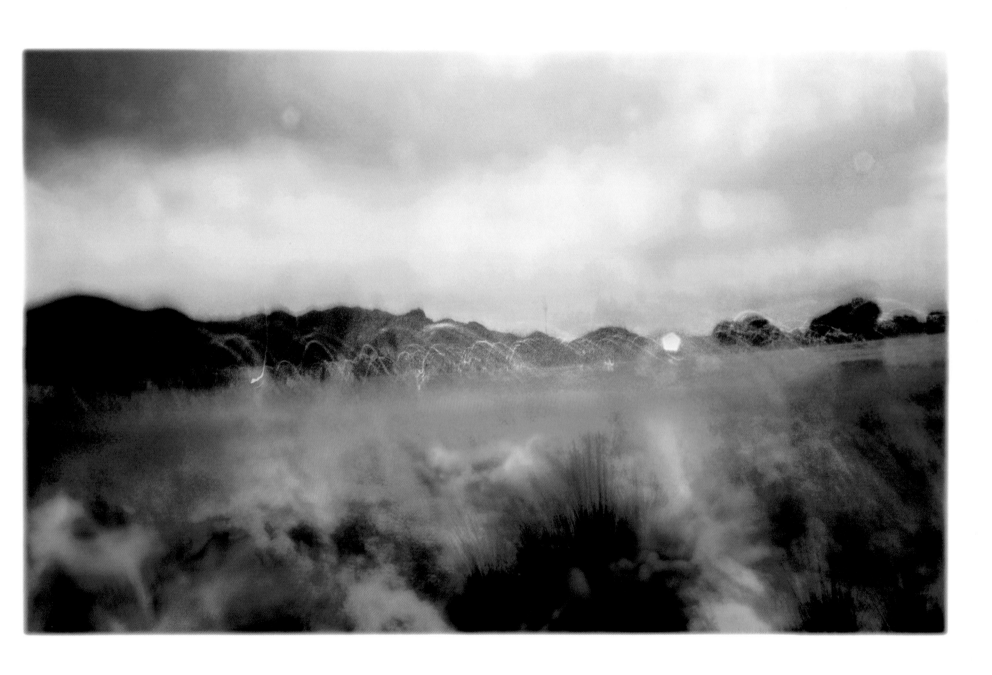

SELAT FLORES, INDONESIA (PANEL THREE)

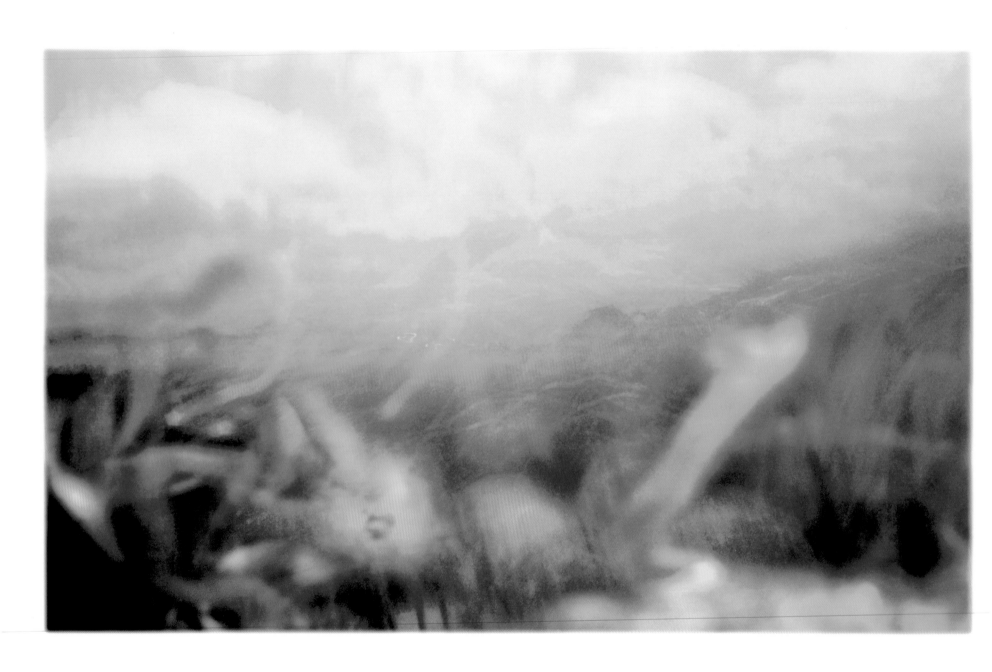

SELAT FLORES, INDONESIA (PANEL FOUR)

152

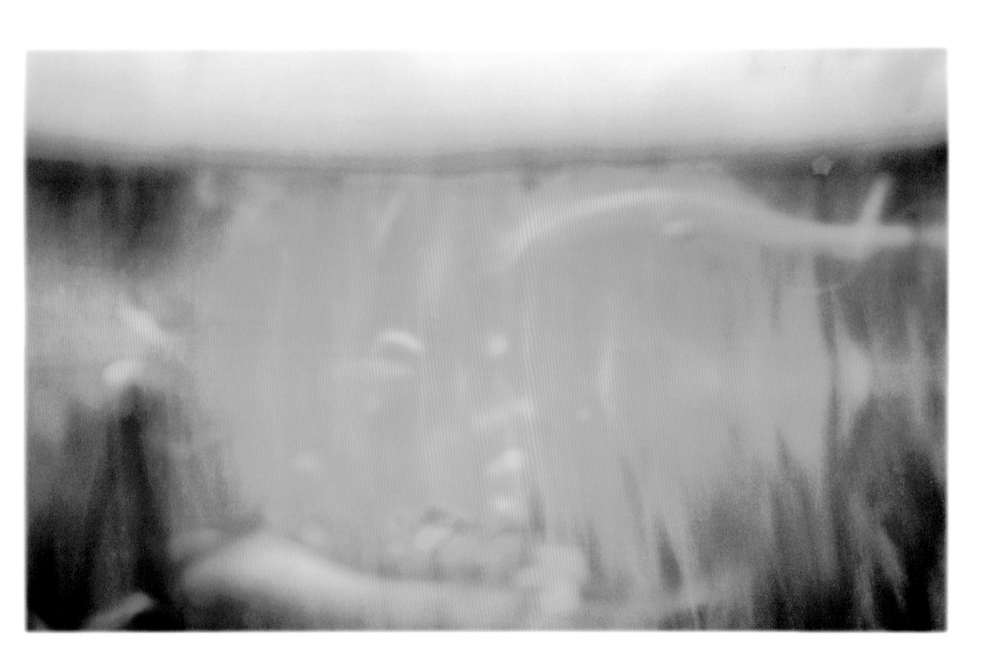

SELAT FLORES, INDONESIA (PANEL FIVE)

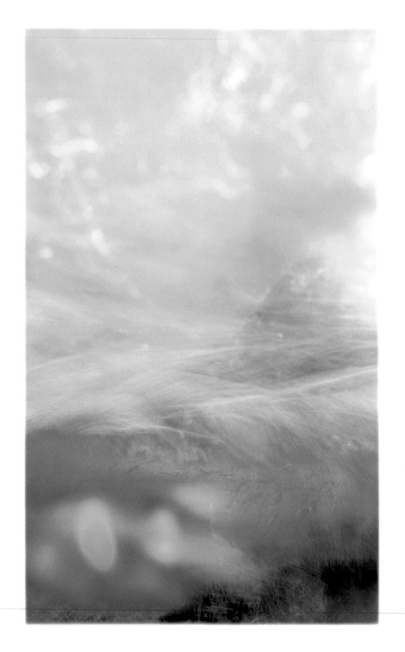
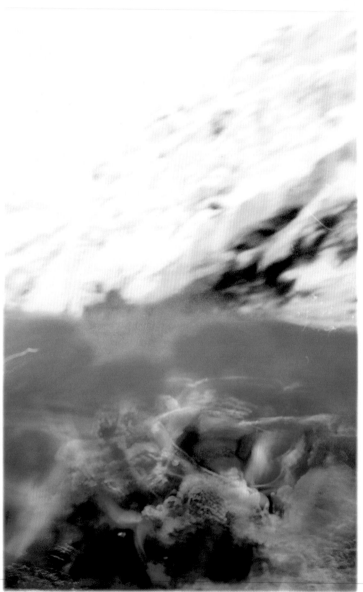
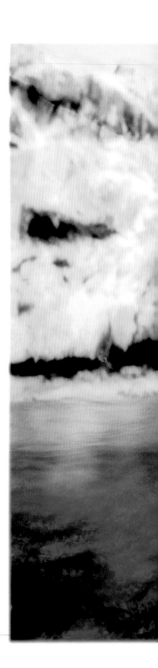

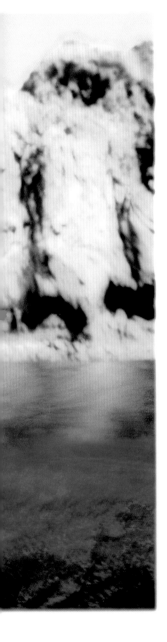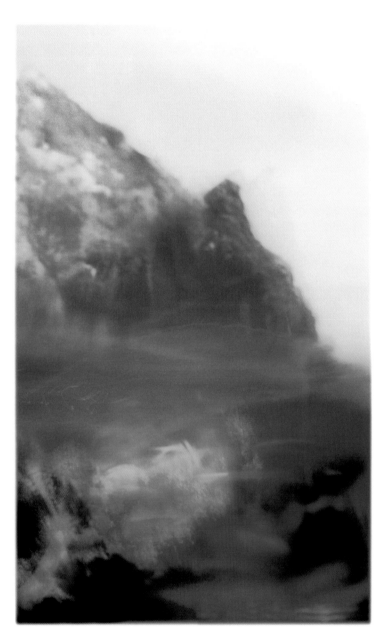

ISLAND OF RINJA, TELUK LEHOKUWADADASAMI, KOMODO NATIONAL PARK, SELAT SUMBA, INDONESIA

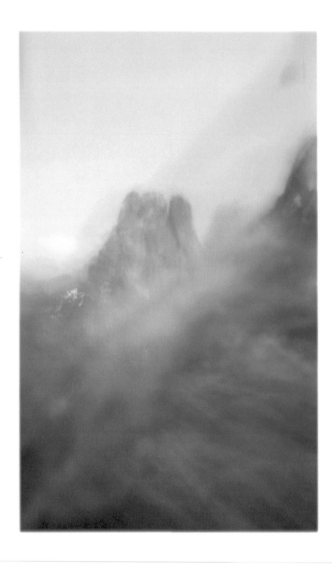

ISLAND OF KOMODO, SELAT LINTA, KOMODO NATIONAL PARK, INDONESIA

ARTISTS' BIOGRAPHIES

WILLIAM CHRISTENBERRY

For more than thirty years, William Christenberry has been making pictures in and around Hale County, Alabama, documenting rural southern landscapes and the worn, remote margins of small-town life. His photographs are included in the permanent collections of the Museum of Modern Art, New York; the Phillips Collection; the Smithsonian's American Art Museum; the High Museum of Art, Atlanta; the Corcoran Gallery of Art, Washington, D.C.; and the Library of Congress. He is represented by Hemphill Fine Arts in Washington, D.C.; the Morgan Gallery in Kansas City, Missouri; and the Pace/MacGill Gallery in New York City.

LYNN DAVIS

Renowned landscape photographer Lynn Davis began her career as an apprentice to Berenice Abbott in the summer of 1974. Her work focuses on cultural and natural monuments around the world. Her photographs are included in the permanent collections of the Museum of Modern Art, New York; the J. Paul Getty Museum, Los Angeles; and the Hallmark Collection. She is represented by the Edwynn Houk Gallery in New York City.

TERRY EVANS

Noted for her haunting and hopeful images of the American prairie, Terry Evans captures the farmlands, meadows, wetlands, and forests that symbolize the heartland. Her work has been exhibited in museums nationwide and is in the permanent collections of the Art Institute of Chicago; the Museum of Modern Art, New York; and the San Francisco Museum of Modern Art. She is represented by the Yancey Richardson Gallery in New York City and the Carol Ehlers Gallery in Chicago.

LEE FRIEDLANDER

A son of Washington's Olympic Mountains, Lee Friedlander has been a devotee of wild places all his life. He is known for breaking with convention as well as artfully documenting the buried details and symbols of a visually satiated society. His photographs are included in the permanent collections of the Metropolitan Museum of Art, New York; the Museum of Fine Arts, Boston; and the Victoria and Albert Museum, London. He is represented by the Fraenkel Gallery in San Francisco and Janet Borden Inc. in New York City.

KAREN HALVERSON

Landscape photographer Karen Halverson has spent a great part of her career documenting the anomalies, ironies, and wonders of the American West, from the Colorado River to Southern California to the "New West" of subdivision and sprawl. Her work is in the collections of the San Francisco Museum of Modern Art; the Corcoran Gallery of Art, Washington, D.C.; and the Smithsonian's American Art Museum. She is represented by the Paul Kopeikin Gallery in Los Angeles, Alan Klotz/Photocollect in New York City, the Yancey Richardson Gallery in New York City, and the Sandra Berler Gallery in Washington, D.C.

ANNIE LEIBOVITZ

Known around the world for her portraits of political and cultural icons, Annie Leibovitz in recent years has focused on capturing more than just famous faces. Her work portraying everyday women, for example, has ranged from a Las Vegas showgirl to an elderly carnival performer. Her images are included in the collections of the National Portrait Gallery, Washington, D.C., and she is represented by the Edwynn Houk Gallery in New York City.

SALLY MANN

Sally Mann's highly acclaimed *Immediate Family* series was followed by a series of landscapes of her native South. Her work is in the permanent collections at the Whitney Museum of American Art; the Virginia Museum of Fine Arts; and the Corcoran Gallery of Art, Washington, D.C. She is represented by the Edwynn Houk Gallery in New York City.

MARY ELLEN MARK

Noted for her revealing and sympathetic portraits, Mary Ellen Mark has created images of diverse cultures that have become landmarks in documentary photography. Her work is in the permanent collections of the George Arents, Jr. Collection at the New York Public Library; the Chrysler Museum of Art, Norfolk, Virginia; the Museum of Contemporary Photography, Chicago; the Museum of Photographic Arts, San Diego; the Cleveland Museum of Art; and the George Eastman House, Rochester. She is represented by the Howard Greenberg Gallery in New York City.

RICHARD MISRACH

Richard Misrach has spent most of his career photographing the American desert, revealing it in images that have been described as haunting, potent, and alarming. His photographs are in the permanent collections of the Museum of Modern Art, New York; the Los Angeles County Museum of Art; and the Musée d'Art Moderne, Paris. He is represented by the Fraenkel Gallery in San Francisco.

HOPE SANDROW

Known for both her work with homeless women and her pictures of water, Hope Sandrow interprets space, time, and motion in her photography and installations, which often include raw materials from the places she photographs. Her work is in the collections of the Museum of Modern Art, New York; the Houston Museum of Fine Arts; and the Minnesota Museum of American Art.

FAZAL SHEIKH

Influenced by trips to his family's home in Africa, Fazal Sheikh has documented refugee communities in pictures that reveal the rich cultural and historical ties in some of the world's most remote places. His photographs are in the permanent collections of the Metropolitan Museum of Art, New York; the George Eastman House, Rochester; and the San Francisco Museum of Modern Art. He is represented by the Pace/MacGill Gallery in New York City.

WILLIAM WEGMAN

William Wegman's four weimaraner dogs appearing in these pages—Battina, Chippy, Chundo, and Crooky—are the successors to Man Ray and Fay Ray, the original pair that Wegman made famous. In addition to photography, Wegman has worked in three other mediums: drawing, painting, and video. His images are included in the permanent collections of the Whitney Museum of American Art; the Museum of Modern Art, New York; and the Walker Art Center, Minneapolis. He is represented by the Pace/MacGill Gallery in New York City.

ACKNOWLEDGMENTS

The Nature Conservancy wishes to thank the many people whose talent, time, and vision helped create this book and photography exhibition.

Holley Darden and Jill Isenbarger of The Nature Conservancy envisioned the project in 1998. They have worked ceaselessly since to give it shape and substance, making believers of all the collaborators.

Andy Grundberg, the curator of the exhibition, chose the photographers and edited their work to produce the selection of images that appears here and in the exhibition. He has been the creative force behind *In Response to Place*.

Martha Hodgkins Green, senior editor at The Nature Conservancy, wrote the site information about the Last Great Places and edited the essays and other texts, bringing insight and accuracy to the project. Joseph Barbato was a contributing writer for the project. His fiction and non-fiction anthologies about the Last Great Places served as models for this project.

Many Nature Conservancy staff members accompanied the artists in their travels—Gabrielle Antoniadas, Lynn Badger, Sue Bellagamba, Graham Chisholm, Jeffrey Cooper, Joanna Cope, Rili Hawari Djohani, Erin Dovichin, Jim Dow, Mike Eaton, Shaun Flynn, Stephanie Gifford, Mark Haberstich, Dave Harris, Nick Kingsland, Steve Keibler, Geoff Lougee, Robin Mucha, Chris Oberholster, Harvey Payne, Jos Pet, Mark Pretti, Bob Rogers, and Joel Tuhy. Their own deep response to place is evident in their dedication to protecting it.

Michael L. Sand, editor at Bulfinch Press, guided the book through the publication process with energy and critical acumen. Melissa Langen of the Bulfinch production staff helped ensure that we would turn out a beautiful book.

Katy Homans brought great sensitivity and harmony to the book's design. Andy Simons carried this spirit into the design of exhibition materials.

Ultimately, we are most grateful to the artists themselves, for their gift of pictures. They have helped us all to see the Last Great Places in a new light. In their response to place, they remind us that the essence of protecting the natural world lies in our own individual, intimate relationship with it.

The mission of The Nature Conservancy is to preserve the plants, animals, and natural communities that represent the diversity of life on Earth by protecting the lands and waters they need to survive. To date, the Conservancy and its members have been responsible for the protection of more than twelve million acres in fifty states and it has helped like-minded partner organizations to preserve millions of acres in Latin America, Canada, the Caribbean, the Pacific, and Asia. The Conservancy owns more than 1,300 preserves—the largest private system of nature sanctuaries in the world. The Nature Conservancy is on the Web at www.nature.org.